Dream Spaces

2

17

Dream Spaces

Memory and the Museum

Gaynor Kavanagh

Leicester University Press
London & New York

LEICESTER UNIVERSITY PRESS
A Continuum imprint
Wellington House, 125 Strand, London WC2R 0BB
370 Lexington Avenue, New York, NY 10017-6550

First published 2000
© Gaynor Kavanagh 2000

British Library Cataloguing-in-Publication Data

A catalogue record for this book is available from the British Library.

ISBN 0-7185-0207-8 (hardback)
　　　 0-7185-0228-0 (paperback)

Library of Congress Cataloging-in-Publication Data

Kavanagh, Gaynor.
　　Dream Spaces: memory and the museum/Gaynor Kavanagh.
　　　　p.　cm.
　　Includes bibliographical references and index.
　　ISBN 0-7185-0207-8. — ISBN 0-7185-0228-0 (pbk.)
　　　1. Museums—Philosophy.　2. Museums—Social aspects.　3. Museums—
Educational aspects.　4. Memory (Philosophy)　5. Memory—Social
aspects.　6. Learning, Psychology of.　7. Communication and culture.
　　I. Title.
　　AM7.K37　2000
　　069—dc21
　　　　　　　　　　　　　　　　　　　　　　　　　　　　　　99-43639
　　　　　　　　　　　　　　　　　　　　　　　　　　　　　　CIP

Typeset by BookEns Ltd, Royston, Herts
Printed and bound in Great Britain by Creative Print and Design Wales, Ebbw Vale

Contents

Acknowledgements

This book has been a joy to write, largely due to the people who professionally, academically and personally have provided help and inspiration. It has also been generously facilitated by the University of Leicester and has received the ready co-operation of a good number of museums. This is my moment to thank them.

I would like to thank colleagues in the museums profession for providing me with the benefit of their opinions, experiences and case work. This has enabled the grounding of the work in the real world of museums and the best practice to be found there. I thank John Beckerson, Mark Suggitt, Sandra Marwick, Elizabeth Carnegie, Helen Clark, Alexandra Robertson, Harry Dunlop, Lawrence Fitzgerald, Cynthia Brown, Robin McDermott, Cathy Ross, Margaret Brooks, Denise Brace, Rory O'Connell, David Symons, Angela Fussell, Kath Davies, Andrew Lane, Sandra Bicknell, Peter McCormack, Mark Rowland Jones, Elfyn Scourfield, Martyn Brown, Virginia Adsett, Anne Wheeler, David Broom, Victoria Pirie, Lloyd Langley, Steph Mastoris, Mervyn Jones, Fionnuala Carragher, Anne Fahy, Beth Thomas, Meinwen Ruddock, Yvonne Cresswell and many others.

I would like to thank Pat Midgley, Ann Heeley, Geraint Jenkins and Pam Schweitzer for being pure inspiration. My colleagues at Museum Studies in Leicester were, as ever, remarkable.

I am grateful to those who kindly and with care read through either sections or the whole of the book in draft. Their thoughts were especially helpful and appreciated. Whether the final text relates to the valuable points they had in mind though is another matter. I am also very glad of the support and encouragement given by everyone at Continuum.

The work was aided enormously by the University of Leicester granting me a term's study leave in 1994, out of which came the early literature search and the development of the initial idea, given expression in a paper to the annual conference of the New Zealand Museums Association later that year. I was also granted a semester's leave in the 1998/99 academic year which helped me bring the text to a first full draft. Grants from the Arts Faculty's research funds enabled me to travel to museums, spend time in oral history archives, and talk with experienced museum professionals and others.

I am grateful to all the museums and archives which gave permission for the use of images, extracts from oral history interviews, and one figure. I acknowledge Birmingham City Museums and Galleries, Glasgow Museums

Service, the Living History Unit Leicester, St Albans Museums Service, Museum of Welsh Life, Somerset Oral History Archive, Croydon Museum Service, Manx National Heritage, Edinburgh City Museums, Ulster Folk and Transport Museum, Nottingham Castle Museum and Art Galleries.

Jim Roberts prepared one of the two figures used. The artist Marilyn Jeffries from Wells-next-the-Sea kindly gave her permission for the use of the print on the cover. Miles Tubb generously supplied some of his Newhaven photographs which, for me, sum up so well the spirit of the book.

Finally, this book has really only been possible because of the unconditional support and constancy of family and friends. I would like to thank Eric and Margaret Coles, Mel and Marcia Hillman, Paul and Elsa Wainwright, Ulrike Harris, David and Wendy Roberts, Kay Raitt, Phil Reed, Joyce Daly, Anne Hargreaves, Jonathan Bell, Helen Coxall, Peter Gathercole, Janet Owen, Barbara Lloyd, Kevin Moore and, of course, Shaun Kavanagh. This book is for Paul, Christopher and Andrew, the future and all our dream spaces.

GAYNOR KAVANAGH
Rotherby, May 1999

1 *Dream spaces, memories and museums*

A man in his mid-eighties is sitting in his front room, dressed in a suit. The best china is on the table. He has written himself a note on blue paper. He is talking with purpose and as much precision as he can muster about his experiences of the First World War. A woman, almost a total stranger to him, is sitting by a tape recorder occasionally asking questions. He remembers trying to struggle over the beaches at Gallipoli under enemy fire. Later in the war, his plane was shot down while on a reconnaissance mission over Flanders. He had to hide out until he could get back through Allied lines. He remembers how many of his fellow pilots died and coming home to find the world had changed.

In a quiet sunlit room, a group of women are passing around objects borrowed from the museum. One of these is a buttonhook. The person who brought them asks the women what they recall of buttonhooks. Several recall seeing them and using them, but one woman has a different response. She had been a metalworker in Sheffield. As a very young woman, she actually made buttonhooks and remembers what it was like for her. She remembers the working conditions, the length of the day, how much she was paid and the people with whom she worked. The session closes and a trolley arrives from which the women are served their tea by a helper at the residential home. The talk goes on, someone tells a story at which they all laugh. Once tea is over they drift away, taking with them their own thoughts.

A museum curator opens a box and finds in it a pair of shoes. They are hardly worn. His experience allows him to date them to the 1920s. He recognizes the style and knows how, maybe even where, they were made. They are men's shoes, of average size. The owner's feet were a little broad. Perhaps the shoes pinched. In this collection there are good samples of shoes from the twentieth century, men's and women's shoes and a few pairs of children's shoes. He goes to the catalogue. It confirms all the details of date, size and fabric. It tells him when the donation was made and who gave them. The fact that the shoes had such little wear intrigues him. He looks up the name and address in the telephone directory and after a couple of calls finds the son of the shoes' former owner. He goes to see him and is told something about the man. He had been a bank clerk who had died in 1974 at the age of 79. He had bought the shoes so that he could take his wife dancing. He hated it, she loved it. She had died when he was in his early forties and he never wore them again. The shoes were given to the museum ten years ago when the family was sorting out the contents of the loft. The son is

thoughtful for a moment and then his eyes fill a little. He smiles to himself in the remembering.

A woman is spending the afternoon in the museum. She has with her a sleepy 3-year-old in a pushchair. As it is term time and mid-week, the museum is not busy. She has half an hour before she must leave to collect her elder child from school. She sees a bakelite telephone and it makes her think of a current TV drama set in the 1960s. A bit of the plot comes to mind and then a phrase from the signature tune. She thinks about something her aunt said about the 1960s and that old photograph she found of her aunt in her 'flower power era'. She laughs, her child wakes and they look at a painting of the market-place in the 1830s. It does not look like that now, they can't quite make it out, but her child likes the dog running across the foreground. They call it Ben (because it's like their neighbour's dog) and wonder what it was running from or to. They leave because time is pressing. That evening the real Ben is taken a biscuit and is told about his painting.

Each of these is a memory-based episode connected to the work of history museums and for each of these stories there are many more. Every object, interview, handling session and visit has behind it a host of connections, some touching, others funny. Such narratives as these prompt thoughts and feelings. They also provoke recall of personal episodes that conform or contradict each other. These episodes are taken from the work of history museums, that sector of museum provision which deals specifically with material relating to the more recent centuries of human experience. How the threads of memory, imagination, feelings and identity run through each is the subject of this book.

Mark O'Neill has argued that 'museums are places where people go to think and feel about what it means to be human' and that museums are used 'to assert particular definitions of humanity' (1994); but he goes on to point out that the range of lived human experiences permitted in museums is extremely limited. He sees the restrictions as being embodied in the bounds placed on what people, both staff and visitors, can feel in them. Although the poster and the mission statement may claim a verbal welcome, this is often accompanied by a non-verbal rejection at the door or display case. This is a way of thinking that I share. I also seek to situate an idea of humanity within the notion of the museum. While recognizing that this is open to abuse, it is nevertheless also open to something enabling and emotionally honest. Therefore the trajectory taken here springs not from objects, collections or the institution, but from people and how the past is remembered within the present. The emphasis is placed upon the personal and private as it comes into contact with the formal and official. This means considering both the rational and irrational. In this work, the term 'dream space' is used to cover these and the ways in which they interlink in our lives.

The idea of the dream space comes from a paper by Sheldon Annis (1987). He described the museum as an expressive medium and the visit as a movement through three overlapping symbolic spaces: cognitive, pragmatic (social) and dream. The visitor travels in, through and out of these spaces, organizing and threading them together in ways that make meaning and associations in their lives. The first of these, the cognitive, lies at the centre of the educational purpose of museums and gives rise to the order and rationality which the museum seeks to impose on everything in its charge. At the root of effective

museum provision is learning through cognitive facilitation, which is arrived at through skilful manipulation of the museum's space. This is done in the light of knowledge of the museum's subject and the needs of audiences, and presupposes the acceptance of the social nature of the visit. By 'effective' in this instance, I mean in terms of knowledge gain or achievement of some form of insight and additional understanding. This is what constitutes the museum as an important site for learning, a place where learning is potentially open and lifelong.

The second space is the pragmatic or social. In this, Annis argued, our social natures are indulged. We play out our roles on the visit: partner, parent or friend, according to the company we keep. The motivation for the visit is usually social, as opposed to business or economic necessity. It is often spontaneous, with a minimum of obligation other than gaining some form of satisfaction. It takes place in personal time, through choice, and has a goal of promoting some form of social union through role enhancement by the sharing of an experience. Thus, by enjoying an exhibition with a friend, the friendship is further bonded. In time it may not matter what the subject of the exhibition was, although this could still play a part in the memory of the visit.

Annis's third category is the 'dream space', which he defined as 'a field of subrational image formation'. In the museum it is the field of interaction between objects and the viewer's subrational consciousness (Annis, 1987: 170). Difficult to pin down, it is near impossible to interfere with, situated as it is in the rich inner life of all of us. It is within the dream space, at times interacting within the cognitive and the social, that the most enlivening, enjoyable and possibly subversive parts of the visit lie. It energizes both our imaginations and our memories. It illuminates feelings. Anarchic and unpredictable, through the dream space we can arrive at all sorts of possibilities not considered by those who make museum exhibitions. In dream space, many things might tumble through our minds: bits of songs, half-written shopping lists, things left unsaid. The shape or shadow of something, its texture or colour, the operation of space and the people moving through it can be triggers to an endless range of personal associations. Therefore, in accepting Annis's idea of the dream space, we have to accept more fully the imagination, emotions, senses and memories as vital components of the experience of museums.

Nevertheless, it is important to remember that dream spaces are not confined to the visit, as Annis described. History museums also work with dream spaces and all they provoke in most of their activities, not least their recording, collecting and outreach work. They engage with dream spaces both as product and process, most evidently through personal recollection.

In terms of recording and collecting, memories enter the museum as *product*, as a source of information, something which can be stored, interpreted, returned to and employed. The curatorial role here is concerned with finding both objects and memories, then keeping and using them within some system of explanation. Much of this is taped recordings and notes taken of oral testimony. These may contain: descriptions of events; opinion; accounts of methods, procedures or rites; or stories and songs. Such archival commitments involve the museum in working with individuals and groups. Certain ends are usually in view, such as exhibitions, demonstrations, educational programmes or publications. Exhibitions with components taken from oral history, whether as script or sound bite, are now

common. The tapes and sometimes their transcripts are held together as collections, and are made available for research purposes. Although entered into ostensibly as a matter of co-operation, ultimately it is the museum's short- and long-term agendas which have priority in creating memory as *product*. In sum, museums need memories as a primary source. They gather and employ them extensively.

By extension, museum products are dependent on access to memories. Museums increasingly provide a range of services, which in this instance might be seen as products in the commercial sense of the word. A museum seeking to establish a high-profile social role will be working on outreach and other programmes. The extent to which they engage in these is a benchmark of their 'community' responsiveness. A museum's products may be a series of workshops for adults with mental health difficulties, outreach work with prisons or reminiscence sessions with ethnic elders. Each of these would be facilitated by access to memories: the event and those who experience it are co-dependent, up to a point. Museums need to be seen to have such products within their work. Therefore, outreach is 'produced' and is identified as part of the social role played by museums. It becomes a constituent and to some degree self-serving part of the museum's agenda.

Memories as product place the museum in a situation which is about taking. No matter how well done and how thoughtfully organized, the basic motive is one of appropriation. This may well be to a larger end, such as enabling people through access to forgotten or neglected histories. Nevertheless, the museum needs to have a variety of products, and in the case of history museums these are increasingly based on someone else's memories.

When each of us brings the past to mind, we go through a *process* of remembering. The extent of recall is enhanced by access to prompts, things which stimulate the senses. Remembering is facilitated by environments or circumstances, in particular those where narrative and reflection are safe or perhaps unavoidable. The multi-sensory experience of museums, together with the social nature of the visit, puts many visitors in a situation where recall is natural, even spontaneous, but museums cannot predict the deep inner resources that people draw on when engaging in the process of remembering. Some exhibitions may be designed to provoke a mood or play on those memories which are perceived to be jointly held. There is no guarantee that this will be shared by those who visit. This is because the process of remembering can be a very individual matter, a defining part of the self. Whether moved to anger, tears or sheer unadulterated boredom, the position of self within that response is undeniable. Understanding this becomes essential to appreciating how and indeed whether museums communicate.

Processes of remembering can have an effect on our moods, ideas of self-worth and our general sense of well-being. In some situations, the process of remembering can have therapeutic value. If handled with skill, facilitating the process of remembering can promote positive feelings and enjoyment. It can also allow for the release of negative emotions and provide an opportunity for resolution. The process of remembering is never guaranteed and carries with it the possibility of distress as well as pleasure. Work with reminiscence, a process with therapeutic intent, is aimed at bolstering a sense of self-esteem through positive reflection, and is about giving.

These two areas of *product* and *process* may well fuse at times, but need to be fairly well distinguished in the minds of those who work with them. For example, oral history work, although essentially about product, inevitably involves the process of remembering. An oral interview may be conducted with the intention of using some of the material in later gallery work, but it may provoke painful memories and stir unresolved grief. Does the curator have any responsibility here, if in this instance the goal was product and not process? If in a reminiscence session an older adult recounts an episode, the narrative of which holds considerable primary source value, does the museum ignore it because its role in this instance is process not product? Similarly, if memories are stirred by a particular exhibit, does the museum disregard them, on the grounds that the product – the exhibit – is complete in itself, and no further amendments can be made? If an exhibition makes someone cry, either then or later, or laugh with derision, what is this and what should this mean to the museum?

The purpose of this book is to open up museum thinking to a greater awareness of the products and processes with which they are engaged. The literature available to us, research which points to aspects of the process and product of memory, is extensive and very diverse.

Cultural critiques of museums have tended to dominate both the museum and heritage studies fields. Although intellectually stimulating, they are of limited assistance in this particular regard. The absence of balanced examples of good practice and the assumptions that all museums are the same and all visitors innocents abroad rather reduces their helpfulness. For example, Walsh describes public history as just another form of entertainment, as 'a comestible to be consumed, digested and excreted' (1992: 39). Wright believes that 'where there was once active historicity, there is now decoration and display: in the place of memory, amnesia swaggers out in historical fancy dress' (1985: 78), as if it was all right once, but not now. Hewison was prepared to declare flatly that the past is 'a major economic exercise' (1987: 28). Huyssen offers the view that the planned obsolescence of consumer society found its counterpoint in 'a relentless museum-mania'. He views museums now as a mass medium, 'a site of spectacular *mise-en-scène* and operatic exuberance' (1995: 14). Within these forms of critique there is an anxiety that museums are simply manipulative, reductionist, even cynical institutions cashing in on the weakness of a gullible public, forever needing to escape the present.

It would be naive in the extreme to argue that the charges made are totally unjust, as too many examples of unreflective, gratuitous museum provision exist. There is no denying that there are any number of examples of where the past has been commodified to meet purely economic ends. Where this happens, we all lose something. An able reflective society needs available, challenging, thoughtful and accurate histories. Some of the museum projects that have engaged in the worst excesses of shabby history-making have been relatively short-lived, whereas others have prospered. But there are yet other forms of history museums that have worked against this trend, whose imperatives have been and still are primarily social and educational. They form a significant proportion of history museums operating in this field. Imperfect, constructed, partial, affecting, informative and encouraging though they may be, to convict them all on the basis of others is, to say the least, unhelpful to us.

Cultural critics also underestimate the visitors' capacity to answer back, to disassociate from museums and what they say, and to find their own meanings. Perhaps the hardest part of all is that some critics appear to dismiss the simple human need to remember, to feed the spirit and the mind. This helps to place a life in context by touching something of others' lives and by connecting to a broader historical frame of reference. This may not be madness nor ignorance nor human frailty nor a grand social plot, but something honest, thought-provoking and personally enabling. So, to get closer to this, we have to explore other ways of understanding memory.

Neuroscientific studies of the brain are able to tell us a great deal more about how the mind works. Research has been greatly facilitated by the technologies of magnetic resonance imaging and other techniques. It is now raising questions about gender differences, personality and the senses (e.g. Gregory, 1987; Greenfield, 1995; Rose, 1992; Pinker, 1999). By being able to *see* our minds actually at work, neuroscientists can point to where some of the divisions between nature and nurture, between innate proclivity and cultural condition-ing, occur in human development. Through neuroscience and the controversies that spring from it, we can get closer to understanding the neurological relationships between emotion, memory and the senses.

The field of psychology, although prone in the past to disassociate the study of memory from feeling, is now offering many useful ideas about autobio-graphical memory and about the communicative and cultural functions of emotions (e.g. Conway *et al.*, 1992; Conway, 1997; Parkinson, 1995). Hitherto, the dependence on experiments within laboratory conditions has inhibited aspects of study within these fields. Greater freedom has come with the development of methodologies which test and observe behaviour in their appropriate settings. From these, social and individual patterns are being discerned, such as the performance role of emotions where we indicate how we want to be seen through the emotions we express.

Studies of particular value to this work have come from social gerontology, as well as behavioural and clinical psychology of the older adult. These have opened up new forms of understanding about our memories in later life and about the efficacy of talk about the past (e.g. Coleman, 1986; Bromley, 1990; Bond *et al.*, 1993; Bornat, 1994; Kitwood, 1997). Through this work, one is prompted to consider the layers of memory gathered through our lives and the different ways in which we deal with them. The changes that have been witnessed in attitudes towards older adults and their memories is summed up strikingly in this often-quoted piece by Rose Dobrof, describing her early work as a junior social worker in the 1960s: 'it was even said that "remembrance of things past" could cause or deepen depression among our residents, and God forgive us, we were to divert the old from their reminiscing through activities like bingo and arts and crafts' (Dobrof, 1984: xviii).

Historians discuss the value of memory in relation to other forms of evidence, and there is a much greater acceptance of the importance of memory in framing the past (e.g. Samuel, 1994; Thelen, 1990a). Samuel came to the defence of history-making by claiming that 'history is not the prerogative of the historian, nor even as postmodernism contends, an historian's "invention". It is rather a social form of knowledge' (Samuel, 1994: 8). He argued that memory is

historically conditioned and the act of remembering is part of the social process of maintaining knowledge of the past. Thelen has pointed out that the relationship between the study of history and the study of memory is a strong one. By connecting with memory, historians are building bridges 'between their craft and wider audiences who have found professional history remote and inaccessible'. He also argues that 'by reconnecting history with its origins in its narrative form of everyday communication, attention to memory transcends specialisation by speaking the language of face to face association and firsthand experience' (Thelen, 1990a: viii).

Both writers see a value in the relationships between academic history and spontaneous memory and history-making at an individual level. There are useful parallels here, which are being recognized elsewhere. Marwick has described how historians are 'not trying to represent the past, they are trying to produce knowledge of it', and he acknowledges a similar process within the individual's need to recall past events (*THES*, 16 May 1997). Although other historians such as Jenkins (1991, 1995) throw serious doubt on the integrity of this, it is sufficiently well accepted as to be the basis of much of what historians do, both in universities and the public domain (Evans, 1997).

From this brief survey, it is obvious that there is a huge amount of material to draw on here and much which has a relevance within museums. However, the historians who work in them need to have so much more in addition to the firm intellectual grasp that these studies offer. Working with memories, either as product or process, requires a range of social skills and a developed capacity for empathy. This has caused dilemmas. Are museums about objects or people?

This question has been central to the ways in which history curatorship has developed over the past twenty years (Kavanagh, 1990, 1996). Traditionally, museums were places which housed and exhibited selected objects; curators tended the inanimate. But once the emphasis shifted in the postwar years from antiquities to *social, cultural* and *industrial* histories, understanding the recent past through objects alone became impossible to sustain or indeed justify. As soon as museums moved from antiquities to histories, they were committed to embracing a wide range of source materials. They had to develop 'archives' which were integrated; that is, they included not just objects but images, the spoken word and references to many forms of primary material from landscape to local government records. This required considerable adjustment in both museum theory and practice. For some this went too far. History curators were berated with the charge that they had distanced themselves from objects and were moving dangerously close to social work (Tucker, 1993).

The concern that museums were 'dangerously close to social work' is not to be taken lightly, nor to be read solely as a reaction against change. As museums have developed an increasingly close relationship with social histories, they have inevitably also developed a relationship with people's memories of events, processes and episodes. Through them, they are exploring the *private* territories of dream spaces in the *public* domain of the museum. This is not only hugely important but also potentially hazardous, especially if approached with a lack of understanding or an agenda of appropriation. Museum curators have indeed moved closer to social work in some respects, because what they do has become not just more social but also highly personal as well. They are now working in

areas where much harm, yet hopefully also much good, could be done. Without a feeling for people's lives and histories, museums become remote and irrelevant. But, where there is an engagement with the past from personal and social perspectives, both scholarly and professional responsibilities have to be accepted. These hinge on an appreciation of what the past means to people: what they remember of it, and how they felt and what the return to this memory does for them in the present.

What it might mean to someone is summed up in this story, and the moment it conveys is vital to how this book has been thought about and written.

A reminiscence worker in the North East of England brought to a residential home some photographs borrowed from the museum. In the group he was working with, there was one man who said little, if anything at all. He was very withdrawn and not much was really known about him. One of the photographs handed around was of the local quayside. The museum most probably collected it because it pictured activity on the quay and encapsulated something of a lost era. For once, the man was interested. He looked at the photograph carefully for a long time. He then pointed to one of the figures walking along the quay and said very firmly 'that's me'.

(Recounted by Professor Bob Woods, University of Wales,
at the Conference of the European
Reminiscence Network,
Blackheath, London, 1997)

2 *What is memory?*

Within the hard yet brittle shell of our skull rests the brain, soft grey matter fundamental to our existence. Scientists believe that within the brain lies the secret of our consciousness, the very thing that gives purpose and shape to our capacity to live. Susan Greenfield has described consciousness as arising from 'a kaleidoscope of memories, prejudices, hopes, habits, and emotions which are constantly expanding and enriching your life as you develop' (Greenfield, 1995: 1). This is an inner world, private and largely inaccessible to anyone but ourselves, which engages with the outer world but remains separate from it. It is alive with images, scenarios, feelings and fantasies, shifting yet real. It can be heightened by such experiences as falling deeply in love or dulled by a good dose of influenza. Aspects are held much deeper, in what is called the subconscious or unconscious, which has been described as having no vocabulary as we would understand it, but as experienced through 'mainly pictures, images and sounds which, without much ado, change their meaning or merge into one another' (Balint, 1968: 97). Within our consciousness and from this our minds, rational and irrational thought co-exist.

In Eastern traditions and traditional philosophies, in particular Taoism, Zen, Yoga and Buddhism, consciousness is conceived in a holistic sense linked to mind, body and spirit; for example, in Taoism consciousness is perceived as the unrealized dimension of all of life. Consciousness becomes something which flows through all life and can be transcended, through a sense of harmony and peace. In Western academic traditions, consciousness is seen as a transient although variable state, something we study either through the functioning of the brain or within the academic frameworks of cognitive psychology and psychoanalysis (Taylor, 1978).

My discussion here is largely about memory, although it will be clear that it is inappropriate to confine ourselves to just this if we wish to understand dream spaces. Memory does not exist in an emotional vacuum nor in a space devoid of the irrational.

It is almost impossible to think of ourselves without the capacity to recall, to be conscious yet mentally unaided. Our memories give us the ability to accept it is morning or night, remember our home addresses, recognize our friends, recall pieces of information about our work, relate stories about our school-days, find a pair of shoes in the wardrobe, and get to the beach and back. So much of what we take for granted such as walking or lifting a cup at some stage in our lives had to be learned and the information stored to be used again and again.

To be without memory or to find it erratic or fading, as with Alzheimer's disease (a degeneration of nerve cells in the brain), can be totally terrifying, as it strikes at and seems to obliterate that very sense of who we are. Imagine waking up one day not knowing how to boil water in a kettle, and not being able to recognize a life partner. We literally *remember* ourselves in all our conscious acts, a process which is continuously rehearsed, modified and played out. Every time we repeat an action or bring something to mind (however small) we are underlining, reinforcing and buttressing the subjective sense of self. Having a memory which is satisfying grounds the self and is the basis of both personal and interpersonal action. Through it we examine, within ourselves and with those we trust, something about who we are.

Our memories are stored somewhere within the brain, an organ of extraordinary capability which is the body's control system. Protected within the skull it divides into three regions: the *cerebrum* through which our thoughts are enabled, the *cerebellum* which co-ordinates movements, and the *brainstem* through which vital functions such as breathing are regulated. The cerebrum constitutes about 89 per cent of the brain's mass and it is this part of the brain which is the centre of our intelligence, memory, speech and consciousness. Different areas of the cerebrum seem to have different functions – behaviour and emotion, hearing, taste, motor skills and so on. They link together and co-operate through an elaborate communications system that enables us to process vast amounts of information in seconds.

Research suggests that certain parts of the brain have an instrumental role in the retention of memories. The *hippocampus*, shaped like a ram's horns and situated in the sub-cortical area of the brain, is known to be critical in the laying down of memory, especially declarative knowledge. The *medial thalamus* is vital in relaying incoming sensory information to the cortex. Both have a role to play in the consolidation of permanent memories. The importance of the hippocampus is well recognized. It is known that in some people the hippocampus is reduced in size, probably the result of excessive exposure to *glucocorticoids*, the chemicals released in times of extreme stress. These appear to impair memory functions, especially those associated with traumatic events such as rape or battlefield experiences. The clinical evidence is as yet not categorical, but it does raise essential questions about the mind's physical ability to deal with trauma (Schacter *et al.*, 1997).

The study of the brain and its functions has been substantially aided by the increasingly sophisticated means of investigation that have become available with PET scanning (positron emission tomography) and MRI (magnetic resonance imaging) among others. Originally designed for medical diagnosis, the availability of such equipment has created options for scientific research which hitherto would have been deemed totally impossible. It has given rise to a number of important and continuing studies, for example, the extent to which gender differences determine how the brain functions, and whether there may be genetic determinants to behaviour patterns. The science of the brain is seen to be on the threshold of discoveries which could be as significant as those of Darwin, and they will be equally hotly contested (Wolfe, 1997). They raise fundamental issues about the relationship between nature and nurture; whether we are as we are because of primarily physiological and

neurological factors, or political and cultural circumstances. Do we shape our worlds or do our worlds shape us? The imaging techniques now available will enable knowledge of *how* the brain works to become much more specific. Nevertheless, *why* the brain works as it does will continue to be within the field of philosophy.

The physical location of memory within the brain has long been a matter for debate. We can identify different function areas within the brain, saying, for example, where physical co-ordination and sight are located. Yet the seat of memory, the place/s where memories are 'kept' has eluded us. Maybe this is because, rather than being in just one place in the brain, memory is in fact stored throughout it. Susan Greenfield argues that there is more to memory than the congress of isolated neurones. Instead, 'different brain regions contribute to memory processes in different ways' (Greenfield, 1997a, 1997b). This makes a lot of sense. There are different types of memory, each connected in some way to each other and to the different functions which the brain controls. Thus the memories of how to hop on one leg or the French word for 'window' or the content of a painting are stored in connections to those areas where the memory was first imprinted through movement, sound and vision.

For example, memories of language are held within the language location in the brain, and work together with other locational functions in the storing and retrieval of information. So if I think of a 'concert', I have different areas of my brain working on this simultaneously. My last experience of a concert had elements which were audio- (the music, conversations, traffic), space- and size-related (awareness of my specific spatial relationship to a huge concert hall, physical closeness to people), visual (the movements of orchestra and audience, my companion, my physical journey to my seat and back), related to smell (a huge audience on a warm night) and taste (ice-cream). In such circumstance 'concert' means more in the memory than just the word and the music, and any one of these elements, including the ice-cream, can lead back to the memory of it.

Neurobiologists believe that when we learn or experience something there must be electrical and chemical changes in the brain, although no one totally agrees on what those changes are. Studies of the memory capacity, for example, of chicks or sea slugs, may help plot neural changes, i.e. what happens in the brain on the point where a memory is formed, but has not as yet helped explain what happens when that memory is prompted or how that memory is accessed. Nevertheless, it is accepted that memory is a kind of ingestion that can be retrieved if appropriate prompts are given (Gregory, 1987; Rose, 1992). The ways in which these prompts work and the individuality of retrieval, interpretation and response, based on a lifetime of associations, moves the study from the physical to the phenomenological. Greenfield has described memory not as an 'add-on brain accessory but a cornerstone of holistic and cohesive consciousness', incapable of being divorced from the subjective stance of the individual (Greenfield, 1997a). In other words, our memories are us and they come in many forms.

Memory can be described as a whole range of processes for retrieving and storing information, anything from the brief storing of information (yes I did lock the door) to a facility to retain knowledge, say, to speak fluently in a second language or recite the names of all the presidents of the United States. Memory

also has a duration, short or long term. Short-term memory is dependent to some degree on priorities and experiences. It is transient and easily interrupted. Memories of driving daily to work or shopping at the supermarket merge into one consolidated account, until recall of one particular feature is needed. On which part of yesterday's journey could I have picked up a nail in my car tyre? Why did I buy tinned pears when nobody at home likes them? The anomaly breaks through, even illuminates, the monotony. Otherwise, the short-term memories are rolled together: not hundreds of journeys to work or shopping trips but one. Unless they are 'fixed' in some way like this, they can slip away.

Long-term memory is of a different order. We literally carry it with us through life and whether we are 4 or 94, our fixed memories are there to be accessed, encoded within the brain structure, whether we want them or not. Long-term memories are notoriously difficult to erase and have been compared with scar tissue. The physical embodiment of our memories means that nothing can take them from us: electric shocks, freezing and anaesthetics will not remove them (Rose, 1992). We can push them to one side, try to ignore them, sublimate or deny them, convert them into something better or worse. But ultimately only death is their end, unless we have passed them on to someone else. Oral traditions, biographies, recollections of our memories held by our children and grandchildren are memories that are externalized and re-presented for use by others. They are given a life of their own, outside of ourselves.

Within long-term memory there are different forms of remembering. Semantic or declarative memory provides us with a lifetime's stock of words and meanings. But it is understood that our brains operate more through recognized meaning than through pure information. I know that when I dig the garden I am using a spade and not a chandelier, because 'spade' is the word I have learned for the oblong of steel attached to a shaft of ash wood which is used to cut and turn the soil. I know equally well that the spade is more effective at this task than another garden tool, such as a hose-pipe or lawn rake. So if I said 'I dug the garden with a box of tissues' or 'I phoned the soil with my new spade' it would read as nonsense, unless you had spent your whole life calling a 'spade' a 'box of tissues' and for 'dug' used the word 'phone'. The words and meaning are one in my brain, as these words are in yours, but it is the meaning that your mind is working on.

If I had written the words for 'garden', 'spade' or 'hose' in, say, Swedish or Mirpuri, it would have been difficult for many readers to access the meaning of the last paragraph. Technically we would be cognitively impaired, as the words are beyond non-Swedish or Mirpuri speakers' range of remembered words and their connections. Indeed when we learn a new language or are bilingual, the inadequacies of words in relation to the physical and sensory realities become frustratingly clear. The 'seeing' of meaning and the naming of things is an inexact exercise. Imagine three very different people searching the landscape for a 'mill'. The first could be looking for one with sails, the second for one with a water wheel, the third for a building equipped with looms. But this is how we name our worlds and our words are fixed when we learn our language, the vocabulary culturally determined. It emerges through a continuous process of reference. We live our lives in a constant state of naming which arises out of a negotiation between words, space, things, feelings and other people.

Semantic and declarative link us to procedural memory. Knowing the words for and meanings of things helps us in the procedures we adopt. In a history class, students may be required to learn the six points of the Chartists' petition presented in 1839, 1842 and 1848. They know the words to use to declare them and can learn them by rote, but it would be procedural memory which would be vital to writing them down, presenting them verbally, or typing a note about them on the computer. Procedural memory can be highly ritualized and full of protocol. How do you greet an archbishop? Or it can be mundane and repetitive, such as tying a shoe-lace or filling a bath. Some forms of procedural memory require great mental effort, such as the precision of open heart surgery or intricate parade ground manoeuvres. Others may not; instead they become 'second nature' such as buying a newspaper or saying goodnight to the kids. This is because procedural memory can be either explicit, requiring conscious memory of past experiences, or implicit, when a task does not require conscious recollection (Groeger, 1997: 67).

Episodic memory is our ability to remember events, places, connections, information and people within the terms of our lives. It is highly subjective: we remember life's episodes on our own terms, as we see ourselves, and maybe not as others see us. We do not remember things sequentially, unless we rehearse the memories regularly, but literally in episodes hinged to key life events (Conway, 1997). Sometimes this might be organized around major events, such as 'before and after the war', or life events, such as 'when he started work' or 'just after the operation'. Sometimes they might be hinged to rites of passage, such as 'before your Uncle Harry died', or 'not long after we got married'. Each memory in turn gives rise to further memories, like rooms leading from one to another.

If there is a need to remember in detail, the human inclination is to organize key elements into schemata. The better the system of organization, the more likely is detailed recall. For example, students evolve revision techniques which suit them and develop means of encoding the data they need within assessment processes. The elements (or episodes) of a geography course can be organized in such a way as to promote learning them, triggers to recall (such as mnemonics) can be established and means of working with information within a written examination rehearsed. Remembering the details of a wedding for recounting to a family member who is unable to attend is best aided by some form of schemata or premeditated process of recall, for example, describing first the music and then the clothes people wore, who was there and who was not.

Remembering the details of episodes such as a road accident, a row at work or a complex transaction may take on a similarly conscious and deliberate approach, especially when the recounting of such memories has outcomes likely to be of importance, for example, the legal settlement of a dispute.

Episodic memories are particularly context dependent and may be especially vivid and affecting. They can be linked through or be prompted by semantic and procedural memory. When I speak to my father on the phone and he uses Welsh words that are no longer part of my regular vocabulary and certainly not part of the language sets I encounter living in England, I have to use my semantic memory to recall what the words he uses mean; for example, that a *bosh* is the kitchen sink or where you wash up. When he uses it, the word brings back procedural memories of washing up at my great-aunt's house before it was fully

plumbed and episodic memories of events and situations there which stem from my childhood. In these ways, memory spills out of the neat categories of semantic, procedural and episodic. It refuses to be contained.

What we understand about the making of memories is that they are context-dependent and highly sensory. The ways in which we came to remember something in the first place can lead us back to that memory at a much later point in time. The term for this is 'encodement specificity' (Tulving, 1975, 1983). The cue can be audio (an old song), visual (a faded photograph), association with smell (engine oil) or it can be a feeling (fear or contentment). In museums, the cue is sometimes a tactile one. The sensory experience of weighing something in one's hand or moving one's fingers over its surfaces can release memories which have lain dormant.

Our senses substantially aid our access to and absorption into memory. This is because in our daily lives we constantly use them to explore and measure our encounters. They are the systems through which we participate in life, and through them we gain admittance to perception and judgement. Very little of this happens with our full awareness.

What can you taste in your mouth right this minute? How many different sounds can you hear right now? We rarely stop to appreciate the senses we have unless they become impaired or are lost. We see a full moon, hear a lyric, feel the breeze on our skin, taste mint or chocolate, and smell the ocean; all without great thought to how we got to that point – sufficient that it is there to be enjoyed. But they can easily be rolled into sustainable and vivid imprints. Thus a moonlit evening by the edge of the sea, sharing a box of mint chocolates while a light wind gathers on which the strains of music from the local tavern's radio are wafted towards you is or might be a memory. (It could also be the night you were aware that a hurricane was building or your relationship was at an end.)

Here is a memory, wrapped around senses. One day last summer, I was reading in the garden. My senses picked up changes in the wind, light and temperature: there was a thunderstorm approaching. I sensed it, the cats sensed it too. I knew it wouldn't snow, that made no sense. My senses said rain – lots of it. This was my perception of the weather, but I also had a concept of it too, a little shaky perhaps, but I could crank out a little knowledge about how weather fronts are formed and storms develop. However, my perception of weather changes works much more quickly than my conception of it. This saved me from intellectualizing, and, like the cats, I moved swiftly to keep dry.

Without thinking about it, our memories come back through stimulation of the senses. Smells can be particularly evocative: roses, brewing coffee, wet dog, baking bread, disinfectant. Smell is by far the most fundamental of our senses and exists within the very centre of the brain. The olfactory area of the brain has evolved into the neocortex, the complex neural centre of our functions and the part of the brain which controls emotional and sexual behaviour. Those memories 'fixed' by feelings and smell seem to be particularly strong.

Yet senses, like our memories, are to some extent culturally and generationally dependent (Classen, 1993). A hundred years ago, acceptance of the stench from foul sewers, bad drains and inadequate stabling would have been common in urban environments. Today we would not tolerate it, and indeed have legislation to prevent it. Body odour and the stench of smoke-filled rooms,

again in pre-deodorant and pro-smoking days, were taken for granted, and are now found to be unacceptable. The sight of animals being driven to slaughter in sheds behind high street butchers' shops has similarly become unacceptable and the whole process is now shielded from view in out-of-town abattoirs. The noise of rock music, neighbours, even church bells, drives some people to the edge of their sanity, yet enriches the lives of others. We wouldn't know how to wash the body of a dead friend, and someone else now gives this form of loving touch for us. And we taste food through chemicals and chemicals through food, wondering which is which. Perhaps it is because the organization of many sensory experiences changes that the recovery of memory through sensory stimulation is so important. To a generation that grew up predominantly on home cooking rather than processed foods, the smell of cake-baking is evocative in a way that more recent generations would perhaps more readily identify with the smell of a McDonald's outlet.

Memories are to some degree both context- and audience-dependent and are therefore prompted by the availability of others. On our own, we may ruminate about things, laugh out loud at a transient thought, entertain a whole mass of data and impressions. The shift from a private to an expressed memory is dependent on the presence of an accepted listener or listening group and will alter accordingly. A retired farmer's explanation of how to milk a cow by hand may vary according to whether the audience is a group of men of his own age in a bar, an earnest history curator, or his 13-year-old grandchild who needs to be shown immediately because the power in the milking parlour has failed. The words used, the illusions drawn, the detail given, the emotions shown may well vary a great deal. Each situation demands something different from the teller, and the telling is adapted accordingly. The audience–teller relationship to some degree inevitably shapes the memory and determines how it is conveyed.

The way we feel may also prompt our memories. People tend to remember more sad things when they are depressed than happy ones. Equally, when tremendously happy, it is hard (and thankfully usually unnecessary) to recall very distressing times. This is referred to as mood dependence and congruence (Bower, 1981; Brown, 1987: 265). The forms and expression of our feelings may well be wrapped up in claims we make to identity. Happy, resourceful people can convey difficult memories in ways that are different from those more readily given to melancholia. Thus not just the audience and mood but the expression of memories equally plays a constructive part in our identities. People who have deliberately cultivated identities as strong, resourceful, talented individuals are perhaps less likely to admit to, recount or bring to mind episodes of shameful incompetence, or the malicious exploitation of others. We are making ourselves as much as making a record of the past when we bring things to mind. This is as evident in what we forget as in what we remember.

3 Remembering and forgetting

If our memories are context-dependent and respond to prompts, why is it hard to remember things? Why do people forget or mis-remember? Is it unreasonable to expect anyone to remember accurately?

In some ways, forgetting is more an art than remembering. The mind is not like a tape recorder with an erase button. Once known, something cannot be truly 'unknown'. However, in lives where the burden of pain is high or where there is a personal stake in remembering in certain ways, some self-protective means have to be found to deal with memories. Coping strategies come into place, certain situations and people avoided, music carefully screened, talk altered. Life can be paced and organized: anything to avoid circuitously travelling around pain or difficulty. These may be put into perspective and managed, but cannot go away entirely. Some people are more adept at this than others. Forgetting can be a highly selfish act, especially where alternative memories are intentionally produced, practised and performed to the point where they take a more satisfactory form than the 'real' ones and are therefore absorbed as 'reality'. Thus, if we do not want to remember something in a particular way, other ways of remembering will be found through having another story to tell. Children are particularly adept at this – 'his head hit my fist', 'the greenhouse got in the way', 'it wasn't me, Mum'. Thus in childhood the strategies of memory management are learned.

In many ways, forgetting is as important to us as remembering; it shields and aids us. The sheer bulk of memories has to be managed. We don't necessarily need to remember who we saw last Wednesday week when out walking the dog, or how much the electricity bill was three years ago this August. We don't need to hang on to slights and difficulties once resolved, or minor episodes of enjoyment. We condense these into abbreviated forms, summaries that may or may not be needed again, but which are certainly not in the forefront of our minds.

We negotiate with ourselves over the more difficult bits, say, by omitting the detail or skating around something more specific. Margaret Castleton, a lady in her nineties, gave an account of her life in the North End of King's Lynn to True's Yard Museum. Her broadly chronological narrative included a description of her younger brother being born, his subsequent illness and death. She made reference to her mother 'taking against her' because she felt the girl had brought the baby's fatal illness into the house. When she was 4 years

old, her father took her away to live with an aunt and only after a long period had elapsed (at least a year) was she taken back to live with her parents. Throughout the interview she repeated firmly what a good home, what a clean home she had had, and made good mention of her father, but not her mother. Her coping strategy would seem to be assertion that all was well and good and that she was lucky, especially with her father. It would seem to be the best and most acceptable memory she could make from what must have been traumatic and unhappy early years.

Sometimes this elliptic description of events may be because the claims are too important for it to be otherwise. Anyone who has witnessed a trial, watched someone's marriage fall apart, or experienced a contest with a supplier of faulty goods or services will know that there are endless versions of the same event. The work of historians is also evidence of this. The presence of contradictory accounts can demonstrate that the things which are remembered, what is included and excluded, the words which are used, the illusions drawn, may be as relevant as the actual content. A person may indicate as much about themselves and their life experiences in what they do not say as in what they do. Evidence is as much in the silences as in the words used.

Sometimes, even when we are making the best effort to remember, we are in fact forgetting, or at least eliding the detail, summarizing several episodes into one. There may be no malicious or even wilful intent in this, just a kind of mental shorthand which the brain performs. This was examined in a study undertaken by Neisser and Harsch on the permanence of memory of the Challenger space shuttle explosion on 28 January 1986. On the day following the disaster, a group of students was asked to record on a questionnaire a detailed structured account of how they had heard about the disaster. Three years later the group was asked to write down what they remembered about how they heard about the disaster, using the same structured questionnaire. They were asked to score against each element, using a scale of 1 to 5, how accurate they felt their memory to be. The accounts were then compared. For a quarter of the students, none of their memories accorded with the original account, and only three out of the forty-four students produced details which were exact. The students were very confident in the accuracy of their memories, but in fact somehow, for most of them, the memory had changed over time and had become alternative versions of the same event (Neisser and Harsch, 1992; Ofshe and Watters, 1995: 38–41).

What emerges from a consideration of memory is that we do not totally forget, but neither do we totally remember, and there are a host of reasons behind both. Without memory we would have great difficulty even getting out of bed, yet even this act is conditioned by a wider environment. We have remembered that it is a bed and not a hammock, groundsheet or cardboard box. We have remembered that we have to wake up and get out of bed in order to meet social and personal obligations. Even in these seemingly simple ways, our memories have complex relationships with our social and cultural experiences and do not exist outside of them. We live in a social world with cultural conventions and political necessities which impact upon us and shape who we are or are permitted to be. Because of this, the ability to remember is not purely an individual matter. Remembering needs some kind of structure, a social

formation, which enables and promotes agreement about what was and was not, what happened and what did not happen (Connerton, 1989: 39).

Research into memory has revealed just how suggestible we can be, especially in relation to memories of trauma (Yapko, 1994, 1997). Effectively, we can be led into certain memory forms and provide details that are not at all consistent with our experiences (see the Neisser and Harsch research discussed above). We can also find ourselves responding to very subtle forms of social pressure. Research undertaken by Asch (1952) identified the extent to which the individual may tend to concede personal memory or judgement to the power of the group. In other words in a group reminiscing about, say, pay levels in the 1950s, if one group member has very different recollections from the rest, it is harder for them to stand up for what they remember. Peer group pressure is not confined to teenage years. For many individuals, it is easier to conform with the group than doggedly argue the case based on what they remember.

The influence of corporate power and issues of class and authority are particularly evident within studies drawing on memories of work. John Bodnar undertook research on labour–management relationships at the Studebaker automobile plant in South Bend, Indiana by interviewing former workers and managers. He was particularly interested in the narrative structures which underpinned the personal accounts of work at the plant. He concluded that the interviews he conducted produced evidence of structures of memory that were unanticipated. They related not so much to individual experience (although there was much of this) but more to the pattern of institutional power and social order that existed in the plant in the past. The narrative plots were influenced by a 'powerful agent in the social space under examination' (Bodnar, 1990: 75). It seems that the work which had given meaning to their lives was in the hands of a strong corporation whose influence extended not only to how they experienced work itself, but what they remembered of it. Similar characteristics in workplace research can be found in the UK, for example, Bill Williamson's study of the mining community in Throckley, Northumberland through the life of one man, James Brown (1982).

False memories, ones which are conflations of the truth, suitably embellished, are by no means uncommon. This may be due to the need for a coping strategy, already identified, where difficult memories prevail. But they may also be the product of much repetition through which revisions and plausible fabrications have been introduced and accepted as 'true' memories. This is particularly so where the narrator's social status and identity hinge on the story so constructed being readily accepted in the wider world. Robert E. McGlone's study of how the descendants of John Brown's family recall both him and the Harpers Ferry conspiracy (the seemingly heroic but abortive and ultimately tragic raid aimed at seizing the federal arsenal at Harpers Ferry, Virginia, in October 1859) and how this relates to other forms of evidence about the episode does a great deal to teach us about false memory. This might be approached as historical evidence by looking for the controlling scripts. He writes how

> something profound was at work in the Browns' reconstruction of their roles in the Harpers Ferry conspiracy. In their troubled search for collective vindication, they ultimately shared in the evocation of a portentous childhood event – a solemn family

oath to make war on slavery – that had either been forgotten for half a century or had never occurred. Convinced that the sacred oath explained the history of the John Brown family, they infused an invented memory with mythic significance.

(McGlone, 1990: 52)

In particular, he has observed that when historians 'learn to read the underlying meanings of our errors in memory as shrewdly as they now interpret deliberate falsehoods, they will open a window to the self. And when scholars of the family discover the logic of false family memories, they will unlock the matrices of family identities' (McGlone, 1990: 71).

The handling of memories, especially of more recent events, which have a significance within the public domain, has a particular sensitivity and enhanced proclivity for manipulation and amendment. It is not unknown for a British Senior Civil Servant (Sir Robert Armstrong) to give evidence in which he was later to admit that he had been 'economical with the truth'. David Thelen's study of Watergate, and how it has been remembered by those who were in one way or another closely involved, focused on the discovery of the Watergate tapes in 1973. Thelen gathered evidence from Donald G. Sanders, Scott Armstrong (both of whom were on the Senate committee investigating Watergate) and Alexander P. Butterfield (who revealed the existence of the tapes in his testimony to the committee). Through the interviews Thelen undertook it was evident that over time the memories released in the process of recall had been rehearsed and revised, elided and reconstructed. The narratives given contrasted strongly with each other and with other forms of contemporary evidence. Although suspect in terms of accurate accounts, they were nevertheless real and truthful for the narrator at the point of narration. The use of memory as evidence has to be handled with considerable care and discernment by historians and all those seeking valid information about the past. It is inevitable that memories of historical episodes are crafted within the perimeters of present-day needs in the context of the relationship with the enquirer. Hindsight and personal necessity allow for agreement, disagreement, revision and negotiation over the meaning of past experiences, and whatever meaning has been derived from this has been preserved or absorbed to some extent because of concerns that are about the present and perhaps not about the past. From the study of the memories of these events, Thelen wrote about the value of memory in general terms to historians. He concluded that people depend on others to shape their recollections and will refashion the past to please the people with whom they are discussing it. Accounts made by others are used in order to gain confidence in an individual's own memories. (Thelen, 1990a, 1990b).

In the use of memory as evidence, the need for verification of oral accounts against other sources is obvious. It is not that we maliciously lie about the past, although clearly some do. It is more that we have a very personal stake in how we remember and are influenced by who, what and where we are at the moment of remembrance. Our memories are pure to us in that moment, but they are not necessarily a direct route back into the past. Because we often accept the fallibility of our own memories, we attempt to aid remembrance by gathering images and other materials of those things we deem to be relevant to our lives.

Museums have a particular investment in the belief that objects have a special

power. The experience of reminiscence work and handling sessions would appear to suggest that objects provoke memories and ideas in ways that other information-bearing materials do not, or may not to the same degree. The experience of people in a position of care along with research into objects as memorabilia in later life, however, suggests otherwise. Whereas objects may be cherished, it is photographs that aid memory, seconded by jewellery (Sherman, 1991). A clear distinction can be drawn between that which is valued for itself (chosen and cherished objects) and that which triggers a host of memories (photographs). There may well be a number of variables here as the physical and visual evidence of life experience is gathered on a haphazard basis and is easily lost, destroyed, appropriated, stolen, misfiled. What remains, to a lesser or greater degree, depends on the individual's way of constructing and using their memories.

Within our own lives, the most obvious way in which we keep track of the past is through photographs and, increasingly, home-made videos. Few major life events of a positive nature would now go completely unrecorded. Giving birth, a child's first steps, birthdays, school plays and sports days, Christmas and other holidays, major anniversaries, graduations, reunions and new grand-children are some of the major life occasions on which a visual record would be axiomatic. But people tend to skip recording those life events which are painful. Funerals, signing divorce papers, major family rows are not often committed to film, nor are images taken of people with whom difficult working relationships are experienced. On the surface, it would appear that by gathering such partial family albums, the tough memories are excluded. Yet again, reminiscence work in this area suggests this is far from the truth. A photograph of a wedding may include a parent who died shortly afterwards or the strained face of a partner struggling through the last stages of a difficult marriage. (The air-brushing out of ex-partners from family photographs is not unknown.) A photograph of the kids on the beach may prompt memories of the cost of the holiday and the difficulties caused by a low income. The encodement of memory within photographs goes far beyond what an 'outsider' may read into the image.

Conway (1992a, 1997) argues that in autobiographical accounts there is a hierarchy of memories which moves from the broad life event (for example, relationship theme) through to general events (courting) to event-specific knowledge (first meeting at a dance). In broad terms this may be how recall happens in general conversation. A theme is arrived at and within this there are cues and prompts to memories which move from generality to specifics. Thus a casual conversation with a stranger on a train about new employment legislation in that morning's paper might lead on to comments about work (broad life event), which might cue in memory of working conditions (general event), and then about an accident witnessed at work (event-specific knowledge).

However neat this appears, it would seem to be resistant to a whole range of situations where recall works differently. Indeed, it seems to suggest that unless positioned within the appropriate memory set, event-specific knowledge does not follow, or may follow but with a greater degree of difficulty. Thus if one is not keyed into thinking about, say, leisure interests, one is unlikely to have a vivid memory of winning at the Eisteddfod or scoring a particularly satisfying goal in a local match. What may however be helpful is not so much the notion of

a broad life event (although Conway's approach clearly has both its merits and applications) but the feelings and responses within it. For example, in a particularly buoyant mood one is more likely to remember moments when that degree of elation was similarly experienced: this is mood dependence and congruence (see above).

The cues present in photographs may actually cause the memory process to work in the opposite direction to that which Conway suggests; for example, from the specific event (the image of a child's birthday party) to general events (celebrating that child's other birthdays or life stages) to a broad life event (having that child or being a parent). Indeed, we can work with an image laterally and beyond the frame, beyond the neat hierarchical patterns. The coat you were wearing in the photograph of a baby's christening may have been very expensive and bought at an exclusive shop (lateral memory moves into incomes, shopping, clothes shops, sacrifices for fashion, other forms of clothing, what you wear now) and is perhaps now used for gardening (lateral moves into gardens and leisure time, current difficulties with garden, disputes with neighbours, how things change). In the midst of this the memory of the christening may be lost, or not cued as one might expect. Indeed, should the christening be remembered, it might not be for its ritual significance but because the car broke down on the way home (Radley, 1990).

Absent from the family album are records of a considerable number of ongoing life events. We do not often record ourselves taking examinations or a driving test, voting in an election, doing the washing or changing the beds, being interviewed for a job, taking the bus to work or paying the gas bill. These events are often within the domain of documentary photographers, working to their own agendas, and can be found within photographic essays of contemporary life. However, such ongoing life events are defining in terms of role and self-perception and may give rise to many memories in later life. Few women in pre-war years had their photographs taken using dolly tubs in their backyards, nor would they have wanted to be caught on film, hot and wet in their working clothes. Yet a great deal of fun and vast stores of memories have been generated in reminiscence sessions using a dolly peg or a scrubbing board. An image can be clear in the mind and memory without having to exist in photographic or physical record.

The keeping of a photographic album is not universal, but most adults have a range of images that provide forms of life references and which are carefully kept, even if too painful to look at, for now. The keepsakes of life experience are also gathered, perhaps not as 'collections' but as loose assemblages of personal treasures. Pearce (1992) has called these the 'tears of things', souvenirs of life. Battered toys, presents from old friends or a much loved aunt, something made during apprenticeship days, a stone with a hole in it collected on holiday thirty years before and kept for its lucky properties are the stuff of such mementoes. They fill the odd drawer or cabinet and help us to hold on and let go. By making the past tangible, they are a touchstone to a memory, the physical evidence of the past: it did happen and touching this thing proves it to me.

Pearce, in her study of private collections (1998), discusses how people frequently wish to attach memory value to collected things, but that they prefer to do this to things which are rare, interesting or good looking. She draws a

distinction between men who regard their collections as providing a link to community and the past and women who express continuity in terms of possessions passed down the female blood line. Pearce does not distinguish between cherished objects and aids to memory, instead seeing such collections as having a mixture of memory value and intrinsic value.

The point at which the stray, outwardly disconnected range of things we hold on to becomes a formal collection, as Pearce would define it, is open to question and has warranted much examination. Suffice it to say that things are put by, not so much for reuse at a later date, or because of increasing monetary value, but because there is a memory connection of some sort. Sometimes such material may be elevated, revered as a 'souvenir', such as the tattered Christmas decoration brought out every year in memory of the Christmas forty years ago when a son brought it home from a school art class, or given an extra special station in the home such as Granddad's clock, awarded by the firm after thirty-five years' faithful service (the manager got a bigger one on his retirement).

There are a number of ways in which we might begin to understand how we use objects as tokens of life experience (also discussed in Chapter 8). In this regard the study of art therapy in relation to psychotherapy and psychosis has a number of useful thoughts from which we can extrapolate general points. We project our thoughts and feelings on to objects, and by so doing engage in the process of transference. Although some curators might like to believe that objects speak for themselves (a worrying notion in its own right, smacking of supernatural powers and pseudo-psychic phenomena), such 'messages' that people receive are in fact the product of this transference (see e.g. Lubar and Kingery, 1993: vii). In actual fact an object is neutral, contained and inanimate. Because of this, it is useful in the mediation of thoughts, memories and agendas. As an object cannot 'speak for itself', people project their own speech and meanings on to it or into it (to be explored further in chapters 12 and 13).

An object specially selected for memory-bearing purposes may take on the role of a fetish, a way of dealing with desire that in an extreme case can be a substitute for relating to other people. Examples might be a locomotive name-plate held in lieu of the whole thing to drive, souvenirs of unrequited love or the ashes of a dead partner kept next to the bed. Or it might take on the role of a talisman, a consecrated object enabled to ward off misfortune. Thus we think that luck in examinations is enhanced by always having a certain pen, or a football team's success is ensured if you always have the same seat, wear the same clothes, eat the same food when your team plays at home (for a useful discussion of this in relation to art and psychotherapy, see Schaverien, 1987, 1997).

However defined or categorized, the transference of emotion and memory on to the concreteness of an object separates that object from the run of the mill and appears to invest it with something almost magical. It is important to stress that this does not mean that the memory is lost from the mind or would not exist if the object were absent – the transference is achieved by projection. By its very nature this is temporary, as the object may well outlast the memory association. It is therefore not a full 'installation' of the memory in the object; at its most basic it is a matter of association. Sometimes this 'memory' material is almost latent. We use things every day that were given, bought, modified, shared, yet

these experiences may only come to mind if the appropriate question is asked, for example, the worn and faded towel kept in the back of the car, which a friend recognizes as one he left behind with you after your housewarming party two years ago. In this way the view of an object moves from or fluctuates between different statuses, the one overlapping the other, just as memories do.

There are many other ways in which memory is consciously kept, and these should not be overlooked. The writing of diaries, the storing of email messages, and the keeping of verbal accounts of events on tape, for example, the extensive exercises undertaken by politicians with an eye on their memoirs are ways of keeping a grip on the detail of the past, although future royalty payments and some control of their reputation may also figure. Similarly, the growth of interest in genealogy promotes knowledge of connections to past generations beyond living memory, gives a sense of rootedness, even pride in family and can help reveal all sorts of connections including patterns of health problems. It is little wonder that genealogy has become a major leisure activity. It involves the salvaging of information about families and groups, however sparse, that time, migration and resettlement have dispersed.

Perhaps the most vivid and powerful of what might be called conscious memory frameworks would be remembrancing, the passing down of family memories and oral traditions. By its very nature social, the narrative of family or social group can be extraordinarily affecting and influential. Such traditions would rarely stress anything but the heroic and the humorous, being ultimately aimed at the bond and betterment. In literate societies it is argued that oral remembrancing becomes less important, as there are other ways of carrying information. But both social proclivity to remember in close-knit groups and the disposition within certain cultural settings towards recounting the past ensure that it continues.

Memory can be understood to be multi-faceted and multi-staged. It is not one process nor one experience, but many. It interweaves with so many things, feelings and responses in our individual and social lives. Moreover, its role in our lives, especially in relation to remembrance, would appear to alter in different life stages. All of what has been said so far must now be qualified by considering memory from birth to death.

4 *Memory and life stages*

Memory within different life stages has a particular relevance as museums work and engage with people across the age spectrum.

Children comprise about one-third of visitors to museums. They visit usually with their schools, and often with family members. In contrast, like many organizations such as churches, museums have had difficulty appealing to teenagers in any great number, although some museums have sought to remedy this with special programmes (Whittington, 1997). Adult visitors tend to be drawn largely from those who are still active and in work. The early post-retirement market has become fairly buoyant as reasonably well-resourced people who have retired early or in very good health take the opportunity to fill their new-found leisure time. In the work that museums do, curators are more likely to interview the 'young' older adult (65–74 years) for oral history programmes and to meet the 'old' older adult (75–84-plus years) in reminiscence work. As for themselves, curators working actively and directly in social history (i.e. excluding museum directors, managers and trustees) are more likely to be in the age range of 24–45 (Museum Training Institute, 1993).

Each of these age groups tends to have certain configurations of memory and life experiences which have shaped them in particular ways. A shared and general response to Max Bygraves or the Beatles, to the Suez crisis or the Gulf War, to the smell of carbolic soap or pot noodles, gives them something in common with their age group. Whether or not they remember their parents fondly, love dogs or hate them, is however something that individual life experience has brought them.

Throughout our lives we are building, enacting and using our memory base, finding it at times either a resource or a burden. We add to it all the time through everything that happens to us. The stock will contain life-turning events such as divorce or road accidents; life-enhancing events such as major career successes or the achievement of financial security; life-defining events such as relationships with parents or skills developed; and everyday occurrences from the taste of blackberry jam to the sound of a brass band. We look back, we look forward, we try to make sense of ourselves and our situations through knowledge of our past and present. For some this process may be in a constant state of postponement. For others, it may be a perpetual unhealthy obsession preventing forward movement. But most strive to use the personal past as helpfully as possible, building on the lessons and treasuring the best, in order to live fully

functional and balanced lives. It is not always that easy, but as Conway (1997) has argued, the constructed memory grounds the self.

The drive to understand life experience, especially the process of ageing, has given rise to a field known as life-span developmental psychology, the principal influence on which has been Erikson's theory of life stages (Sugarman, 1986). Erikson, in his book *Childhood and Society* (1950), provided a framework of a number of tasks to be fulfilled within life – from the child's progressive achievement of trust, autonomy, initiative and industry through to the older adult's attainment of 'ego integrity', that is, arriving at some sense of meaning and order of the life led. He wrote that this involves 'acceptance of one's one and only life cycle as something that had to be and that, by necessity, permitted of no substitutions' (Erikson, 1965: 260). The quality of the relationship of one's self to the accumulated life history, the memories of all things past and experienced, is fundamental to any sense of well-being especially in late life. Erikson was quick to recognize the extent of despair that follows from unsuccessful 'ego integrity'. In effect, successful ageing is dependent on how well we are able to come to terms with our memories and resolve both the good and the more difficult parts of our lives. Appreciation of the individuality of late life experience, born of our very different life histories and the availability of the stimuli and environments which aid or hinder resolution and understanding, has led to an approach known as 'differential gerontology'. This rests on the acceptance of the uniqueness of the elder. It is a concept that can be applied across the whole life span.

In this chapter, consideration will be given to memory in childhood and adulthood through to late middle years. We will go on to consider memory in late life in Chapter 5.

As many mothers know and psychologists are now prepared to admit, a baby who is only a few days old can be selectively responsive to its mother's voice, which suggests *in utero* memory (Rovee-Collier and Shyi, 1992). Pre-verbal infants remember those objects, people and events to which they are repeatedly exposed (Fivush 1994; Fivush, *et al.*, 1997) and can express their memories behaviourally. Recall can be improved when a cue is present; little children can, like the rest of us, be reminded. Indeed, it has been argued that we begin to reminisce as early as middle childhood or as soon as we begin to remember things. A child of 10 can reminisce and so can a child of 7 (Webster, 1995).

How children engage with the idea of the past may have a considerable effect on how they come to terms with it both in their personal lives and within wider social and political contexts. It is understood that children who do not have the opportunity to talk much about shared experiences appear to develop detailed and cohesive memories less quickly than those who do (Conway, 1997). The effects of this on memory and recall and its use in later life, especially very late in life, have not been assessed, as such longitudinal studies would be extremely difficult to conduct. But it does raise interesting questions. The articulation of experiences, appreciation of being a narrator who is listened to, and the valuing of life episodes surely has to be arrived at by a process of learning and of finding satisfaction and reward through these acts. The successful exchange of descriptions about and reflections on life episodes in environments which are safe and encouraging must have some constructive part to play in the feeling of well-being and an effective sense of self.

There may be an element of gender difference. Fivush and Reese have argued that parents tend to involve daughters in elaborate forms of narrative conversations about the past; that is, rich, detailed and evaluative forms of reminiscence which the parents and child co-create. They argue that in contrast parents tend to engage sons in repetitive forms of narrative which have a more pragmatic focus and are concerned with achieving correct autobiographical facts. For the girls in their study reminiscence was associated with an enjoyable, shared social experience; whereas for the boys it was associated with repetitive questioning forms of interaction (Fivush and Reese, 1992; Reese and Fivush, 1993). This argument has to be handled with some care as so many personal, social and cultural factors will come into play and disrupt the generalization.

In supportive and secure families, exchange of information may well be a fundamental part of ongoing family conversations. However, for children in family settings which are dysfunctional, that grounding in self through constructive dialogue may be absent. This may be especially true where there has been family breakdown and a child is taken into foster care. Whereas children in secure families take for granted the opportunities to ask about the past, such as the details of their birth or what their father was like at their age, children in care can lose track of the past, even lose it altogether. In the absence of accurate and available detail, the worst can be imagined or fantastic alternatives created. One of the ways that social workers and carers have approached this dilemma has been to help the child make a life story-book as a way of chronicling their lives and holding on to the detail, but also as a means of helping them to sort out why they are in care and why various adults have let them down (Ryan and Walker, 1985).

Life story-books are biographical accounts, usually in the child's own words, of their birth family and subsequent care, experiences such as holidays and interests, the things they like and dislike. They can contain photographs, some old and some taken especially for the purpose, captioned in the child's own words. They can also contain diagrams and maps, diaries and records that record key events and transitions. Relationships with birth families, carers, foster-parents, friends, special places may be encompassed in the book, which is then held as confidential to the child and the primary carer.

Ryan and Walker (1985: 6) discuss their approach to making story-books. They argue that

> Whilst understanding 'self' is difficult, particularly for children severed from their roots and without a clear future, it is made easier by separating out some of the more easily definable parts and discussing them openly with a child. One way of doing this is to talk about the past, the present and future.
>
> *The past* is made up of places, significant dates and times, people, changes, losses or separations and other events, both happy and sad, like illnesses, holidays and birthdays.
>
> *The present* is made up of self-images, reactions to the past and issues like 'What am I doing here? Where do I belong? How do others see me?'
>
> *The future* is made up of issues such as 'What shall I be? Where shall I live? What chances do I have? What other chances will there be?'

The idea of the books rests upon a confidential and safe relationship between the care worker and the child. Through constructing the life story-book an honest

and open account can be arrived at which aims to place the child's life in perspective. In this, 'visiting the past' can be extremely enabling. The children can be taken back to places such as the hospital in which they were born, the house once lived in, the first school attended, and through this are helped to acknowledge their past and to face up to painful events. The important parts of this process are the value and accuracy of the details, and the authorship of the book by the child as a means of affirming their own identity. Images and affirmations of people and locations help make the personal past real. The child's feelings are expressed through talk about the past, blank patches filled in where possible and a life account made visual through photographs. To a child in care, the experience of making a life story-book can be an effective way of getting to grips with a difficult and painful life. The sense of self is aided by the recovery of memories and life history that children in more secure settings can access much more readily.

The process of making a life story-book for a child has relevance here because it reveals the importance of putting a life into perspective through as faithful an account as possible. Irrespective of the length of that life, this has value. The rationale for this rests on the sense of identity. Without it children and the adults they grow into can be limited in some way or inhibited and uncertain. In turn this can lead to depression and apathy. The development of the sense of self depends upon people who are important, especially parents, responding appropriately. If this should not happen, much damage can be done, some of it possibly irrevocable. What this has to offer us is the point that the past is important from the earliest life stages and that family environments contribute a great deal to personal histories. Moreover, children need a coherent and just account of their lives, whatever their circumstances. Freud argued that all subsequent life difficulties are rooted in this. From the earliest stages of our lives, certainty about ourselves springs from a secure knowledge of the personal past, facilitated by the images and information on which we can call. The better the grip on our personal past, the better placed we are to deal with the difficulties and possibilities which life may offer.

With a secure memory base feeding a strong sense of identity, children move into adulthood with some self-assurance. Memories taken from different life roles (ace footballer, good friend, reluctant learner) are integrated into repertoires of self-expression. Uses may be greater for some of these than for others, especially in the powerful context of peer groupings. It thus becomes very difficult to declare a love for Bach or a memory of a stunning piece of sculpture, or allegiance to a certain hockey team, however strongly felt, if your friends are committed to a completely different cultural set. At these adolescent stages, the sheer variety of expression may be so great that recall and exchange of detailed episodic memory has much less currency than is true later. For the older adult the past is a resource, the basis of much communication. This may be true too of middle years adults, as much pub talk can bear out.

Nevertheless, young people need the resource of the past less; they get to know each other through a wealth of references to the signs and symbols of contemporary culture, such as soaps and CDs, college courses and clothes. Older adults get to know each other by drawing from the past in an effort to position themselves in relation to others, taking as reference points life events (children

and grandchildren, the onset of infirmities) or broader historical markers (before the war, after the depression). The past is a primary resource for the older adult, but a signifying part of a greater range of expressions for the adolescent or young adult (Boden and Bielby, 1983, 1986; Wallace, 1992). But this should not be construed as the young being unlikely to reminisce; they simply do it in ways that are different from older adults. Studies undertaken by Webster (1994, 1995) have suggested that the young do engage in reminiscence and this is influenced by gender (girls reminisce more) and the openness of personality. Reminiscence in the young helps to establish and maintain intimacy and may create opportunities for decisions about the present and the future.

Museums are one of many places which enhance opportunities for children and adolescents to talk about the past and often to do so on their own terms within the family unit. Visits open up the possibilities for cross-generational exchanges; things remembered about the child's or the family's past can be talked about. Similarly, aspects of the National Curriculum have used family memories to help a child understand ideas about generations and change over time. Such conversations all add up and can be embedded in a child's memory and from there contribute to that all-important sense of who they are. Furthermore, we have all been children and carry with us both the patterns of talk about the past we experienced in childhood and the notion of reward (whether negative or positive) these bring with them. This equips us to establish meaning and connection between the things we see, touch and hear in museums and our own understanding about the past, however enabled that may be.

As the years pass and the stock of memories increases, so do the explanations and justifications for present-day attitudes and actions. The created memory has a role in validation. It has conscious effects in that we can knowingly interact with it, placing current states and future plans into context by drawing on past experiences and episodes, selecting that which appears to have a use, putting to one side for now the memories that seem less appropriate or helpful. The created memory also has unconscious effects, where past experience feeds actions and decisions in ways which lie hidden unless contested. For example, the school bully has learned about power, the bullied about fear, and this feeds into their adult behaviour through memory.

The memories we hold can therefore both enable and restrain us in adult life. Coming to terms both with the difficulties and the best of the past within the complexities of present situations is often a personal challenge. This can be relished, problematized, dealt with deftly or systematically ignored. Individual personality, state of health, social situation and cultural contexts have a great deal to do with our ability to relate to past and present experiences.

In material-driven Western societies, people can become aware of dissatisfactions, perhaps feelings of emptiness or lack of fulfilment. There is an expectation of happiness, of what Kitwood has called 'some richness of experience and relatedness, some core of goodness which has eluded them, but which they sense is their birthright as human beings' (1990: 194). By the same token, even though on an otherwise even keel, we can be completely and unexpectedly traumatized by events beyond our control through no fault of our own, such as witnessing a fatal accident, being a victim of crime or abuse, or experiencing a stillbirth.

In a televisual culture, happy or at least resolved endings are common in media representations. These tend to be rich with images and narratives of happy nuclear families, fulfilled motherhood, successful careers, pleasure through possessions and opportunities such as long-haul holidays. It is not surprising that people hold their lives up in comparison and ask why their experiences are so different, why their lives do not match. Sometimes, what may be needed is the comfort of secure family or social groups to offer support or distraction, or convictions about spiritual paths which allow wisdom or judicious acceptance, or, crucially, the financial resources or power to effect change. Without one or all of these, it is easy for people to slump into depression and to look for answers in themselves and their memories, increasingly with the aid of others through counselling or psychotherapy.

To meet the perceived need for specialized help in dealing with personal difficulties, especially the burden of past experience, there has been a tremendous growth in the field of therapy and a wide variety of techniques on offer. There are three principal approaches. Carl Roger's 'person-centred' approach aims to give 'unconditional regard' and, through the preparedness of the counsellor, to 'walk in the shoes' of the person undergoing therapy, to facilitate change. Psycho-dynamic counselling has a more analytical approach. The counsellor makes links and looks for patterns of behaviour, and uses these to develop a situation where the person in therapy can help themselves with the minimum of intervention. Cognitive behavioural therapy aims to support and reward good behaviour, looking for positive aspects of the way someone thinks and behaves and building on these. Beyond these and their hybrids, there are many others centred on play, music and art and more esoteric approaches using orthodox and unorthodox beliefs. The number of approaches within therapy is supported by an increasing number of practitioners who, like members of any other occupational group, vary in what they offer. The problems presented to them are by definition drawn from an infinite number of unique situations. There can be no categorical here. What appears to be the case is that a significant proportion of clients feel certain enough about its benefits to return and to recommend it to others.

Tom Kitwood (1990) has identified three potential outcomes of therapy. The first is enlargement of the experiential frame. For some people, the opportunity to talk to someone they completely trust is a rarity; it may even have been absent altogether. Kitwood argues that to become more open to experience and to live more truthfully requires a lowering of defences. This involves experiencing that which was defended against. The second outcome is a deeper self-acceptance, stemming in part from the acceptance of the complete unity of the person, which aims in turn to become part of the lived experience and, as Kitwood says, if all goes well, is taken forward into everyday life. The final outcome proposed is a shift in identification, a greater recognition of the unity between the body and the mind, feelings and thoughts. Essentially, Kitwood argues that therapy works towards 'the formation and enhancement of persons as sentient beings', and that it is 'dealing with the development of a kind of unity between thought and feeling ... a synthesis of love and understanding for which our culture does not have a concept' (Kitwood, 1990: 205–6).

The culture of personal concern and confession which has developed and which expresses itself in the use of therapies is paralleled and sometimes opposed

by a critical climate sceptical of the emotional needs it appears to indicate. Broader explanations and deeper solutions are sought. For example, there is a seeming intolerance of those who will go to any lengths to achieve a much-needed child, and some commentators seek explanations not within the indescribably painful experience of childlessness, but instead in society's models of successful adulthood which include happy parenting (*Independent*, 28 May 1997). In other words, people's needs are seen as culturally driven and therefore not especially individual, although where the dividing line comes between social pressure and personal perspective is by no means clear. What is obvious however is that intolerance of someone's need can be as strong as the culture in which that need may or may not be embedded.

The general evidence is that discussion about the past is useful and potentially therapeutic, often irrespective of who this is with, as long as mutual respect and trust exist. The specific value of psychotherapy in helping us heal or deal with memories is however more open to question. Indeed the view is taken that within the psychotherapeutic relationship there is as much potential for harm as there is for good. This is an area where broad generalizations can be unhelpful and the middle ground hard to strike.

In a large study of the benefits of psychotherapy, Lambert *et al.* (1986) concluded that it brought about much greater changes than either spontaneous recovery or placebo controls. Previously, Dawes in the late 1970s had shown that patients in a group who received psychotherapy had double the chance of feeling better than those who did not; but she also concluded that patients who saw a highly trained psychotherapist did no better than those who visited a pleasant professor of, say, mathematics or chemistry who they thought was fully qualified. More recently in *House of Cards* (1997), Dawes has gone further in challenging the value of psychotherapy and has raised issues such as the validity of methods used in research within this field, the basis of decision-making about clients, and whether psychotherapy is able to build on knowledge of the long-term effects of the work. She argues, 'if a doctor makes a mistaken diagnosis it can often be checked against a blood test or biopsy, but psychotherapists rarely get a clear message that they are wrong.' She believes that psychotherapists arrogate to themselves a knowledge and a certainty to which they have no right and which is not based on research (quoted in Burne, 1997a). The bitterly contested regression therapies and their potential to produce recovered memories of sexual abuse in childhood are a case in point and a prime example of where the knowledge and role of the therapist has been both challenged and defended (Conway, 1997; Cooper, 1997; Ofshe and Watters, 1995).

In more recent years, study of the brain using scanning techniques is making a useful contribution to understanding our sense of well-being. The brain cells that control happiness have been identified in the left pre-frontal lobe of the brain, just above the left eyebrow. It can be stimulated through such activities as exercise, deliberate smiling, positive thoughts and setting achievable goals. In other words, through the right forms of activity, the brain can be encouraged and in turn enabled.

The study of chemicals in the brain also gives useful pointers to promoting well-being. Prozac and similar drugs have been found to have a positive effect, far less addictive than earlier mood suppressants such as Valium. However,

research on crayfish suggests that far from being independent triggers of behaviour, brain chemicals such as serotonin have different effects, depending on the animal's psychological state. Thus the effects of taking a drug will be mediated to some degree by how we are in ourselves and where we are positioned within social relationships. In other words, taking Prozac in a prison cell does not make you feel free.

The body itself is now being seen as having a significant impact on the way we feel; the Cartesian split of mind and body is outdated and is being replaced by a more holistic perspective. For example, brain scan studies of children with anorexia have revealed reduced blood flow to the part of their brain which controls vision. This may help to explain why girls with this eating disorder stare at the mirror and declare themselves fat: their visual perception may well be distorted. Bryan Lask, who carried out the study, suggests that there should be a new approach to anorexia which involves treating it on three levels: by addressing the biological factors to aid more accurate vision, by addressing the psychological factors (teenagers with low self-esteem are much more at risk) and the social factors (no one gets anorexia in cultures where being fat is thought attractive) (Burne, 1997b).

What this points to for the future is a more integrated way of helping people with difficulties hitherto believed to be purely psychological. Freud believed that by bringing repressed and unhappy memories, usually of childhood, into the conscious mind, healing and resolution could take place. The bringing to mind was only half of the process; resolution was the other, perhaps tougher, half. A more integrated approach stands to benefit all who find themselves dealing with memories and their echoes in behavioural patterns.

What possible relevance does all of this have to museums?

First, it should remind us that visitors are not empty vessels and are responding (or not) to what they see in ways that are influenced by their minds, personal histories and sense of well-being. Museums add to the layers of memories and can be places where connections are made. Our individual relationships with our own past, our ability to see ourselves historically, our preparedness to talk about thoughts and feelings can be affected if only in small ways by the kind of spaces which museums provide.

Second, it should also remind us about people as whole beings, not just as filing cabinets for oral histories of haymaking or the manufacture of Morris Minors, ready and waiting to be opened, emptied and shut again. Whatever we recall has infinite connections to all sorts of memories, added layer by layer within our life span. Even the way we describe simple tasks like grinding coffee or boiling nappies is connected to who we are, how we perceive ourselves and who we have been enabled to be.

Third, for those people who work in museums, there are questions about the ways in which their own memories and their feelings about the past may intervene in what they choose to do. These may influence what they set out to achieve and the activities and programmes of the museum. The relationship between the personal and the professional self has not gone unnoticed.

The professional persona is one which strives to ensure that all will be rational and objective. The safe and sound expertise of the professional is seen as a guarantee of that, but underneath the veneer there is still an individual with a

wealth of feelings and great pools of memories. Mark O'Neill has argued that professionalism is seen as counteracting subjectivity, 'a form of peer group pressure to maintain a necessary detachment in the name of jointly understood standards ... these standards can easily become defensive and what is needed is not less subjectivity, but more'. He describes the ways in which he recognized how his own background has influenced the exhibitions and projects he has undertaken. As an Irish male, brought up in a rigidly Roman Catholic country, in a large and what would now be called dysfunctional family who experienced material poverty, his background has influenced his work in the community museum in Springburn, and later in developing the St Mungo Museum of Religion in Glasgow (O'Neill, 1994).

Mark O'Neill was aware of his own need to find ways of dealing with the realities of his life and that this was finding expression in those exhibitions and programmes which engaged with the real concerns of people in the Springburn area. Similarly, as someone who had abandoned Christian belief as a young man, but not its conditioning of ethics and guilt, he was very aware of the persistence of religious influence, even in a post-Christian society, and the gap left not least for atheists by the abandonment of belief. This sensitivity, coupled with an identification with marginalized groups, was brought to the creation of the permanent displays at the Museum of Religion.

In writing this paper, O'Neill expressed himself with candour and emotional honesty. Moreover, he was challenging museum professionals to let themselves off the hook of professionalism once in a while, if only to allow reflection on their own humanity. How can museums be places for thoughts and feelings if those who create them are not aware of their own?

Few studies have been conducted on the impact of the professional as a person on the museum as an institution. For one, we can look at Catrin Stevens' biography of Iorwerth Peate, the first curator of the Welsh Folk Museum. While in no way seeking to minimize the importance of what he achieved or his sense of vision, she quietly questions whether the museum at St Fagans, within his own time, might have been the Llanbryn-mair of his youth recalled (Stevens, 1986: 72). It can be read as a preferred past stripped of all the things which Peate abhorred – including mass production, industrialization and the effects of war. Seemingly, memories selected from his childhood and adult life were given expression through a museum of the Welsh people.

Plate 1 George Hackland, Newhaven, April 1998. He is holding a photograph, taken in 1923, of himself at 3 years old with his grandfather, Willie 'B.' Jarvie. His grandfather was born in the 1850s. D. O. Hill and Robert Adamson's pioneering series of callotypes was taken in Newhaven in 1844. The continuity of the Newhaven community is such that the 150-year period between then and now can be bridged through family associations. Images isolated in time are reconnected to the present. Courtesy of Miles Tubb, Newhaven.

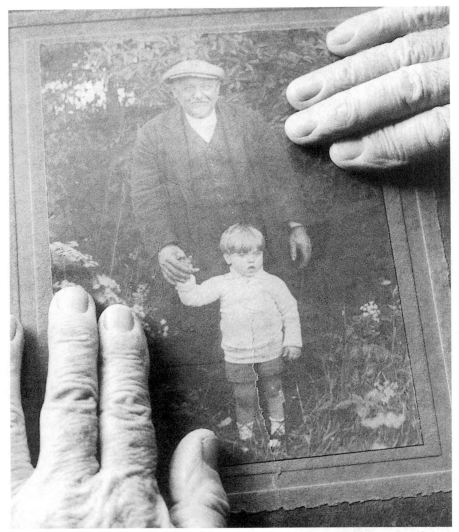

Plate 2 George Hackland holding the photograph of himself and his grandfather. Courtesy of Miles Tubb, Newhaven.

5 *Memory in late life*

As a life moves towards its conclusion, the vast pool of life's memories becomes a principal point of reference, a source of sorrow or enrichment. In later life we are more fully who we are, the person shaped by all that life has had to offer or deny, the sum total of personality and engagement. The ability to live fully and well within this is dependent on the degree of support, stimulus and security that is found in the last years. Where this is supplied in good measure, old age can be a time of liberation from lifetime constraints, offering opportunities for creative expression or meeting challenges hitherto denied. But this is not always the case. For many, old age is not a time of tranquillity; it may be beset with adjustments to the loss of partners, independence and good health. The figure for depression in the over-65s is as high as one in seven. Yet each adjustment successfully made is an achievement in its own right equal to anything undertaken in earlier life. In making such adjustments and in fulfilling life's final potentials, memories have a role.

Historically, attitudes towards the older adult and towards memories and reminiscence have varied enormously, and at times have been hard, even dismissive. In Western society, where wisdom is perceived to be not the sole prerogative of the elders and where there are myriad sources of information, older adults have found themselves marginalized, even to the point of redundancy. For a time, it was believed that this was effectively a natural choice, a view underlined in the brisk years of the 1950s, when a major study on intellectual decline was undertaken in Kansas City by Cumming and Henry. Their results were published in 1961 and through them they argued that people turned inwards as they aged, became more absorbed in the past and willingly less engaged in social contacts and outside activities. It was argued that this had a social purpose, that through disengagement the old made way for the young. Society did not offer new roles to them and the older adult did not seek them.

The disengagement theory emerged at a time when ageing was also considered as negative deterioration, something to be avoided and warded off by increased stimulation in present realities and by distractions such as watching television. Dobrof (1984) recounts how reminiscence was seen as pathological, something to be discouraged. When residents in her care wanted to talk about childhood in the shtetls of Eastern Europe or arrival in Ellis Island or the early years in the Lower East Side of New York, she was advised that they were regressing to the dependency of a child, denying the passage of time and the reality of the present (Dobrof, 1984: xviii). This was happening in Britain too.

Coleman (1994) comments on how in the late 1960s and 1970s care staff would frown on encouraging reminiscence with their elderly residents. The 1960s had little truck with old men talking about their war wounds and trench experiences, and women remembering a lifetime of hardship.

Other ideas emerged. For the caring professions and reminiscence workers, the turning-point has been seen to be Robert Butler's article published in *Psychiatry* in 1963 in which he argued that reminiscence in late life is in fact a life review, a mental process which occurs spontaneously and is universal. It has as its end the achievement of wisdom, serenity and increased self-assurance. In other words, it is natural to call the past to mind, and may even be something each of us needs to do in late life. The effect of that one article was to legitimize reminiscence in care situations. It permitted those already aware of the satisfaction that the older adult derives from memory to begin to work more constructively with memories. It also encouraged further research into the functions of episodic memory in late life. Through this, the standard of care for the elderly is benefiting. For a while, nevertheless, the disengagement theory and the life review theories co-existed.

This should not be seen in isolation, however. By the 1960s, there was a parallel interest in memories outside of the field of social gerontology and nursing care. Although slow to gather pace, and often not rooted in a concern for therapeutic benefit, the oral history movement had begun, enabled by the availability of more portable tape recorders. Seven years before Butler had published his paper, George Ewart Evans had published his highly influential *Ask the Fellows who Cut the Hay* (1956) and had followed this in 1960 with *The Horse in the Furrow*. What distinguished these two works from earlier folk life or folklore studies was an undeniable regard for the remembrancer (Howkins, 1994). Discussing working with people in East Anglia, Evans was to comment:

> the older generation . . . in spite of compulsory education, persevered in the old culture, which was entirely oral. For that reason they were its chief carriers . . . *what was to them in the present context a disability* has to us proved an advantage, enabling them to provide us with rich material relating to a long historical past.
>
> (Evans, 1970: 21–2; my emphasis)

Reflecting the dominant idea that the old ways and memory of the past were a *disability*, Evans was nevertheless able to see its value and respect the transmissive purpose. He was critical of how the old had been 'more patronised than respected' and was very aware that through talk about the past the true worth and dignity of the individual could emerge (Evans, 1960).

But these were and to some degree still are separate worlds. Clearly the value of oral testimony recognized by Evans and later others (especially Thompson, 1978) was not acknowledged or perhaps even known about by social gerontologists, and by the same token life review was not always understood by oral historians. Even with his deep regard for his informants, Evans's interest was in the product of oral history more than the process of reminiscence.

What the disengagement theories of ageing and approaches to care had not fully accepted was Erikson's view of late life as being about what he called 'ego integrity', a means of coming to terms with the life allotted (1950). Jung's idea of the second half of life having different goals and being more directed towards

inner, spiritual or religious imperatives, coming to terms with an individual's collective unconscious, has relevance here too (Storr, 1995). Butler recognized these needs and his paper remains a milestone. More recently however his idea that reminiscence is universal has been challenged. Wallace, in his study of the social construction of talk about the past, (1992), found that such reminiscence was a social activity brought about by the opportunity to be a narrator, rather than an internal psycho-development process to which one is naturally led. In his view, talk about the past bolsters self-esteem and promotes social integration, but is dependent on an audience that is interested. Other work had pointed to the positive benefits of remembering the past with others. McMahon and Rhudick's study (1964) of a group of veterans of the Spanish-American war drew attention to the amount of reminiscence the group engaged in and how well-adjusted the members of this particular group seemed to be. But listeners can be scarce. Studies on the geriatric wards in Southampton indicate that as many as one-third of the very old people there feel they would like to tell their life stories but do not have available listeners (Coleman, 1994: 9).

The ideas which have sprung from Butler's work have tended to centre on a concern for the individual's sense of identity and self-worth and sense of well-being. In methodological approaches, clear distinctions have emerged between *reminiscence*, which is spontaneous, unstructured and often very social, and *life review*, a process which is structured and comprehensive and usually undertaken by a trained carer or therapist. Reminiscence may involve elements of life review and by the same token life review may prompt or contain reminiscence: the line is hard to draw. But the difference is the role that either activity may play in the well-being of and, sometimes, the standard of care given to the older adult.

Research on reminiscence has given rise to both methodological and theoretical problems. Literature reviews suggest that there is an absence of certainty about its benefits because the studies entered into have been empirical, with some type of limitation in-built into either the sampling or the form of analysis chosen, and as a result the findings have been open to challenge (Thornton and Brotchie, 1987). Particular difficulties have arisen when studies have attempted to make sense of contradictory evidence: that some individuals found talk about the past rewarding and uplifting, while others found it deeply depressing and guilt-ridden. The difficulty may lie in seeing reminiscence as a unidimensional construct, and those who engage in it as heterogeneous units. In other words the qualities of the memories and the uniqueness of the individual may somehow have got lost in the statistics. The acceptance of subjective variability within differential gerontology gives individuals back their rights to be exactly who they are. Two studies of memory and reminiscence are especially helpful in this regard.

Peter Coleman (1986) undertook a longitudinal study of fifty people in sheltered accommodation in London. Their average age was 80 years and there were twenty-seven women and twenty-three men in the study. To give evaluative form to his research, Coleman used six different types of questionnaires to indicate states of well-being and changes within it. The work continued over a ten-year period and through it a reductionist perspective of the role of memory in later life has been overturned. This was a process to some extent already on its way with differential gerontology and work such as that by

Thomas (1976), which stressed that individuals react to their experiences in old age according to their life histories.

Within the group of people he worked with, Coleman was able to identify quite different sets of attitudes towards the past. The value of reminiscence within their lives varied too. There were those who valued their memories, found them to be a source of great treasure and took tremendous pleasure in relating them to other people. They saw their past as a happy time, a time of achievement. Even though their lives may not have been easy, they were adjusted to it. There were also those who were deeply troubled by the past, who viewed it with a sense of regret. These were people who had a nagging self-doubt and who had not been able to somehow achieve a sense of stability by arranging their memories into anything which could be a source of comfort. For this group, the past was a source of despair, even great sorrow. Another set of people within Coleman's study saw no point in looking back. These were often people with high morale. They had effectively resolved their pasts and had no further 'work' to do on their memories. They found it unrewarding to go over 'old ground'. A small group in the study found reminiscing especially painful and it exasperated their sense of loss and depression. This set included a widower, undergoing deep bereavement for his wife, who had no will to go on living. Finally, Coleman identified a group which appeared to be closest to Erikson's model for successful ageing, having reached what he called 'integrity'. These were individuals who in their different ways had come to terms not just with their lives but also with their impending deaths. They lived in the present with courage and optimism. Interestingly, each had a strong faith or belief, not necessarily in religious terms, which contributed greatly to the way in which they found a sense of coherence in their lives.

Coleman's work has led to greater preparedness in formal reminiscence work. It demonstrated how much depended on the person and their situation. Enabled reminiscence would need to take into account both the individual and their need and to be more sophisticated in its approach. On the whole, reminiscence work with older adults could enable a natural and usually helpful process. However, at times it would need to be positioned either to offer an appropriate form of counselling that people with difficult memories might need, or respect the individual's choice to leave the past well alone. For some, disengagement was a choice; for others, life-review was essential. There was ground between the two theories.

Whereas Coleman identified how different individuals approached or avoided talk about the past for very specific and personal reasons, Lisa Watt and Paul Wong (1991) and Wong (1995) have concentrated on the different forms of reminiscence through analysis of content. They argue that reminiscence should be seen as a multi-dimensional construct, each dimension serving a unique psychological function and bearing a different relationship with well-being. In other words, we are capable of using different forms of reminiscence, according to how well we are within ourselves. Wong and Watt came up with a taxonomy of reminiscence within which are six categories.

Integrative reminiscence, closely resembling Butler's idea of life review, is about achieving meaning, coherence and reconciliation with one's past. It involves putting the pieces of life's experiences together into an integrative

Plate 3 Mary Johnstone with her granddaughter Victoria, who is holding a photograph of her mother Margaret at her age, Newhaven 1998. Courtesy of Miles Tubb, Newhaven.

whole, which is the meaning of that life. Instrumental reminiscence is where the past is used as a resource; that is, it is instrumental in solving a current problem or coping with difficult situations. This gives rise to a sense of control and continuity in identity. People prone to use this form of reminiscence tend in Watt and Wong's view to maintain a high level of mental and physical health. Transmissive memories have a purpose and in their way have a relationship to oral history and to some forms of cultural tradition, where the memory is gifted to an accepted person for a purpose. This sense of purpose also elevates the person making the transmission of knowledge and, through this, significantly aids psychological well-being. This may be experienced in different ways, but is perhaps most common within family settings. Here the transmission of memories may have in-built lessons on morality or process. Narrative reminiscence is story-telling for the sheer joy of it. Within a peer group or within settings where a biographical account is called for, the reminiscence takes a narrative form. Narrative reminiscence has the principal aims of enjoying the telling of the tale and interacting with an audience.

Watt and Wong identified two further, potentially negative, forms of reminiscence. Escapist reminiscence can take the form of fantasy, or a manipulation of the memory so that the past is a much better option than the gloomy present. This form of reminiscence can be effectively self-defensive, especially where the present is actually unpleasant. But, it can in certain circumstances be more harmful than beneficial, taking away a sense of perspective on present-day reality. Obsessive reminiscence involves rumination upon unresolved life episodes and can lead to depression, agitation, even panic.

These forms of differential gerontology helped equip those working with the older adult with valuable perspectives, which are useful not just in therapeutic situations but in many circumstances where the past is brought to mind. They alert us to the need to think about the individual, the whole person and the life which has been led. They prompt us to tread with care, patience and respect, with interest and open minds. They are especially useful in the work that museums may undertake with older adults in oral history, reminiscence work and inter-generational education activities. It should alert curators to think about the older adult as a person with both a past and a present and a need to cope with and enjoy both.

6 *Remembering and the society of others*

Memories can be spoken. They can also be danced, drawn, sung and performed. They are the first form of history-making and the oldest. In many respects, speaking about the past is the most natural way of keeping alive some knowledge of it. Such talk about the past can be understood as a warm and human proclivity. But once elevated from casual conversation or private acts of transmission, it can also be seen as something which can be ritualized to perform social and political functions. When this happens there are underlying aims, not least confirmation of identity (individual, group or community) and the enrichment or buttressing of culture. To these ends, it is often given expression in particularly vivid or emotive ways. David Thelen sees memory existing in different forms along a spectrum of experience. At one end are the personal, individual, private memories and all the issues of motivation and perception that are tied to them. At the other end are the collective, cultural and public memories, and the linguistic and anthropological issues of how traditions and myths about the past are established to guide the conduct in the present (Thelen, 1990a: vii). The historian can address the ways in which the personal and the public support and contradict one another.

Testimony can be a force aimed at social unity, through the ordering of lore and legitimization of the holding of power. It can also be employed to prompt pleasure and pride, terror and dire warnings. The forms of oral testimony, whether narratives, recounted stories, poems or genealogical calendars, have such ends in view. Further, they have embedded in them preferred moral codes. Those who embody the group histories can be held in particularly high esteem. They need not necessarily be older adults but are nevertheless entrusted with a very special role. Those occasions when accumulated wisdom is transmitted are deemed to be significant events and can have deeply rooted social purposes. They can also be mesmerizing and unforgettable experiences, as those who heard the late politician Emmanuel Shinwell talking about his early experiences of the Labour Party, or the late historian C. L. R. James talking about cricket and Caribbean identity would no doubt testify.

The influence of written as opposed to the spoken word can have an impact on oral testimony, by serving to undermine or reinforce it as suits the moment. It can also lead to new or alternative traditions (Hobsbawm and Ranger, 1983). However, great care is needed here. It should not be assumed that there is a polarity between principally literate and non-literate societies. It would be false

to assume that written history is a direct replacement for spoken history. It would also be false to assume that written histories do not influence spoken accounts, and vice versa. In societies with high degrees of literacy, new functionaries may emerge, such as professional historians or documentary film-makers, controllers of the formal official versions of events. Yet the alternative, subversive and highly personalized accounts do not disappear. Oral and literate centred accounts, the memory and the document, the story and the monograph co-exist. But their purposes and range of influence may differ. Some historians write to challenge the established order, others to defend it. Similarly, some remembrancers create memories to bolster power, others to reject it.

The transference of oral testimony is dependent not just on the individuals who take on the role of remembrancers. It also depends on how they recall episodes and learn the traditions. In some societies this needs to be achieved with the minimum of error and distortion. Repeating things out loud, with rhythms and ceremonies, embeds the memory, ritualizes and elevates it from more mundane recollections. Oral traditions and testimony tend to acquire conventions of their own. In comparison, historiography is rich with traditions especially within academe, such as those associated with the conventions of the monograph, intellectual criticism and peer review, albeit they are invested with an academic rationale. All societies have in common structures for history-making as well as specialists who carry the separate elements of oral testimony. They follow the conventions of their different roles and maintain whatever traditions prevail.

Literate societies evolve different forms of ritualized oral cultures. Social recollections are fragmented into individual, group or family memory and become isolated but, in personal terms at least, not inconsequential. The oral slips into contemporary forms with new functionaries: tabloid newspapers write colloquially as gossip machines, and television soap operas, with internal histories of their own, articulate moral codes. For many, the position of oral testimony as an essential component of group identity and self-knowledge can shift from the centre to the edges. The official versions of the past hold the ring, make the past legitimate and elevate the accepted informal account into approved evidence. Such dominant histories are defined as much by what they exclude as by what they include.

As a counter-current, marginalized groups may strive to keep alive their histories through joint cultural endeavours, investing remembrance in forms of community expression, projects or programmes. In the absence of a place within the central structures of histories, for example, the National Curriculum or the collections of the major museums and art galleries, a sense of the present from awareness of the past has to be generated in other ways. However frail and problematic this may be, it can also mark exceptional, but often highly necessary, resilience. An example of this has been the emergence of histories of gays and lesbians, which act to support gay and lesbian cultures today.

Thelen sees this as fertile ground for the historical study of memory which would involve the study of

> how families, larger gatherings of people, and formal organizations selected and interpreted memories to serve changing needs. It would explore how people together

searched for common memories to meet present needs, how they first recognized such a memory and then agreed, disagreed, or negotiated over its meaning, and finally how they preserved and absorbed that meaning into new ongoing concerns.

(Thelen, 1990a: xiii)

There are many powerful reminders of the importance of long-term oral transmission, even if we first encounter these through the written word. A repeated framework of memory holds the fabric of belief together, and therefore underpins social cohesion. It is there to remind us who we are, and what our place in that society actually is; to give us a sense of self *within* the sense of social group. Moreover, longitudinal oral testimony is at its most expressive in huge genealogical sweeps and in stories of ancestors, such as the creation stories of Australian aboriginal groups and the lineage of Joseph given in St Matthew's Gospel. In more modern times, genealogical sweeps are maintained, for example, in the recitation of Cup Final winners between 1950 and 1970, or those scientists who have been in receipt of a Nobel award. These are aimed at reinforcing cultural continuity, as well as responsibility both to the past and to forebears. By inference, this also lays down duties with regard to present and future generations and makes quite explicit where allegiances lie.

In general terms, it is thought that in societies where the dependence on oral transmission is high, the older adults tend to be given privileged positions within the group. They have a place in advising on all manner of practical matters, but have a primary role in guarding the society's values and the belief systems upon which the culture rests. This cannot be taken as given, however, and such generalities have to be guarded against. Thomas reminds us that in pre-industrial England, when literacy was by no means universal, growing old without property could be a desperate and humiliating experience. Ageing was riven with fear, as it could so easily lead to a late life not necessarily blessed by the benevolence and respect of the community, especially when the older adult could make no significant economic contribution (Thomas, 1976).

It is also sometimes supposed that in Western societies where a vast variety of information sources exists, older adults are more likely to find themselves on the edges of life, their transmissive abilities dismissed or ignored, with likely consequences for their sense of well-being (Gutmann, 1987; Coleman, 1993, 1994). But here too there are exclusions and exceptions. Politicians, doctors, writers and lawcourt judges can have an influence, even a degree of control, which actually gets stronger in later life. This is also true in some families or firms, where a strong matriarchal or patriarchal presence is to be found.

The facility to write fixes memory. It makes solid, visual and tactile something which is otherwise carried only by sound and body language. It enables a permanent record, whether this be on stone, parchment, copperplate, digital recording or video film. This is something which cannot 'slip your mind', it is something one can touch and see to be 'real'. It does not need to be repeated to be remembered, just safeguarded; it is there, ready for consultation. The inanimate replaces the animate bearer of information. Through such fixing and in a way not dissimilar to memory, an element of knowledge is chosen, shaped and set down. However, unlike memory, it cannot be changed beyond the point of recording, other than by reinterpretation of its meaning.

In time, its survival allows others to interrogate it; to ask why did it come down to us in this form, what does it say, what does it not say? But unlike a lot of transmissive memory, it can come with authority attached. The majority of formally retained documents are official, and are therefore seen as the principal accounts. Seemingly, the elevation of the written over the spoken has overridden memory, rendered it suspect, literally the stuff of hearsay. With it has come the ignoring of those who seek to remember, and therefore the loss of alternative views of ourselves and the human condition. This is most evident and accepted in formal and official settings, where only one broad account, one main version of events, can be accepted. Thus the histories of successful battles may omit the personal defeats within them and the long-term effects of the action. Histories of successful political campaigns may skate over the moral compromises and greater opportunities lost. Institutional failures are explained through the consequences of outside rather than inside forces. Although such histories as these may form the mainstream accounts, individual perspectives born of experience, say, in coming to terms with the personal consequences of such episodes, remain not just relevant but vital to better understanding.

Indeed, within strong oral accounts we can find the material of resistance, of challenge to the established order, and of counter-hegemonic tendencies. Literacy may well have legitimized the hierarchical order, but it has failed to restrain spontaneous and richly varied memory forms, especially those which are in some way subversive or reactionary, anti-establishment and satirical. Behind any formal history, there would appear to be alternative accounts (not to mention gossip and the stuff of wild speculation) which may pose direct challenges to the content of official records. Just because a history has been written, or an official version of events created, it does not mean that the alternative spoken ways disappear; it simply means they go unrecorded. This is especially true if nobody asks, or if nobody listens.

For example, just because English botanists gave indigenous plants a botanical name and grouping, it did not stop people calling them by their common name such as Poor Man's Pepper, Sauce Alone, and Fat Hen. Nor did it stop people believing in such plants' magical or medicinal properties (Thomas, 1983). Although this may well have driven the scientists to fury over what they saw as the ignorance of the common people, it was a knowledge literally as old as the hills and no scientific naming would drive it away entirely. The common or local names of plants have come down to us through oral testimony, repeated from one generation to the next. We know that this has been a frail process and many names have been lost.

Similarly, just because some of the old customs were tolerated and recorded in folk life journals for being quaint or picturesque, it did not necessarily negate their operations within fairly complex community relationships. The Furry Dance held in Helston in Cornwall on 8 May each year involves the weaving of the dancers through the houses in the town. However lovely the dance may look on a warm May morning, heavy with the smell of bluebells, it is a levelling gesture showing the overruling of normal respect for property and persons and thus the 'levelling' of the town's citizens (Bushaway, 1982: 177). In this regard, meaning is not always lost in the personal or social sense, just because someone

else, seemingly more powerful, is perceived to have appropriated it for their own ends.

Outside of the principal periods within living memory, namely the stretch of, say, three to five generations, we can catch only occasional glimpses of the operation of oral testimony and transmissive practices within most literate societies. These come from a variety of sources including: accounts made by middle-class enthusiasts recording practices such as folklore or travellers and chroniclers; witness statements taken in the courts or for official reports: images and forms, such as the decorative detail within churches; the vestiges of naming systems, for example, for fields and tools; procedures and ceremonies; and occasionally within dialect terms. Much of the stories, rhymes and riddles, the protocols of performance and, more than anything, the description of events and personal reflections on them have been lost with the passing generations. Some elements may well have been blended into later mixes, vague traces of memories ghosting through later recollections. However, more often than not, the personal account is the least likely testimony to survive. Some action or method which was commonplace or the detail of an episode observed becomes beyond recall. Neither social mechanisms, contemporary values nor immediate necessity prompted the making of a more permanent record.

Occasionally however, a few firsthand accounts do emerge through the lucky survival of wills, diaries and letters, although these are likely to be restricted to a certain social stratum. These serve to indicate the degree of loss we experience when such evidence cannot be found. The Paston letters, for example, give us unparalleled insight into three generations of a Norfolk family during the fifteenth century, their increasing affluence and social connections, and are especially important for divulging something of the life and attitudes of Margaret Paston. It is a rare glimpse into the personal fortunes and relationships of the Paston family, rendered all the more significant because it reveals so much about a woman's life. Nothing oral, no memory traces, exist of the Pastons; all that we know is contained in the documents that survive, and without them we would know nothing at all about the family (Virgoe, 1989).

Historians have paid more attention to oral accounts than might first be supposed. In times when only the very wealthy and specially trained, such as clerics, could read and write, accounts of events came from witness statements. Henige and Thompson have both provided overviews of this (Thompson, 1978; Henige, 1982). They point out that in both early Greek and Roman texts there is an obvious use of witness accounts and firsthand experience, alongside the great legends and stories. Bede, in his *History of the English Church and People* written in the eighth century, was keen to point out how in the writing of the section on his beloved Northumbria he was 'not dependent on any one author, but on countless faithful witnesses who either know or remember the facts, apart from what I know myself'. His willingness to accept an oral account as a legitimate record was echoed in the work of later historians and writers up to and including the eighteenth century. Works such as Clarendon's *History and Rebellion and Civil Wars in England* (1704) and Bishop Burnett's *History of His Own Times* (1724) are cases in point. Macaulay's *History of England* (1848–55) drew on a wide range of sources including poetry, diaries and 'anecdotes'.

In the early nineteenth century, the ease of working with oral accounts began

to lose its credibility for historians and slipped into disuse. Although not lost entirely, the eyewitness account became seen as unimportant. By then, the accumulated repertoire of printed histories and sources was such that historians could choose to rely on both that which was to hand and the work of others. Attention shifted to remote periods in time, beyond human memory. Thus historians could safely stay within their studies, poring over printed sources, considering the facts as presented, creating a version of events that satisfied a notion of veracity that need not be tested 'in the field'. By 1898, a primary text *The Introduction to the Study of History* could begin with an unequivocal statement: 'the historian works with documents. . . . There is no substitute for documents; no documents, no history' (quoted in Thompson, 1978: 47).

This was not entirely the case for the antiquarian happy to study remains, monuments and buildings, nor for the emergent anthropologist, influenced by A. C. Haddon and others experimenting with field recording. But for the historian, now part of a professional group seeking distinction from other academics, the written word, and if need be the printed word, would suffice. This gave historians a number of advantages as they attempted to professionalize their craft. It emphasized the specialized monograph, based on documentary sources and original in its approach, as the test of a scholar's ability. By claiming documents as their sole source, historians carved out for themselves a territory and an approach which did not overlap with others, such as archaeologists. Finally, by cutting themselves off from the outside world, some semblance of objective neutrality, through distance from society, might be claimed and viewed as a professional virtue. This held true for several generations. In the 1950s George Ewart Evans remarked on the self-consciousness and exclusiveness of history at universities, and how history departments were 'very loath to admit oral history into their canon' (Evans, 1987: 36). Even A. J. P. Taylor, who did so much to make the study of history lively for the amateur as well as the professional historian, was prepared to reveal his contempt for oral history by describing it as 'old men drooling about their youth' (quoted in Thompson, 1978: 62).

The years of distance from all but documents had isolated historians and narrowed their range. It had shielded them from talking to people outside their class and helpfully prevented them from being unsettled by views and accounts discordant with the dominant official written versions. It had saved them from the responsibility of explaining the objectives of their research to the people whose history they were studying, an act rendered totally unnecessary if all that needed to be consulted was inanimate.

Historical enquiry may have retreated to the safety of the study, but other means of recording and thinking about the past continued. A host of individuals and groups saw the value for their own work in making some form of fixed record of the things which they heard and observed.

7 *The art of listening*

In the nineteenth century, historians became more concerned with document-ary than verbal evidence. Nevertheless, eyewitness accounts and verbatim testimonies were brought increasingly into the public domain via a number of different routes. Newspapers carried detailed extracts from evidence given in court cases and witness statements on accidents and events. The minutes of formal meetings, regardless of whether they were of major importance or only local significance, similarly contained verbatim records of discussion and decisions taken. Detailed inquiries into social conditions were undertaken by government as the basis for subsequent legislation. Published as Royal Commission reports, they contained transcripts of evidence, and as a result give extraordinary insight into, amongst others, the lives of mill workers, miners, slate workers and farmers. They also usefully include opinion on a range of contemporary matters, from working conditions in rural areas to the importance of the Welsh language.

The following two extracts are examples of how something of the spoken word, in these cases witness statements, comes through official reports on special conditions. The first comes from the Report on Conditions of Employment, 1843.

IN SOMERSETSHIRE

I went out to work when I was nine years old. Geo. Small.

They (boys) are generally employed at nine years old. Mr. Somers.

I don't think anything like half the boys at the age of nine, of this neighbourhood, are employed. Mr. R. King.

Boys are generally taken from school when about 10 years old, if they can obtain employment from the farmers. Mr. Ward.

The above statements show the ages at which boys go out permanently to work. But when they do not do so till they are 10 or 12 years old, they are, before that age, nearly all occasionally employed for one, two, or more seasons, at hay-making, potato-planting and digging etc; in these occupations boys are useful, and they nearly all find profitable employment. Boys who remain at school after they are 9 or 10 years old, are frequently taken away from school, for a fortnight or three weeks at a time, for such work. Boys, also, from the earliest ages, assist their father and mother in the cultivation of the allotment or potato-ground. And before a boy is regularly hired by the farmer,

he frequently at an early age accompanies his father to his work, not to labour, but to wait upon him, as it were, in different ways.

The second extract comes from the Royal Commission Report on Conditions of Woman and Children, 1867.

A little girl in the Vale of Taunton Deane, being asked what she had for breakfast said, 'bread and butter.' What for dinner? 'bread and butter.' What for supper? 'bread and butter and cheese.' It is a fair sample of what the agricultural labourer lives on, except that where no cheese or butter is produced he had nothing but the bread dipped perhaps in cider: the wife drinks tea, and there is sometimes a bit of bacon for the husband after his work, unless they are so poor that they have to sell every atom of the pig to pay the rent. There is besides a concoction, called teakettle broth, given to the children: hot water flavoured with a few herbs or tag ends of bacon, sometimes little but the pure hot water.

The mechanisms through which people could be 'heard' were becoming more sophisticated. There were significant advances in printing and in the publishing world. Newspapers and periodicals became popular and accessible to a broader social spectrum. Liberal politics at both national and local level demanded a more open system of government, one where accurate reporting was important. For present-day historians, committee papers, newspapers and Royal Commission reports are tremendously valuable sources of information, vital in gaining a perspective on times remote from living memory. They provide access to accounts which were unlikely to have been preserved in any other way.

The usefulness of these and other accounts was not lost on contemporaries. Engels, in writing *Condition of the Working Class in England in 1844*, drew on these sources as well as on his own experiences. Marx, in writing *Capital*, also used published contemporary description from newspapers and government reports, although he was not known directly to engage in what others would have seen as fieldwork (Thompson, 1978). Authors were similarly swift to see the usefulness of this material. For his novel *The Mayor of Casterbridge* (1886), Thomas Hardy seems to have based his account of the sale of Michael Henchard's wife Susan to a passing sailor on newspaper reports, although, as E. P. Thompson (1993) has demonstrated, Hardy's understanding was somewhat limited in terms of the social significance of wife-selling and the role of the wife in such rituals. Hardy was primarily a novelist and poet; he therefore had no difficulty taking artistic licence with the newspaper accounts that formed the basis for his narratives. His romantic distortion of the available evidence of rural life in general has been criticized elsewhere (Snell, 1985). Many other novelists used primary evidence within their work. Walter Scott, Arnold Bennett, Charlotte Brontë, Emile Zola and Charles Dickens drew on their own memories, written accounts and conversations with other people in the production of their major works.

As the nineteenth century wore on, the biographical memoir became increasingly popular, and towards the end of the century individual biographies, including the biographies of working people, emerged as a recognized genre (see e.g. Burnett, 1984). At the same time, surveys of working life by those who knew it all too well, such as George Bourne (Sturt) *Change in the Village* (1912), were being published. Bourne's work in particular set about refuting the romanticized notion of the country village.

Yet at the time that George Bourne was writing so vividly from firsthand experience about the rural village as a place of industry, grinding poverty and change, a movement to record that which was defined as 'traditional' was well under way. The task was seen as a 'rescue mission' and it was approached with zeal. Aspects of cultural traditions were regarded as unique survivors, historical and in their way beautiful. They were also seen as hugely vulnerable in the face of rapid social change, and the view was taken that without a record they would be lost for ever.

In the years which turned the century, leading theorists on folklore and anthropology articulated a view of the 'folk' as a very separate body of people, remote and untouched by cultural change, unlikely or unable to innovate or modify, and substantially content with their lot. Sir Laurence and Lady Gomme in the influential text *British Folk-lore, Folk Songs and Singing-Games* published in 1916, wrote how:

> In every society there are people who do not progress either in religion or in polity with the foremost of the nation. They are stranded amidst the progress. They live in out of the way villages, or in places where the general culture does not penetrate easily; they keep to old ways, practices, and ideas, following with religious awe all that their parents had held to be necessary in their lives. These people are living depositories of ancient history.
>
> (Quoted in Boyes, 1993: 4)

The folklorists believed such people to be the last survivors of some form of self-sufficient way of life, where independent communities were, in Cecil Sharpe's view, capable of building their own church, hanging their own rogues, making their own boots, shirts and wedding rings, and chanting their own tunes (Boyes 1993: 5).

In the last quarter of the nineteenth century the search for the 'folk' intensified, and is expressed through the growth of societies and their publications, such as the *Folk-Lore Record*, first published in 1878. These bodies were committed to recording stories, dance, songs and music and to preserving buildings and byways. The concern was to look for a purity of tradition, unsullied by anything remotely modern, and the expectation was that this was definitely there to be found. This belief led to a rejection of the notions of social change, individual intervention in practices, influences of migration or spontaneous adaptation. Moreover, the recording and recovery of these traditions was to be used, partly as revivals, partly as the inspiration within contemporary art-forms, music in particular. It was conspicuous that the people who benefited from this were not the 'peasantry', but the successful and upper-middle class.

Underneath the grand intentions lay a panicked reaction to change, and in some instances a need to buttress senses of racial superiority. In the face of rapid, alien, even imposed changes, memories of a past that was deemed to be unchanging, harmonious and innocent were sought. By studying the oral 'property of the unlearned' it was expected that it would be possible to arrive at the reasons why 'some races are in a state of arrested progress while others develop a highly-organized civilisation' (Burne, 1957: 1–2). As Georgina Boyes points out, the social and political implications of this were manifold:

> The superiority of white Aryan races, the inferiority of women and the evolutionary

inevitability of patriarchy were all 'proved' on the basis of cultural data gathered throughout the world. Through the study of folklore in particular imperialism and the existence of a class system could be shown to be justified.

(Boyes, 1993: 9)

Anything that did not fit into the recorder's view of the folk was ignored or limited. Boyes explains how a version of the Morris dance 'Bean Setting' collected from a Northamptonshire man in 1910 was publicly denounced as non-folkloric because it had been invented three years before and moreover its creator was 'not a traditional dancer', though he had previously been a member of a Morris team in Lancashire.

Folklore and folk life studies from this time disclose what might be described as a lack of interest in the people whose lives lay at the heart of the research. The researchers were keen to record song, stories and so on, but were not committed to recording what lay behind or beyond the 'tradition' and how it might be situated in modern life. Thus in referring to the notes and recordings, one can find only vague references to the person who was the source of information on the tradition. Their occupations, interests or opinions were outside the scope of the recording. In essence, the people who gave the information were not important; but *what* they gave was fundamental to a major cause.

Interest in 'the old peasant life' became a characteristic of a number of nationalist movements in Europe. Horne has explained this in the following terms:

for conservatives in established nations, the peasants could be presented as breathing the true spirit that held the regime together: for those trying to establish the uniqueness of 'new nations' against imperial occupiers, the peculiar customs of the peasantry could be made to seem 'proof' of the unique culture of the nation, and of its long history.

(Horne, 1984: 172)

The interest taken in 'the folk' varied, from representation of rural life in artists' work to the collection of tales. However, from the turn of the century, an emphasis was placed upon folk culture, primarily its material elements. The lead was taken by the Scandinavian countries, especially Sweden, where the movement stemmed largely from the work of Artur Hazelius (Bringeus, 1974; Horne, 1984; Hellspong and Klein, 1994).

Hazelius had dedicated himself to creating a detailed record of the material and oral traditions of Sweden which he believed to be threatened by the effects of rapid industrialization and the commercialism it brought in its wake. In his view, regional identities were being affected both by the infrastructures which industrialization needed and the mass markets it promoted. The feelings of threat and potential loss were exacerbated both by fears and hopes for Scandinavian national boundaries.

His collecting and recording activities led very swiftly to the founding of two museums, which were to influence the museum scene in Scandinavia and, in time, Europe. Under his supervision, Skansen became the first purpose-built open air museum; many were to follow. It was situated on a hill just outside Stockholm from which it took its name. Selected buildings from the different regions of Sweden were moved to it, reconstructed, refurnished within the correct tradition and opened to the public. An arena was built so that folk dance and music could be performed there. Close by, Hazelius oversaw the building of

Nordiska Museet. This was intended to be the intellectual heart of the museum, a place for research and for the more demanding form of exhibits that would not be possible in Skansen.

Hazelius insisted from the outset that the methods of collecting should be both systematic and meticulous, whether it be material or oral traditions. Hazelius, co-workers at the museums and other Swedish regional ethnologists adopted and developed a range of recording methods. These included field observation, verbatim transcription, questionnaire surveys and the employment of diarists. This professional approach to the task soon led to the establishment of an academic discipline of regional ethnology or folk life, which was able to build on the already accepted field of oral tradition at the universities of Lund and Uppsala. A department of regional ethnology was opened in 1918 by the University of Stockholm, directly opposite Nordiska Museet, and this was dedicated to the study of the whole tradition. Folk life and folklore in Sweden were therefore treated as subjects worthy of serious study and not just a hobby for middle-class intellectuals and retired gentlefolk. Moreover, they were to have a place within both national education and popular leisure patterns. Many towns in Sweden opened their own museums and open air parks. Open air museums in Denmark, Finland and Norway were relatively commonplace by the end of the first decade of the twentieth century. Frilandsmuseet, the Danish open air museum, was founded in 1897. The Sandvigske Samlinger (the Sandvig Collections) were opened in Lillehammer, Norway in 1904.

In general terms, although the methodology for folk life studies improved, its partiality remained open to question. The folk life approach tended to disassociate itself from present-day realities of rural poverty, industrial unrest and unpicturesque traditions (of which there were many). The recording of folk life within industrialized communities was generally absent, especially where there was radical political activity. As a consequence, the 'folk' involved in work in heavy industries, such as mining and iron working, got rather short shrift. New industries such as bicycle manufacturing or financial services were totally ignored. However, the search for an unblemished rural past continued until well into the 1950s and 1960s, undeniably leaving us with archives of extraordinary interest and value, if somewhat restricted in scope.

Issues of nationalism were also present in recording work undertaken in Ireland. It is not difficult to link the work of the Irish Folklore Society and later the Folklore Commission with the assertion of identity in the new Republic. In the editorial of the first of its journals, Séamus O'Duilearga wrote:

> The aim of our Society is a humble one – to collect what still remains of the folklore of our country. We are certain that the nonsensical rubbish, which passes for Irish folklore, both in Ireland and outside, is not representative of the folklore of our Irish people.
>
> (quoted in Almqvist, 1979: 8)

The Folklore Society of Ireland was established in 1927, and much if not all of the early recording was made in notebooks through transcription. In 1935 the importance of recording folk tradition was such that the Irish Government founded the Irish Folklore Commission to take over from the voluntary body which had begun the work. In 1971 this was transferred to University College

Dublin as the Department of Irish Folklore. There is now a huge archive at the University; its extent is testimony not just to the assiduousness and energy of the early recorders, but also the preparedness of the government to pay for its continuation. Bo Almqvist, in an address on the fiftieth anniversary of the founding of the Society, commented that he believed that 'one of the greatest achievements of the Irish Folklore Commission is that it has helped in giving many a tradition-bearer and many a place in Ireland their self-esteem, the most necessary quality for a full human life' (Almqvist, 1979: 18).

Here are two examples of the Society's work. Caoimhín O Danachair recorded this information about Our Lady's Well at Mullhuddart, County Dublin in 1954:

> The water from this well cures sprains, cuts, bruises, rheumatism and sore eyes. The well is visited on 8 September. Small religious objects and flowers are left as offerings. There is a legend that the well moved from the outer side of the road and there are nine cures in the water, but nobody knows what they are. The structure of the well has been here since at least 1744.

In 1962, O Danachair recorded the following about a sweat house and well at Creevaghbawm, Tuam, County Galway:

> Sweat houses were found in many parts of the country. They were used to cure pleurisy and other ailments and also as a type of former-day 'sauna'. A fire was lit in the house until the walls and floor were hot. The fire was then raked out and a layer of rushes was often spread on the floor to prevent feet being burned. The person stayed in the sweat house until he or she had sufficiently sweated. They then washed themselves in the well opposite the sweat house.

Both extracts were taken from an exhibition of photographs *I gCuimhne Na nDaoine*, held in Dublin in 1985.

The need to reinforce a sense of identity was also evident in the development of a folk life archive at the Manx Museum on the Isle of Man in the late 1930s. Indeed the two projects are linked.

The museum director, William Cubbon, was very aware of how the island's subsistence rural economy was giving way to a new prosperity built on tourism and financial services. He began to develop a library and archive on Manx history and archaeology. Then, in 1938, the cottage of one of the last remaining Manx speakers, Harry Kelly, was gifted to and opened by the museum as a tribute to the old way of life. This gift focused the museum's attention on the recording of the traditional life, but no plans developed because of the war. However, in 1947, Eamon De Valera, Taoiseach of Ireland, visited Harry Kelly's cottage, and on hearing the difficulties the museum was experiencing in establishing its planned folk life survey, offered to make available the equipment and expertise of the Irish Folklore Commission. This development proved both unexpected and mutually beneficial, as Caoimhín O'Danachair recalled in this interview held at the Manx Folk Life Survey:

> And when he [De Valera] returned to Ireland he applied to the Irish Folklore Commission as a body engaged in similar work to go to the Isle of Man with recording apparatus and make the required recordings. And the good man was astonished and indeed horrified to find that the Irish Folklore Commission didn't have any such apparatus because they hadn't interested themselves hitherto in it. Well, when the head

Plate 4 John Kneen (aged 95) and Harry Boyde (aged 78), speakers of the Manx language, being recorded by Bill Radcliffe and Mark Braide with the assistance of the Irish Folklore Commission's recording van in 1948. Reproduced by kind permission of Manx National Heritage.

of a Government is interested in something, usually something happens! And wheels turned and wheels perhaps within wheels turned and before very long money was available so that we set up a recording unit.

It was a disc-cutting unit – you cut 16 inch discs each of which had 15 minutes on each side ... we were using all sorts of peculiar methods. One had to work with batteries and convectors because one was working outside the scope of the normal electrical grid usually ... you had to balance your turntable so that your record was running absolutely level for doing that. And you used pieces of rock and driftwood and things like that to prop up the apparatus.

(Harrison, 1986: 196)

The folk life movement in the UK became more effectively organized through the formation of the Folk Life Society in 1961. It made evident its interest in both material and oral culture both through its journals and its annual conference. Yet it kept within the boundaries of the 'tradition' that Gomme and others had set two generations earlier. The Society drew its members from folk museums and bodies such as the Irish Folklore Commission and those few university departments which had some interest in regional studies. As the years wore on, the dominance of museum people led the society more and more towards the study of material culture, not least in respect of male-dominated craft traditions. A pattern, not just

of enquiry but of folk life curatorship, became firmly set, and would be characterized today as uncritical and object-centred.

George Ewart Evans, whose recording and writing were fundamental to the development of oral history in England, found himself turning away from the folk life approach. At one point he had considered his interest in people and their spoken accounts of their past ways of working, living and believing to be within what was being defined as the 'Folk Life' field. But he came to see those engaged in 'Folk Life' as being solely concerned with the object, as if they were archaeologists with no access to human memory. His discontent spilled over when he wrote in the *Folk Life* journal:

> with all this talk about the object aren't you being contradictory and a little bit glib? You warn us against dehumanising the object and yet you yourself are committing a worst offence, using men and women as objects – merely to take information from them, to read them as documents.
>
> (Evans, 1987: 248)

Attention to oral testimony was evident in the work of some museums and regional ethnologists before the years of the Second World War. But the emergence of oral history as a distinctive approach within the academic study of the past can be seen primarily as a postwar phenomenon. Its history tends to be told in terms of individual academics and the influence they had both in legitimizing the use of oral testimony as evidence of the past and influencing others, mainly academic colleagues, to embrace it too. In the United States, Allan Nevins at Columbia University is credited with opening the country's first oral history project in 1948 (Nevins, 1996) and in Britain, the work of Professor Paul Thompson at the University of Essex is seen as having a similarly significant influence, although the importance of guidance published in 1978 by David Lance, head of sound archives at the Imperial War Museum, and the example set by George Ewart Evans in the United Kingdom and Studs Terkel in the United States should not be underestimated.

The Mass-Observation project begun in 1937 was intended as an anthropological study of the British way of life. The work, which was conducted by Tom Harrisson and Charles Madge, continued until 1949. They collected all sorts of information, for example, on the football pools, the private lives of midwives, sex in Blackpool, and anti-Semitism in the East of End of London. Nearly all the recording was through written accounts and diaries.

But the naming of some of the key figures and major projects should not disguise the fact that people were increasingly responding to the challenge of capturing memories. They were enabled by the availability of equipment which at last put audio recording within reach, being increasingly affordable, portable and usable (if not immediately user friendly). The advent of lighter machines, using cassettes rather than reel-to-reel, placed oral history within the reach of anyone who could press the record button.

Such is the importance of oral history that historiographies of oral history, which chart major methodological and ideological shifts, are increasingly common, although these tend to concern themselves with university-based study and exclude other initiatives (Thompson, 1978, 1996; Henige, 1982; Dawson, 1996; Dunaway, 1996). This is a significant omission, because if there

has been any democratization of history-making in the past fifty years it has come about in precisely this area, as people find they can make their own histories and that the craft is not owned by academics alone. Many oral historians would agree with Ronald J. Grele that the oral history work 'in the community, among amateur historians, local libraries and schools [*and I would add museums* – G.K.] has contributed much to the inspiration and creativity now associated with the field' (Grele, 1996: 73).

Universities have remained influential in the development of oral history, particularly in reflecting on how memory as evidence might be better understood and more effectively examined (Thomson, 1998). They have also supplied the essential infrastructure of learned publications and societies through which critical exploration of oral history has been possible. The History Workshop Group was especially effective. In the early 1980s its work emphasized the 'democratising of the act of historical production, enlarging the constituency of history writers, and bringing the experience of the present to bear upon the interpretation of the past'. It was part of a wider European movement to write 'history from below', and through this recover something of subjective experience. A good part of this work was undertaken in or close to Marxist or socialist tradition (Samuel, 1981). The approach may have changed, but oral history has retained the interest of academics. In the study of social and economic history today, oral testimony is accepted without question in most universities.

As ideas about oral testimony changed and developed, so too did the perceptions and assumptions which underpinned it, especially in relation to informants and the reliability of their evidence. Nevins has been seen as one of the first generations of university-based historians whose work through the 1940s and 1950s was largely concerned with the memories of prominent individuals. Nevins himself described this early work as 'adventurously entertaining' and one which provided a 'new experience, a fresh view of history, a larger knowledge of human personality'. He sought to illustrate this by recounting an interview in which a union leader had been reduced to tears when recalling having been sent to prison for alleged racketeering, and another in which a centenarian had remembered how as a small child 'he had seen a Negro hung in front of his father's parsonage' (Nevins, 1996: 31). For Nevins, the interview exposed the informants' degree of self-knowledge and candour. He observed that in his view 'a great many people never attain self-knowledge, and constantly deceive themselves as to their real motives and acts: they constantly dramatise themselves'. Others he saw as being 'seriously deficient in candour: they don't like to tell the truth about themselves, sometimes for good reason'. He saw the oral historian as someone equipped to deal with this:

> in the hands of an earnest, courageous interviewer who has mastered a background of facts and who has the nerve to press his scalpel tactfully and with some knowledge of psychology into delicate issues and even bleeding wounds, deficiencies can be exposed; and oral history can get at more of the truth than a man will present about himself in a written autobiography.
>
> (Nevins, 1996: 37)

Nevins would also expect the interviewer 'not to hesitate to ask the most embarrassing questions, the questions that lie at the heart of the matter' (Oral History Association, 1966: 28).

From the 1960s onwards a radical shift took place, with a new generation of historians who sought to empower people, especially those whose histories had been marginalized or ignored. The role of oral history in promoting community awareness and a sense of personal or cultural identity became more obvious, but some of the thinking about the evidence value of oral history remained very much the same. Concerns about accuracy overshadowed the work to some extent. Historians were ever anxious about whether testimony could be trusted. If psychologists were able to argue that there can be an expectation of about 60 per cent accuracy in recounted memories, where did this leave the evidence value of any recording (Conway, 1992, 1997; Cutler, 1996)?

The reliability of the unreliability of memories was a concern which led historians to more detailed consideration of the methods that might be used in interviews. For example, Moss asked 'does the interviewer get the most possible out of the interviewee; or does much appear to have been held back, omitted, suppressed, or distorted?' (Moss, 1996: 118). Exactly what the historian should be 'getting out' of the informant was another problematic area. Dunaway, for one, stated that the 'oral historian seeks historical detail in interviews, not emotional reactions ... the historian gathers source materials, whose significance may be determined only after years of study' (Dunaway, 1996: 311). In such views the informant gets reduced to a mere cipher, someone from whom memory is extracted as efficiently as possible. Their views on their own memories, their reflective processes, and their contribution or comment on what might be made from their memories would appear to have been regarded as irrelevant.

In the 1980s and 1990s, academic enquiry was beginning to turn more towards the content of the interview, and new forms of analysis emerged. It was recognized that memory was constructed rather than produced, that there was no deep well of knowledge residing in our minds, unmediated by subsequent experiences and present-day needs. The shape of what was remembered became as interesting as the content (Thelen, 1990a). It was accepted that people remember things in certain ways for reasons which are real and important to them and this in itself adds to, rather than subtracts from, the quality of evidence which oral history can give. Further, attention was beginning to be given to the relationship between the interviewer and informant and that whatever transpires from that relationship is to a degree constructed by it. This was found to be especially important in the recording of women's histories, where the exchange of questions and answers needed to proceed with an awareness of forms of communication which were gender-specific (Gluck and Patai, 1991). Consideration was also given to the narrative nature of the interview. The use of narrative and specific language forms links the interview and the memory to broader social and cultural contexts (Portelli, 1991, 1996) and also places the interview closer to the experience of a performance. The informant becomes the performer, narrator or story-teller, relating to and in effect defined by an audience (the interviewer) with all that may follow for inclusion and exclusion of information; nuances achieved through emphasis; and the playing out of socially or politically defined roles (Tonkin, 1992). These themes will be discussed further in later chapters. We will now deal with the place of oral history in museum work.

8 *Oral history and museums*

It has been estimated that somewhere in the region of a hundred museums in Britain 'use oral history as a means of preserving people's memories of life at home, at work and at leisure, capturing the emotions and dialect of ordinary people, as well as the information they provide' (Conybeare, 1998: 28). The extent to which this is an accurate reflection of the amount of work currently engaged in and indeed its scope is actually open to question. The figures could be substantially higher than this, depending on how 'oral history' as a term is being defined and understood. This will be discussed in Chapter 9, but for our purposes the term 'oral testimony' instead of 'oral history' will be used, in recognition that a good part of the early recording work has been as much about dialect, stories and the description of processes as about the recounting of episodes.

It is certainly fair to say that more museums than ever before take notice of the things that people remember and are prepared to record these memories in some form. Curators have written about their work in this field (for some examples see Brigden, 1993; Ross, 1993; Copp, 1994; Bell, 1996; Carnegie, 1996; Fussell, 1997). There is no doubt therefore that this is an important area of work, yet the motives behind it may vary. Some museums see the recording of testimony as part of their archiving function, and large museums like the Museum of London have dedicated facilities to this end. Others approach it as a means to an end – often to find text suitable for use as captioning or within publications. Many more museums see these as not mutually exclusive and have a very flexible approach to what gets recorded, when, and how it is used, as is the case with Glasgow.

The commitment to maintain an oral archive in a secure state varies. Some museums go to great length to document, index and transcribe tapes, keeping them in appropriate conditions and allowing public access for research purposes, subject to prevailing agreements. Others use tapes almost as ephemeral material and, once their intended purpose is fulfilled (for example, supplying a quote for a temporary exhibition), they are discarded, filed or simply left lying around.

History in museums today is very much affected by funding structures and corporate types. The local authority museums, with their commitment to quality of service, equal opportunities and responsibility to local people, make up the greater proportion. They include museums services in Glasgow, Edinburgh, Tyne and Wear, and Somerset. There are also a number of history museums at

national level, such as the Imperial War Museum, the Museum of Welsh Life and the National Museum of Scotland. They are influential in their ability to innovate technologically and through research. They also set a standard by having a greater scope for collecting than any other type of museum. Finally, history museums are to be found within the independent sector, where the uncertainties of funding have tended to result in strategies aimed to secure financial security in the short to medium term. However, they are still capable of adaptive practice, as can be seen at True's Yard Museum in King's Lynn and at the Museum of Science and Industry, Manchester.

This needs to be put into historical context, bearing in mind what was discussed in Chapter 7. Museum involvement with testimony has been determined by how the word 'history' has been understood. This means following not one strand of the history of history museums but several, as the development of social history practice has been a study of discontinuity, resourcefulness and pragmatism, rather than progressive development. This has been covered at length elsewhere (Kavanagh, 1990, 1994a, 1998). The intention here is not to go over this ground again, but to make some general observations.

The emergence and development of local museums in Britain is closely linked to the municipal reforms of the second half of the nineteenth century and to the imitation of the initiatives taken at national level to provide museums of status in London, then Edinburgh and much later in Cardiff. Municipal reform gave local councils the powers to develop facilities and services of a nature likely to stabilize and improve the lives of people. This was believed to be necessary, as significant social problems had come in the wake of rapid industrialization and largely unregulated urban expansion. The municipal authorities, with their powers being progressively increased by Westminster, set about the task of creating cities which were relatively healthier and economically more efficient than had been possible hitherto. The establishment of basic infrastructures, such as sewerage systems, along with the development of educational provision, were significant turning points. The authorities' confidence rose, as did a solid sense of achievement, and this was given expression in the grand and grandiose municipal buildings and the laying out of grounds and parks. The apogee was the building of the new town hall, which was to leave the ratepayer in no doubt about the self-consciousness of the borough.

Many museums were built between 1860 and 1910, basking in the architectural glory of the town hall, and stealing a little of its thunder from time to time. This was an approach to museum development, motivated by deep-seated civic pride. It was also a feature of the aggrandisement which characterized many different aspects of Victorian life, not least municipal building programmes. Many municipal authorities, such as Liverpool, Leicester, Birmingham, Preston and Bradford, more by luck than good judgement, found themselves not just with redundant or semi-redundant collections of defunct or expiring antiquarian societies, no longer in a position to care for them, but also the gifts of individuals willing to see their names given permanence through benefaction. The acceptance of responsibility for these collections could be justified in their day by arguments based upon notions of social education, self-help and the elevation of the mind of the artisan, with all that might imply for better products and increased profits in the longer term.

Moreover, it was rapidly appreciated that a municipal museum could be a credential of urban achievement and civic sophistication, a point of view encouraged by the rivalry that frequently existed between neighbouring boroughs.

Not surprisingly, in building the new museums, the authorities took their points of reference from the major museums in London, and the values and aspirations implicit within them. These were the blueprints, adopted regardless of whether the authority might be able to maintain them in the future or indeed had founding collections of genuine merit. The architectural features of the new museum buildings, the choice and range of collections and the ways in which the public was considered and provided for indicated that the cities were mimicking the nationals as best they could. As the national museums up to the early twentieth century rarely considered recent human experiences, so the municipal museums chose to overlook them too.

Over a longer period of time, the development of national museums showed steady expansion and patterns of improvement, for example, in the building of collections, research into them and provision of services such as guided tours and educational facilities. At local level, this was much more difficult to achieve. Once the first flush of enthusiasm waned, municipal museums became substantially underfunded; political indifference descended on many. A major consequence of this was that they became staffed by people on low wages, often with no pension rights, and it was therefore not possible to recruit curators of calibre. As a result, municipal museums were rarely at the cutting edge of new thinking. But not all fared badly. Some of the larger museums, Birmingham and Liverpool being good examples, had such a presence in their cities that their needs could not be ignored easily by their funding council, although it has to be remembered that they too found the fight for resources difficult (Kavanagh, 1994a).

A slow decline became evident. In 1928, in a report on provincial museums, Sir Henry Miers was forced to draw a number of depressing conclusions of which these are but two:

> The stronger one's belief in the great work they do, the stronger is the conviction that at present they fail and fail lamentably. There is no doubt that the country is not getting what it should from the public museums.
>
> (Miers, 1928: 38)

> The word 'museum' excites the wrong impression in the mind of people who have never seen one of the few that are really good. This is not surprising when one considers how dull many of them are and how low the worst of them have sunk.
>
> (Miers, 1928: 80)

On this evidence alone, it is obvious that museums had grown increasingly remote from the lives which people led and were not alert to the changes going on around them. This was true not only of what they did but of what they contained. Indeed, very few museums had an interest in either the material or oral cultures of their areas; history was not a word which would be associated with the disciplines being pursued. Archaeology, natural history and art had a seemingly natural place for local curators at this time, as these were the areas in which the national museums specialized and their relevance within museum

provision therefore passed without question. In contrast, no national museum of cultural history emerged to parallel those in the Scandinavian countries. The emphasis remained on the reflection of the national perceived role in empire and as an imperial power: rich, culturally and technologically sophisticated and racially superior. The national museums may have spoken *of* the nation in this, but they did not speak *about* it, and the local museums, which were their reflections, did their best to do the same.

By the turn of the century, professionalized groups of workers who ran museums were aware of Scandinavian models, as is evident in the fledgling *Museum Journal* pre-1914, but there was no apparent willingness to work with the ideas, even on a small scale. Where exceptions exist, for example, in the work of Guy Laking at the London Museum, they demonstrate individual vision rather than responses to a collective movement (Ross, 1998). If museum initiatives from *outside* the United Kingdom failed to spark developments, it is interesting that initiatives *within* the country similarly failed to influence museums.

The period from the late nineteenth century up to the inter-war years coincides with the folklore movements in England. It remains to be explained why such movements, eminently compatible with museums in all their conservatism and reaction to the forces of change, should have had little discernible impact on local museums and the work they were prepared to do, particularly with regard to recording and collecting. It may yet again be the case that without an initiative at national level, for example, from the British Museum, the local museums had not the confidence to proceed. Indeed, where funding disallowed even the proper maintenance of established collections, incentives to make radical departures must have been few.

Admittedly, some museums collected local things in a rather random way. Objects such as scold's bridles, rush nips and mantraps were collected as 'curiosities' or 'bygones', with only the most cursory details recorded in the acquisition register. Some local products were occasionally collected, such as local metalwork, and of course topographical prints and gifts such as police truncheons and tipstaffs were accepted. The older the material the more likely it was that museums would acquire it, so from the founding of municipal museums through to the early postwar decades some important acquisitions were made. In particular, medieval and later material became acceptable within decorative art or archaeology collections, but frequently without any recognition of social historical significance (Kavanagh, 1990).

A pattern of practice was laid down during this time, one revolving around antiquarian interests, which was to last in some form for much of this century. Although more interested in recent material than hitherto, it nevertheless brought with it the urgent and largely unchallenged need to create sets, link developments sequentially in a Whiggish sense of progress, and provide an account of seemingly settled or more curious times. This was particularly true of local museums in England until relatively recently. The argument was fairly straightforward. Museums are about objects: that is all they should collect and concern themselves with. It was a straightforward formula that few were prepared to contest at this time.

Other trends prevailed elsewhere, however, beginning in the inter-war years.

In Wales, Scotland, Northern Ireland and the Isle of Man, other ways of working developed in and for museums, leading eventually to major institutions. These took into account the need to record cultures through both oral and material evidence. However, before these can be examined it is important to bear witness to one initiative, the founding of the Imperial War Museum (Kavanagh, 1994; Miller, 1999). This represents the largest and most comprehensive project in contemporary collecting and recording ever undertaken. Only the collections of the Australian War Memorial were bigger. Even before the war ended, the museum recognized that the recording of testimony would be as important to its task as the collection of objects.

The Imperial War Museum, established in 1916 as part of the short-term initiatives aimed at lifting the war mood, immediately set about the task of making a full record of both the home and war fronts. For the three remaining years of the war, it collected extensively and did this through a series of committees on which served selected, informed and (crucially) well-connected individuals within their fields. No aspect of the war effort was to be ignored. Everything, from the medical corps to women's work, the navy to children's toys, lucky charms to uniforms, was encompassed. Where objects could not sufficiently represent the experience, artists were commissioned to encapsulate through their work something of the difficulties and privations, even boredom, of these years. In addition, plans were developed to record the ordinary soldier talking about his experiences of the trenches. This was to be done using the wax cylinder phonograph.

Much of the museum's plans were seen through, and now form the basis of the collections at the Imperial War Museum in Lambeth. They were at the time and still remain an astonishing collective record of the experience of the First World War. But in the midst of such huge commitments, not to mention the monumental problems in managing the collections as they were being formed and housing them subsequently, the plan for oral records fell by the wayside. The important point may be that within a project as huge as this, with a remit which was so clearly defined, oral testimony had a natural and obvious place, one the museum saw very well, but appeared in the turmoil of events to be unable to follow through.

The Imperial War Museum's extraordinary initiative in contemporary documentation failed to move museum curators elsewhere. It therefore remained an isolated initiative. The reasons for this are hard to fathom. The war was such a traumatic experience that many wanted to move away from it as quickly as possible, and dwelling on even the positive lessons learned was not attractive. The Imperial War Museum had also remained fairly remote from the museum scene in general, so no sense of shared professional endeavour developed. Further, the greater proportion of curators outside of London were ageing, exhausted from the war effort, underpaid and underfunded, and perhaps just not interested in the lives of ordinary people. Nevertheless, the model which the Imperial War Museum provided does serve to demonstrate how significant traces of a moment in history can be gathered in the form of material, visual and (potentially) oral evidence astutely collected (Kavanagh, 1994a). In the inter-war years, nevertheless, most museums continued to work very much as they had done before the war, for which Mier's report provides ample evidence.

Plate 5 In the 1920s, the Imperial War Museum took up its first home in the Crystal Palace. By this time the idea of recording the memories of men who had served in the forces was beginning to fade. Those involved with the museum were consumed by the need to gather and house the collections. There was no time available for the development of sound records at this stage, although by the 1960s this position had changed. Photograph courtesy of the Imperial War Museum, London.

In contrast, oral recording was taking place in Ireland through the Irish Folk Lore Commission, and in the Scandinavian countries, where links to universities and university-based courses added something to the reflective and methodo-logical developments within museums and elsewhere. Such developments in turn influenced a number of museum people, especially in regions remote from distinctly English notions of museums. This was especially so in Wales, the Isle of Man and the Highlands of Scotland, where issues of identity and cultural distinctiveness were keenly felt and in some instances sharply marked by

language distinctions. This development was aided by shifts in the folk life movement away from voluntary societies or individual projects to ones promoted by institutions. Part of this shift was to museums.

Two prewar initiatives where oral testimony had some sort of place are significant here: the Manx Museum and its folk life survey described earlier, and the work of Iorworth Peate and the founding of the Welsh Folk Museum (Stevens, 1986). Peate was a historical geographer who, following his appointment in 1926 as an assistant in the archaeology department at the National Museum of Wales, undertook a substantial review of the bygone collections. From his work on the collection in 1929, he brought together an exhibition of the material supported by a catalogue, written in both Welsh and English. This became a manifesto for the legitimate study of folk material, and through its bilingualism underlined the oral tradition as much as the material.

Peate had a relationship to language that few of his contemporary British curators shared. He wrote in both English and Welsh, and published poetry in Welsh at regular intervals throughout his life. His methods of curatorship were drawn from Scandinavian models and from concepts then employed within historical geography. In his tireless quest for the establishment of a folk museum for Wales, he placed as much stress on aspects of social life, music and dance, folklore and language as he did on buildings, costume and the countryside (see e.g. Peate, 1972). When the Folk Museum came to be developed in the ground of St Fagans Castle in the immediate postwar years, language was to be as important as objects. Staff would be Welsh-language speakers, guides would be bilingual and research would be conducted into dialect terms, stories and poems, and folk tradition.

It took a little while (until 1957) for the museum to appoint its first assistant curator with responsibility for recording oral tradition. This represents one of the first museum appointments totally concerned with testimony. Advice on how this work might be set up was taken from the School of Scottish Studies and from the Irish Folk Lore Commission. The initial tasks set were ambitious to say the least:

A survey of the whole of Wales, area by area, recording

a) Domestic vocabularies. The words used in the home for (a) cooking, (b) meals, (c) social intercourse, etc.
b) Agricultural vocabularies, The words used in seasonal operations – ploughing, harrowing, sowing, reaping etc., sheep, horses, cattle rearing etc.
c) Craft vocabularies. This will include all the traditional crafts of the countryside.
d) Cultural life. This will include religious activities, ceremonial, folk song and dance, folk lore and the recording of folk tales etc.'

(Welsh Folk Museum, 1983)

They were advised that they needed two tape recorders, one which could be run off the mains, the other which could operate on batteries, and 'a motor van in which when necessary, the official can sleep'. The total cost was estimated at £1200. It was not long before it became obvious how woefully inadequate such provision was against the task the museum had set itself. Even so, important recordings were made, not least a centenarian born in 1858. There were internal limits on their project, as well. Emphasis on the rural as opposed to the urban

Plate 6 Mrs Kate Rowlands (born 1892) from Tal-y-Bont, Rhyduchaf, Merioneth. Interviewed by the Welsh Folk Museum in 1961. Courtesy of National Museums and Galleries of Wales (Museum of Welsh Life).

Plate 7 William Roberts (born 1901) from Llidiardau, Merioneth. Interviewed by the
Welsh Folk Museum in 1961. Courtesy National Museums and Galleries of Wales
(Museum of Welsh Life).

Dream Spaces

Plate 8 Mrs Mary Williams (born 1880) from Myddfai, Carmarthenshire. Interviewed by the Welsh Folk Museum in 1960. Courtesy of National Museums and Galleries of Wales (Museum of Welsh Life).

and on Welsh monoglot in preference to bilingual or English monoglot speakers narrowed the field.

It was narrowed further by the selection of informants. Preferably they should be a native of the area, with parents and grandparents brought up in the locality; they must have resided in the area for most of their lives and might be discounted had they lived away for long periods and possibly gathered alien

speech patterns; they had to show no signs of schooling or the aspiration to speak correctly; they had also to be intelligent, fluent and able to answer the questions asked; devoid of hearing impairments; and capable of maintaining local speech even when talking to a stranger (Welsh Folk Museum, 1983: 79–80). This prescription has to be considered in the context of Wales in the late 1950s and early 1960s. Slow and irreversible decline in the heavy industries in the south was taking place, postwar agriculture technologies were changing long-standing methods of farming and consequently many aspects of rural life beyond all recognition. Freer markets were bringing in all forms of mass-produced goods hitherto beyond the pocket and the shopping facilities available to people in remote rural areas. The museum set itself the mission to record the vestiges of forms of speech and belief which were fast moving beyond firsthand experience.

In 1972, the Imperial War Museum set up its Sound Records Department specifically to record memories of war through oral history. The museum began to fulfil the intentions of the museum's founders by recording the memories of veterans of the First World War, and although they had left it late for this, it was not too late. The Department of Sound Records worked systematically and as comprehensively as possible on selected programmes, for example on military and naval aviation between 1914 and 1918, Gallipoli, and the Women's Land Army. The current holdings comprise 31,000 recorded hours, mostly of oral history, but also speeches, broadcasts, poetry readings, lectures and sound effects.

Two models of recording emerged from this project by the late 1970s: a museum archive based on the recording of oral tradition (as was the case in Wales) and one based on oral testimony about historic episodes (as with the Imperial War Museum). These two models ran in parallel for only a limited time. The former became difficult to sustain as the imperative of finding unadapted and unsullied folk practices became doubtful and the notion of 'the folk' open to challenge. It evolved into a search for testimony which could promote understanding of socio-linguistics and a wide spectrum of rural and ceremonial practices. The model based on oral testimony became far more commonplace and a variety of approaches and purposes duly developed. The idea of an integrated archive or collections, where different forms of evidence had a co-relation, began to evolve. The movement away from totally object-centred approaches to understanding the past to far more holistic ways had begun.

9 *Recording memories*

The different forms of oral testimony with which museums work warrant attention. These can be discerned by sampling transcripts and correlating these with the field of interest with which the museum is concerned. Here I am identifying five forms of testimony: that which is concerned with skills, procedures and the use of objects; the use of language; episodic memories; life experience; and being and believing. Of course, there are others, and many interviews contain a mixture and are not confined to one area of memory. But these have been chosen to provide a conspectus.

Rural museums and museums with predominantly rural history interests (not necessarily the same thing) continue to prioritize recording those memories which are about skills, procedures and the use of objects. Industrial and technical museums take a similar kind of interest. This form of recording appears to be less concerned about personal reflection on experiences and the currents and counter-currents which run beneath them, but more with detail and context, factual information and description.

The following is an extract from an interview conducted in 1987 between Hugh Paddy Óg Ward of County Donegal and Jonathan Bell and Mervyn Watson of the Ulster Folk and Transport Museum. They have been talking at length about the gathering of seaweed to use as fertilizer and the growing of potatoes. At this point they are moving on to oats:

J.B. *How would the oats have been sown? How did they sow them?*

H.W. Sowed by hand. Aye.

J.B. *Was there any special trick, or anything, for sowing – to keep it even?*

H.W. No, they used to just get a bucket – they'd get a bag of oats, maybe an 8 stone bag, and take that to the field, and they would have a bucket with them, you see, and just go shaking like that with the hand, you know.

J.B. *Aye. We've tried that, you know. It's very hard to get it even, you know, over the ground.*

H.W. Aye, Aw well you know, I used to do it myself, seemed to do it all right, you know. But there was some of like, I seen some of them, with a bag tied on here, you know, in front, so that they could fill the bag of oats, here. And they used to go with the two hands. One going that way, and that way. And they were walking on, you see. But if you had the bucket, you had to have the bucket in one hand. You only could use the one hand, spreading it. But I seen an old fellow with the bag, like.

Plate 9 Sowing oats by hand, Northern Ireland. Courtesy of Ulster Folk and Transport Museum.

J.B. *When would you have sown – around April?*

H.W. Aye. It was sown about – it all had to be sown around here by 16 April. Yeah that was about the time.

J.B. *And when would it be ready for harvesting?*

H.W. Well that would be in August. I seen them – it wouldn't be before the 15th August anyway. That would be earliest time you could get it.

Where appropriate Hugh Ward was asked to talk about the tools he used.

J.B. *The spades – was there a big difference in the shape of the spades in the old days?*

H.W. The spades in my young day was made much, you know, the same, but you get some of them maybe a bit heavier than others and you always went for the light one. You see you liked to get a handy – what they called a handy spade.

J.B. *Would the blade have been longer, than the modern – ?*

H.W. The same as they are now, like. But the blade now seems to be heavier. They seem heavier now, and blunt. You know, that time you got them nice and sharp on the bottom.

M.W. *Can you remember who made the spades?*

H.W. No, I don't know where – I think they mostly came from Galway. That's what I think, aye. A lot of them came from Galway, I think. There was an old man in the co-operative store one day, he came in, he was wanting to buy a spade, and there were just the six in the store, you know? So he was lookin' through them, you see, and he was trying them out to see which one was the best. So the boy that was in charge of the co-operative store came out, and yer man says to him, 'Is this all the spades you've got?' You know. And the fellow says to him, 'That's all', he says, 'but how many would you want' (laughter). You see – comical. 'But how many would you want?'

(Ulster Folk and Transport Museum Archives)

It is important to bear in mind that not all interviews which search for descriptions of the ways things were done and objects used are about what some might see as 'traditional' practices. The following is an extract from an interview for Glasgow Museums. The interviewer is Harry Dunlop and he is talking to a woman in her sixties in 1995. Here she is talking about surviving the endemic poverty which was the lot of many living in areas of the city such as Easterhouse:

in fact it got that bad that you just couldn't cope. We used to put the money into the meter to get your electricity. In fact, we found a way of jamming it, somebody told us . . . that we found free heat. We weren't brought up to be like that but sometimes you had to swallow it when you got weans. My man wasn't working, so you were drove to go into crime. They told us how to jam these meters – so we were having fires all over the place, the hoose was like a bloody furnace. It got to the stage . . . you had no money to pay the rent, you had to run free heat and then put so much in the meter and [when] you run out you had to open the meter and take the bloody money out to buy bread, tatties, eggs, to make chips and egg or something. With doing all these things you develop a crooked brain because you start saying to yourself that you can't put the money back in. You didn't have the money to put back in – so you are putting yourself further and further in.

The next best thing was someone else talking and telling you to kid-on the meter had been broke into, so what do you do then? There I was at 10 o'clock at night, up the same close with 2 meters, that person is dead now. She was such an honest person until the kids run out of food, till we got the bad times. Governments and societies drove decent folk to do these things. There was us at 10 o'clock at night walking along the road in the dark, trying to throw meters in the canals. (Whenever they cleared the canal they would find loads of meters.) You would meet other folk down there as well. We used to think we were the only ones that did this, but when we got to the canal there was about 40 of them doing the same thing. Everybody was in that position in those days. You had to ring the police up and say that the meter had been broken into and you were shaking in your shoes telling them a pack of lies and they knew you were lying. The police weren't daft, they knew.

(Glasgow City Museums Archives)

As has already been pointed out, descriptions such as these can take place within interviews that also contain other forms of memory or testimony. For example,

Plate 10 Seaweed cutting in Northern Ireland. Courtesy of Ulster Folk and Transport Museum.

in the interview with Hugh Ward, there is a description of an episode from his childhood when he helmed a boat that was almost overloaded with seaweed and people back to the shore, thankfully in calm waters. Similarly, the woman in her sixties in Glasgow talks about her faith in God and reflects on her current situation and the hopes she has for the future.

Much of the recording work devoted to language has taken place where a native language is threatened or is in decline in some way. The interviews are conducted in the language itself, usually on a straightforward topic that is likely to necessitate the use of key words or phrases. The Museum of Welsh Life has particular expertise in this regard, especially in relation to socio-linguistics. Other museums have a constant awareness of the use of dialect and specialist terms. Wherever possible, it is import to pause and clarify words of this nature for the formal record. This is what happened in the interview with Hugh Ward, when Jonathan Bell and Mervyn Watson paused to ensure that an Irish word was formally recorded.

J.B. *You were talking to us this morning about seaweed, and you were telling us the Irish word for seaweed. Can you tell us the Irish word again?*

H.W. Oh aye, the *liáth*, the *liáth* we called it. And then there was other seaweed we cut off the rocks, they called *wrack*.

 Well now they use the wrack in the wrack factory there near Dungloe, for ... I don't know what they do, like. Some says it's made into iodine when it's manufactured.

Later, clarification of a technical term was needed. In this extract they are discussing how the soil was prepared in lea fields:

H.W. Aw, you would just go into the field, and you would start at one end of the field like, and the first sod or two you would take out, you would throw it away, you see, to give yourself a bit of room for turning over the next one. And after that it was sod after sod, with the spade. And every sod went out, it got three or four nicks. That was the way with the lea.

M.W. *Had you any special name for that, like trenching or?*

H.W. No, just delving. Just delving. It was all called delving here.

 (Ulster Folk and Transport Museum Archives)

In an interview for Glasgow Museums, Harry Dunlop talked to the Glaswegian actress and entertainer, Dorothy Paul. In this extract, she reflects on the distinctiveness of the Glaswegian dialect and the use of this within her one-woman shows.

About the language, I try not to compromise. I am going up to Inverness and I go to Edinburgh, there is one line that sometimes doesn't get a laugh, but it gets a laugh in Glasgow '*I had finished my washin*' but *I had a nice wee sapple in the basin so I just signed through my wee brisset at the windae and gie it a wee freshen*'.

 The language is lost. The 'brisset' means the small horizontal curtain, the 'sapple' is a wee bit of nice soapy water which has not been totally exhausted and 'to sign through' is to rinse through. The young folk think this is a foreign language, but it is the Glasgow language.

 (Glasgow City Museums Archives)

One way or another, all interviews are records of forms of speech, dialect and accent, no matter what is being talked about and who is speaking. But museums have the chance to look at speech forms as part of the record and to extend this by considering the use of language; for example, socially and culturally in stories, music, rhymes and ceremonies, as well as technically in the naming of things and the description of processes. Thus the words of a work song, or a salacious urban myth, the words spoken to greet or end the day, or used to describe the innards of a computer or threshing machine are of particular relevance to the task of history museums. Language, constructed through culture, is the baseline for social communication and understanding, and hence a primary means of researching past experience.

The work of the Imperial War Museum since the 1960s has led the way in museum recording of episodes. The Museum's work has been primarily about the historic episodes of war, although the compass of their interest has included

both battle and home fronts and the experiences of civilians as well as combatants. The following two pieces are taken from their work.

In this extract Joseph William Lennox served as officer with the 4th Battalion South Wales Borderers in Gallipoli and Mesopotamia. The interview was recorded in 1984 when Lennox was 89. In this part of the interview he is recalling the death of his father at Anzac:

> We'd pushed the Turks out of a line of trenches which were not very deep and I should think at about six o'clock that morning some soldier came down the line to my platoon and said 'Your father's been hit, better come and see him'. So I went down the trenches and when I arrived I found he was out at the back of the trench, which sloped away from the enemy, being bandaged up. He had his jacket over his head, so they could get at the wound, while the sergeant major, I think it was, prepared a field dressing. There was a certain amount of blood about and I watched for a few moments in some interest, not thinking it was serious probably. I finally said, 'how are you feeling?' I got no reply so I took his jacket back over his head and I saw at once that he was completely dead. No question of it. People have asked me what one felt on an occasion like that and it's very difficult to say. I don't think I had any immediate reactions of great sorrow because one had been in the midst of all this sort of thing. When I saw him I just accepted it as another of the facts of war. I didn't stay very long. As I walked away, I just had a feeling of pride that he had done his job. I went back to my own trench and as I've told several people my own batman was killed the next day and to be quite honest I felt really upset because he knew where all my things were and I didn't!
>
> (Imperial War Museum, 1994: 47)

In the following interview, conducted in 1976, Lilian Buckoak talks about her time in Spain serving with the British Medical Mission between 1936 and 1939. Having joined the 5th Division of the Spanish Republican Army, she found herself having to retreat alongside civilian refugees in the winter of 1938 to 1939.

> During the retreat we used to be held up by the wayside 'Lilliana – can you help; there's a woman having a baby, it's going to be difficult.' And there the women would hold up their voluminous skirts around this poor young person. She probably didn't know where her husband was by that time, but for the sake of the unborn child she was on her way to safety in France. I don't know how many babies I delivered. I don't remember. I don't remember how many sick animals I looked after, but quite often mules were wounded that could still be used. Eventually after haggling at the frontier, we were let through. The Fascists were right behind us. We holed up in the hills because the French didn't want us.

The situation at the border was such that:

> I hid my passport in my knickers. I was one of these simple young English girls who felt you must never surrender your passport at any price.
>
> (Imperial War Museum, 1996: 75)

In all forms of interview there is the potential for received memories to surface, that is, memories which are not firsthand but which have been passed on, very often from parents.

The following is an extract from an interview undertaken by Glasgow Museums with Jenny Lyle in 1995:

> Queen Victoria was paying a state visit to Glasgow in 1888, my father was one of the buglers that played the fanfare for her at the Cathedral.

Plate 11 Esther Liston leaving the quayside in the 1950s. Esther gave up the creel in 1976 at the age of 80. Courtesy of Newhaven Heritage Museum and The City of Edinburgh City Council.

Was that the 1888 Exhibition?
Yes, she opened the Exhibition. It was my father told me. The young buglers were lined up. . . . It was John Brown who lifted the old lady in widows weeds out of the carriage and of course the young boys afterwards had a rerr laugh at the big kiltie. Anyway, he played the fanfare to let her into the Cathedral and they had their laugh afterwards about John Brown.

(Glasgow City Museums Archives)

In more recent forms of interview museums have aimed to place on record people's experiences of life. This is more than asking them to describe a process, outline a skill, or provide a narrative, although these may well come into it. The recording goes beyond this in an effort to get some sort of understanding about what something was like for someone.

The following is an extract from an interview with Esther Liston, the last working Newhaven fishwife. The interview was conducted by the Edinburgh Museum Service and here she is talking about how she came to be a fishwife and what that was like for her to begin with:

> My mother said it was too hard a life and wouldn't let me learn it. Then in 1932 my husband dies and I was left with two sons aged seven and five and 18 shillings a week pension for everything. So, at 36, I started with the creel. It seemed like the natural thing to do. At first I felt as if my neck was breaking. It's an art you know. I used to practise with a two stone box of kippers, then I got used to it.
>
> (Brace *et al.*, 1998: 37)

The following is an extract from work undertaken by Elizabeth Carnegie for Glasgow Museums. Here she is talking with a group of women and the transcript records their various comments and interjections: there is no doubt that Elizabeth had gained their trust and they began speaking with confidence. In this extract, they are half-way through a discussion which began with talk about washing nappies, housework done by boys and girls, getting married and sex education:

What was different about having a man in the house?

You just had to get used to it. You were married and that was it.

You had to tolerate it. It was a different thing if you were deeply in love with him. It was a different way if you didn't feel that way.

And did you not?

[*silence*]

Never?

[*silence*]

If you had a headache it didn't make any difference to him you still had to have intercourse. The only time I had freedom from him was when he died in 1973, because I had to be in the house for him to get his dinner and you would have to have intercourse at all odd times – he was a docker.

I had one that you had to be there and he was out gallivanting with other women.

Did he hit you?

Yes, I was a battered wife, I have never told anyone in here that. He wouldn't let you sleep. He used to come in all hours in the morning and I always knew when he was coming in and I had to get his tea on and if he was drunk and you were dying to go to sleep and he wouldn't let up as he kept on bashing you on the back of the neck.

Was that until you had intercourse with him?

Yes.

And then he would leave you?

No.

See the young ones that are married now, they have the time of their lives – they are the boss now. The women are the bosses.

I was only allowed to take what he would give me money wise.

I couldn't get a loan of five bob off of him.

When the kiddies' half-crown benefit came in, he took that off your wages. In fact, I got a daily wage and if there was no boats up, there was no money. You had to pawn or borrow.

The discussion continues, and concludes with Elizabeth Carnegie observing:

You seem to be happy women now.

We've got no men to bother us. You just have to laugh about it because you survived.

Two years after my man died, I still hurried home at five o'clock to get his supper ready.

It is good to get talking like this.

I had a good life, I had a good man.

I had a ladies' man. My man used to walk up Campsie with his girlfriends.

(Glasgow City Museums Archives)

In the next two extracts the experiences described and reflected upon have a relationship to the values of others and give vivid insight into a cultural moment, when change would soon follow. The first is from an interview by Beth Thomas from the Museum of Welsh Life with Mary Jenkins of Llandarcy, near Swansea. She has been talking about her brother and his friends and how well they got on.

And they used to come, six of them used to come into our house as if it was the house. But you see that mother used to welcome them then. My mother wouldn't trouble if the lot of them was there, as long as they were all together. But it was wonderful. And these boys stuck together till after they got married. And then they had girlfriends, they were all together. And I don't know – er – I don't – we'll have to rub this bit out I expect.

Do you want me to stop?

Stop it? It isn't – no it isn't worth 'cause you'll only laugh at it. When they were all courting now, they were all – they'd go to a dance together, see, with their girlfriends. Now on Sunday, they didn't want to go to chapel or Sunday school, they wanted to go down the Mumbles. That was the beginning, see, they wanted to go down the Mumbles with their girlfriends. And one of them had a little gramophone he used to take to the boys now. So they went down – this Sunday now, they went down to the Mumbles and they had this little gramophone, and of course they started dancing. And the papers next morning – 'Swansea Hooligans on Swansea bay', in great big letters and they (chuckle) . . . and they were a quite surprised. . . . But that was the difference in the day, see. . . . And my father saying 'you'd better stop it, leave it go now, I don't want my boy called a hooligan'.

Why was that? Because it was a Sunday, was it?
Yes, 'cause it was a Sunday see.... Yes it was on the paper, on the *Post* and everybody was having them and everybody could see it. No photo, just, only it was saying 'Swansea Hooligans'. By gum, they were ashamed of themselves and God love them – all they were doing – I don't know, I don't know if they had a swim, but I know they had this little gramophone (chuckle) and they were doing (chuckle) a little bit of dancing, but that's all.... They were getting now see that they didn't want to go to chapel. In it funny, teenagers, they fall away don't they, I know my brother did. He was a Wesleyan for a lot of his life, but they did fall away.

(Museum of Welsh Life Oral Archive)

Finally, in this extract of an interview between Harry Dunlop and Sister Margaret of the Sisters of Notre Dame, recorded in 1992, we hear how a devoted nun responded to the changes which came in the wake of the Vatican Council of 1963 and what they meant to her.

I remember we were told about the new habits that ... em ... we could have it between six and twelve inches from the ground and I am only 5'2" and I remember standing up on a table and putting my shoes off (not to dirty the table) and a friend of mine got a ruler – twelve inches – and so I took it up. And then I went down to Ashdown to make my retreat. The Provincial at that time was a Scot, Mary Consuella, and I was coming over from chapel one morning and she dragged me into her room and said 'come here you' and I said 'yes Provincial' and she said 'what are you going around with that wee kiltie on for?' 'What do you mean?' 'It's up to your knees, giving us a showing-up. They will think everybody in Scotland's like that'. So I said 'it's twelve inches from the ground' and she said 'it is not. Stand up' and she got out a measuring tape – 14 inches – and of course it's because I had my shoes on – it made the difference, 'go and take down two inches'. And it was the first time in my religious life that I felt *no*. So I just went away and I thought – I'm not taking this down ... this was not an important thing, so I'm not going to do it. Now that would have been unthinkable before ... you know a trivial example, but to me it was significant that I was making up my own mind about something.

(Glasgow City Museums Archives)

The closer oral testimony has got to experiences, the more questions arise about how people coped and how they were able to get through the best and worst of times. Museums have begun asking questions about faith and survival. The understanding arrived at has to be situated within knowledge and appreciation of culture and identity.

In the following extracts the speakers are responding to the questions 'Who are we and what do we believe in?' The recordings were made by Helen Clark of Edinburgh City Museums Service for the exhibition *Peoples of Edinburgh*.

These are the words of Trishna Singh, born in Glasgow and now living in Edinburgh:

This is home. There is no real link with India. People that have been born here, married here and had their children here feel more British that Indian. Now during an Asian wedding it's becoming the norm to have a wedding cake – even for the most traditional families – so we're changing all the time.

(Clark *et al.*, 1996: 53)

Alan and Jean Price from Barry in South Wales, also now living in Edinburgh, said:

> Being Welsh is a love of home and hospitality, poetic language and song, friendship and fair play (*chwarde teg*), happy gatherings with a warm welcome (*croeso*) for all – then there's rugby!
>
> (*Ibid.*)

Alan Liu, born in Hong Kong, said:

> My older kid came here when she was nine, so she had a bit of education in Hong Kong. She still classifies herself as Chinese. She still likes to listen to Chinese music, watch Chinese movies and read Chinese as well as the local newspaper, but the younger one's a bit different. She was five when she came here. She's proud to be Scots, but she is still very, very proud to speak Chinese, and I keep telling her 'this is your ancestors'.
>
> (*Ibid.*: 52)

On behalf of the St Mungo Museum of Religion in Glasgow, Harry Dunlop and Elizabeth Carnegie conducted interviews with people of many different faiths. Finally, here is a brief extract from his interview with Cathie Cullen, an Episcopalian, about the place of faith in her life. This comes from towards the end of the interview:

> *Are you frightened of dying?*
> Yes, I must be honest.
> *What is it that frightens you?*
> The pain before it. It's not the after, it ... eh ... I was with my brother Alan, we were talking about this on the bus and I said if I died he was to make sure I was right dead. He can do anything he likes with me, but make sure I am gone! I certainly don't want to wake up and find I'm still alive.
> *Have you ... em.... Is your funeral important to you?*
> Well, who am I?
> *What would you like to see happen at your funeral?*
> Well, I'd like to be left in church overnight.
> *Why's that?*
> It's a special time, I'd rather be near to God. It would be my last time in privacy with God in church before I leave earth. That was where I was taken at the beginning of my life, I'd like to think I'd return there at the end of my life, I really would. I have written down on a sheet of paper that this is what is to happen to me. My mother wants the same thing actually. She wants to be put into church. It's like to spend that time with my Lord before I go. My friends can come if they like, if they think I'm worthy of it. There will be special hymns, one of my favourite hymns is 'O love that will not let me go'.
>
> (Glasgow City Museums Archives)

10 *Working with testimony*

As has been discussed, the recording of memories for archival, research or exhibition purposes is by and large about product. It is principally concerned with obtaining testimony so that some formal record can be kept, if need be indefinitely. Oral archives fall into this category and the work of many historians and history curators springs from it. Because the product and not the process is foregrounded there are implications that need to be considered. These include those which relate to the institution, the interviewer, the relationship between the interviewer and the informant, and the informant and their memories.

For museums, with their commitment to make histories publicly available, the implications of recording premised entirely on product should never be ignored and, where they are, the effects can be telling. One instance will suffice. Chris Healy, reflecting on his/her experience as a historian working with oral history at the Living Museum of the West in Melbourne, Australia, observed that through fieldwork and recording the museum had been able to draw together interesting and valuable history. But s/he went on to comment:

> there were times when I was reminded of voyeurs who stalk the old and believe they catch history in a net of tape which scoops up words before the last breath expires. In its worst moments, the museum simply colonised and cannibalised the collective memories of the western suburbs in order to reproduce itself as an institution.
>
> (Healy, 1991: 165)

The scenario Healy describes was rooted in a model based on product. Healy describes how the museum was working in a situation where there was a well-established collective awareness of community histories that were being explored through a host of local activities. Moreover, these memories were known in a variety of forms within family and group settings. Healy argues that the museum was attempting to take over what was already functioning in its own ways. The museum was seeking to establish itself very quickly, and in its haste had seen only its own agenda. But perhaps more to the point, the museum appeared not to have been valuing the informants and their memories, other than as a means to fulfil the institution's agenda. At the heart of this lies a notion, familiar within the oral history field, that people's memories are a source which can be collected and then used – as suits the researcher.

The prioritizing of ideas of 'product' over those of 'process' is often born of necessity. For many museums, time constraints and a conflicting clutch of immediate priorities prohibit anything but the most businesslike of attitudes to

collecting memories. It might be held that, after all, this is not social work, but what many would see as a fairly standard research procedure set within an institution's agenda. However, there is a strong case to be made that greater awareness of the informant and the formation of their memories through interaction with the interviewer could lead to greater, rather than lesser records of past human experience, regardless of how much or little time can be spent on interviewing. It might also be stressed that although not 'social' work, oral history by definition nevertheless involves very personal acts of remembrance and therefore has to have attached to it a strong ethical stance and certainty about the responsibilities involved. In fact the recording of oral testimony, although at times seemingly robust and straightforward, has facets which are intimate, even delicate.

People who are actively involved in recording work are rarely in any doubt about its virtues or shortcomings as a source of evidence. It adds the personal voice to the historical record. Oral testimony complements other sources and sometimes undermines them. Recordings frequently include information which written or official sources do not contain and apply an interpretation which can be nothing other than firsthand, albeit filtered through hindsight. In relative terms, there are only very limited restrictions to who might be interviewed and

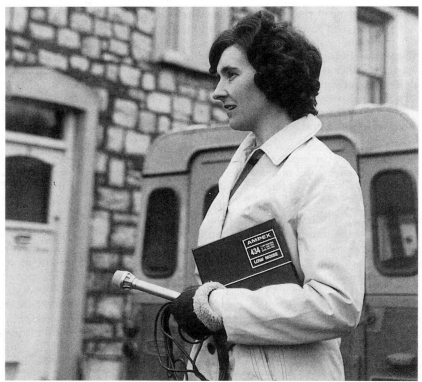

Plate 12 Minwell Tibbott of the Welsh Folk Museum on her way to an interview in Pentyrch, Glamorgan, in 1970. Courtesy of National Museums and Galleries of Wales (Museum of Welsh Life).

therefore oral history can involve all strata without exclusion. As a result, the interview has not only been used to gain insight from major figures involved in national events, but also from the marginalized, dispossessed and disaffected whose lives slip past the official record. It recovers episodes in very vivid ways and allows alternative and often contradictory accounts. Oral testimony seems to allow the historian both to look the past in the eye and hear it spoken out loud. But what is in fact being recorded is a two-person exchange, led by a specific, usually institutional agenda. It is also bounded by the moment and the quality of understanding that can be achieved within it.

A significant proportion of interviews takes place with people of post-retirement age, often in the very late years of their lives. Yet, in discussing what makes for successful recording, many of the texts on oral history put a great deal of emphasis on the role of the interviewer rather than the informant. For example, Beth Robertson wrote the following: 'Listening to hundreds of hours of recordings over the years I have become convinced that the most successful oral history results from well-prepared interviewers' (*Oral History*, spring 1995: 25). Similarly, most of the standard works run through a range of preferred techniques, the things which appear to work best technically and procedurally (e.g. Lance, 1978; Seldon and Pappworth, 1983; Perks, 1995; Morrisey, 1998). Perceptions of the informant's experience of the interview and how their memories are being formed through it have received relatively less attention (but see Echevarria-Howe, 1995; Grele, 1996; Lummis, 1998). Occasionally a cautionary note is struck; for example, Perks advises the interviewer to remember that 'your visit will often have a profound effect on someone who has perhaps never told anyone their memories before' (Perks, 1995: 20); but in his notes on the work which takes place after the interview, little is said about the informant other than in relation to their rights over the material recorded.

This is in contrast to research on reminiscence (e.g. Haight and Webster, 1995b) and on learning (e.g. Falk and Dierking, 1992; Hein, 1998) where studies of both participants and participation have helped shape and develop the methods now used. In oral history, attention has been focused, for example, on the 'text' and on theorizing oral evidence, for example, the memories of a group of cleaners, who, perhaps not surprisingly, were reluctant to engage further in the experience (Elinor, 1992). Oral history has been challenged (Grele, 1991), further theorized (Popular Memory Group, 1982), described (Perks, 1995; Dunaway, 1996) and advised on at length (Perks and Thomson, 1998).

Hitherto, there has been little written about the informant as a whole person or the interview as an interpersonal exchange, unless this has been within reminiscence. But reminiscence work is arguably derived from a different institutional agenda than oral testimony. Further, there would appear to be very little on the interviewer as a social agent, their sensitivity and the qualities of investigation. The extent to which informants are enabled or restricted by the museum's engagement with them and the impact that being recorded has had on people's lives has not been an area of major concern.

This is beginning to change. There is a growing awareness of the relationship between the interviewer and informant. For example, Slim and Thompson, writing about the importance of listening to oral testimony in the development of aid and relief projects, express the view that

the role of interviewer comes with certain obligations. A reciprocal exchange is required in which what is heard is given back and carried forward. People's testimony must be treated with respect ... by applying what is heard in partnership with those who voice it, collecting and communicating oral testimony can become a co-operative exercise in social action.

(Slim and Thompson, 1993: 2)

This takes us so much further forward. It emphasizes the relationship in both the interview and that which springs from it.

Appreciation of the importance of the informant in the construction of what is after all their memories (albeit they are being processed *into* the researcher's materials) has been generated from projects where sensitivity to the subject has been high and where there is awareness of previous experiences of appropriation, marginalization or dispossession. In particular work on women's history (Gluck and Patai, 1991), oral histories in non-Western societies (Vansina, 1965; Tonkin, 1992; Slim and Thompson, 1993) and histories of near unspeakable trauma, not least the Holocaust (Rosh White, 1998), have emphasized that the informant is not a cipher, but an individual with a real life and present-day concerns. It exposes how the collection of oral history, unless carefully considered and conducted, can be like searching for what Tonkin called the 'currants in a cake'. It can be a smash-and-grab process primarily aimed at snatching the phrase, statement or account ideal for the researcher's work. This may have involved the interviewer in listening to what best fits or augments what they already know. Where this is so, a great deal may simply not have been heard and the record is curtailed by default. The people interviewed deserve better than this; it is after all from their private and personal lives that historical evidence is being provided. One way to deal with this is to view the act of recovery as a joint concern.

The interview creates oral history in the formal and academic sense. Oral history, as we know it, is made by putting on a tape memories prompted by structured questions: this act distinguishes it from social conversation. The procedures are orchestrated by the interviewer who controls the whole event. This is likely to be a person whose own life is distant from the memories; they are rarely likely to share them. The dialogue captured is usually one between virtual strangers.

There are tried and tested ways of working which aid the interviewer and structure the interview so that the informant is assisted in recall and reflection. Questions which gently progress from the factual to the descriptive and then to the analytical allow the keying in of memory, the tumbling of recollections and then reflection on them, one after another. Different forms of questions, in particular – open rather than closed – and the minimum of interviewer intervention can promote freer expression of thoughts and descriptions. Beyond doubt, the interviewer's knowledge of the subject and from that the ability not only to relate to what is being said, but also to move the topic both forward and deeper through appropriate use of terms or questions which are apposite are important. The appropriate choice of recording equipment can reduce (to some extent at least) the inhibitions that result from consciousness of whirring hardware. The body language of the interviewer, in particular eye contact, and the observation of appropriate social codes support the process in subtle but real

ways. Informants are especially aided where the interviewer has resisted the temptation to proceed on the basis of received opinion and assumptions resting on social stereotypes. These are just a few of the well-visited wisdoms of oral history work, and for good reason they contribute significantly to the quality of interview achieved.

The informant and the interviewer have very different expectations: the informant to tell their story in their own words and, if allowed, in their own terms; the interviewer to obtain a live moment of the past meeting the present, recorded material likely to be of use at a later date (see, e.g., Cornwell and Gearing, 1989).

For the interviewer, the prospect of the interview is clearly set, existing as it does within some form of work requirement which demands access to original material. The literature on oral history is very supportive in this endeavour and rarely discouraging. In general terms, acceptance is given to the idea that by and large people like to talk and will talk at length about the past: nothing would seem to be more straightforward.

But how people talk about the past may come as a surprise, even a shock. This can be evident within the work of students.

In the study of women and society, Jean Humez found that the students had difficulty generating historical comparisons:

> The work histories are full of fascinating and ultimately maddening variables. I say maddening because there comes a moment as the students and I read through a packet of ten or twenty narratives of older women's experience of their job, when we wish we had all asked the same questions and controlled the age range, economic backgrounds, neighbourhood or geographical locales of our subjects. Then we would have had the power to generalise, at least somewhat, to see the patterns emerge, and to link these patterns with other historical developments in a more systematic way than we are otherwise able to do.
>
> (Humez and Crumpacker, 1979: 58)

They later go on to reflect: 'the problem of balancing the richness of detail and individual complexity with the power to compute, generalise and compare the individual with the type must be endemic to professional oral history, as well as to its use in courses like mine' (Humez and Crumpacker, 1979: 59). How inconvenient that people's individual memories didn't lead to neat classifications and typologies, and that the interviewers had been denied the *power to generalize* about them, that is, *their subjects*! When working solely from the idea of product, with little regard for the individuality of experience, this is just the kind of frustration that sets in. It ignores the richness that comes from understanding the falsehoods of generalities. It corrupts the account into something for the historian's convenience. It disregards or subverts the very evidence it sought to use.

The interviewer has a tremendous impact on the interview, and this is substantially more than the quality of questions they frame. The ability of the interviewer to relate to the informant and the social, ethical and personal codes which they observe will affect the atmosphere and the trust which lies within it. All the hallmarks of upbringing and received norms can be evident in questions left unasked because of needing 'not to pry', deference shown because of age,

culture or class difference, and lack of attention to anything not strictly on the agenda. Many interviewers fear releasing people's emotions through inappropriate questioning and self-consciously hold back, whereas others have been known gratuitously to seek emotional responses. In contrast, some believe that tears can be an expected part of the process and are not troubled if an informant shows their feelings.

But how does this operate from the informant's point of view? The decision to engage in an oral history programme may be founded on the willingness to be co-operative in recording the past, or to set the record straight in some way. Some informants are reluctant to contribute formal interviews and only do so when some form of trust is established with the interviewer on a personal basis. Indeed, for the informant, trust seems to be the pivotal issue in deciding whether to proceed – in particular, trust that the memories will be valued and that any restriction will be honoured. There is trust too in the motives of the interviewer and that what is said will be treated with respect. This is why the idea of rapport has become a keynote in oral history texts.

The importance of rapport is expressed in literature on memories and social work and in texts which support social workers who use case testimony in their client relations (see e.g. Hepworth and Larsen, 1986; Martin, 1995). An example of the importance of this is given by Ruth R. Martin in reflecting on her work with African Americans *as* an African American. She wrote of how the black community was slow to bestow trust and needed to know her as a person. She was judged on the basis of where she came from, what church she attended, where she went to college, what sorority she was a member of, if she had children and where they were. Her answers were judged as a measure of her genuineness and whether she was competent to hear and understand their stories. The question people want answered is 'Can you hear what I am saying and appreciate who I am?' (Martin, 1995: 35–6).

Yet it does not necessarily follow that because an interview takes place that trust or rapport is actually part of the process. Such trust may be only tenuously or temporarily established and therefore may easily slip. The relationship between the interviewer and the informant may deteriorate during the interview itself (Cornwall and Gearing, 1989). Even people in the public eye, used to being interviewed, may not be fully aware of the uses to which their tapes may be put over a period of time. Experience of disagreements over the use of taped material has led to the need to establish written agreements before interviews take place and the form of wording these contain has been developed with the benefit of legal advice (Ward, 1990; Oral History Society, 1995a, b). This may be to the good of the museum, but leaves questions unanswered about the informant.

It is possible to speculate on some of the variables which exercise influence on what is brought to mind and what the person being interviewed is prepared to articulate. The relationship of trust and the confidence this brings is certainly one of them and, once established, shifts the tone of the interview into something more personal than institutional. The informant speaks to the interviewer as an individual, not necessarily as a representative of an institution with a grand plan. This relationship may be further defined by such factors as the size of the generation gap, and the interviewer's tone and body language. Their ethnicity, sexuality and accent may also have some bearing. The interviewer indicates their

interest in all sorts of ways, from the ability to use words appropriately to all the clues they give that they are actually listening. The interviewer's role is instrumental in relation to the memories the informant is prepared to permit, and it may also determine how much or how little the informant is prepared to disclose.

What gets remembered in these types of situations, which are after all largely artificial and not often paralleled within a person's lifetime? How, for example, might variation in disclosure and degree of detail be understood? A number of aspects of the discussion on memory given in the first part of this book have relevance here, and to them has to be added the work of Neisser in relation to the notion of 'self' (1988, 1993, 1994).

Neisser identified five different sources of self-relevant information which help us position who we consider ourselves to be, what we aspire to being, and what we fear we might become. He described the *ecological* self as our physical perception of our world and how we manoeuvre our selves and our bodies through it. The *interpersonal* self is the accepted behaviour we use to communicate with others. These work together as the perceiving self which governs our actions and interactions. To these are added the *private* self, the uniquely personal and individual which underpins our identity, and the *conceptual* self, which gives us culturally specific knowledge of how we are operating and what we are experiencing. The fifth form of self-relevant information is termed the *remembering* self described as involving the extension and development of personal relations through the maintenance, revision and presentation of our own personal narratives.

This view connects with research on remembering in later life – the forms and purposes this takes. As outlined in Chapter 5, Peter Coleman has identified a number of different ways in which older adults engage with their memories of the past. For some, memories are treasured and enjoyed, while other people are troubled by their memories. Some people see no point in remembering and others actively avoid it. From this we learn that in later life in particular (and possibly in earlier stages too) there is a greater or lesser inclination to talk about the past within the setting of an interview – in this instance Coleman's own fieldwork within behavioural gerontology. The extent to which this may vary according to the topic chosen and the relationship established with the interviewer has to be borne in mind. The *remembering* self is to some degree tempered and qualified by what remembering achieves in personal terms.

These two areas of research guide us to think about how within the interview people will be less or more inclined to talk about their own past and this will be influenced by what the *remembering* self derives from the process of engagement with a personal narrative – from Coleman's work it is obvious that the rewards are by no means uniform. We can add to this Wong and Watt's summary of forms of remembrance. Some people bring the past to mind through integrative reminiscence – balanced, reconciled accounts which accept both positive and negative life events. Others talk about the past in ways that are instrumental – using the past to relate to current experiences. Escapist memories glorify the past and deprecate the present and obsessive memories go over and over difficult and bitter episodes. Some people relate their pasts through narrative or descriptive accounts, enjoying the story-telling process, and others extend this by engaging

in transmissive memories aimed at passing on aspects of cultural heritage, wisdom and personal legacy. Oral historians at some time are likely to meet all of these categories of remembering in their work and will have to determine how the preferred form configures the information they feel and think they are receiving about the past.

The interviewer may help access memories with questions and prompts that lead to recall. Tulvig's idea of encodement specificity reminds us of the importance of the appropriateness of the prompt, cue or clue in accessing memories – the things, words, motions, images and smells associated with the laying down of the original memory being critical in its recovery. In oral history interviews, the procedure begins with words and questions to bring things to mind, then moves on to the gradual enlargement of memory by focusing on processes, episodes and periods, and concludes with reflection.

Thus within any situation where the past is brought to mind in some way and articulated to another person, the *remembering* self would appear to act according to an ability to deal with memories, through a number of different memory forms. In other words, what is remembered is being filtered through the idea of self and the individual's relative ability to cope with and relate to personal memories. The sum of this may well be given expression in how they articulate their memories, that is, the form of memory chosen. The interview is tapping into one brief moment in an individual's life and through that moment is seeking to access information. But that same information is constructed out of the remembering self – at that specific instant – and may well change over time. The oral historian is attempting to arrest and formalize something which otherwise has fluidity and the capacity to change.

11 *Dynamics of interviewing*

Ideas about oral history interviewing can be shifted from those based on the mechanics of information gathering to one premised on the unfolding of a subject's viewpoint and experiences through thoughtful and appropriate interaction. This has to view the informant as a whole person and not simply a vessel for the museum's materials. Even the most focused of enquiries, say, on digging potato drills or making hatbands, can benefit from the facility to hear as well as listen to what is being said. Learning to attend to the narrator is not easy. It requires the reassessment of interview strategies. Guidance on this can be found in the work of those oral historians prepared to be reflective on their work (Anderson and Jack, 1991) and on those areas of therapeutic practice where listening is vital (Jacobs, 1982, 1985, 1988).

Without giving attention to the whole person being interviewed the archive created is likely to have certain characteristics. Anderson summed this up through her own experiences when preparing a travelling exhibition on women's lives. She wrote:

> To select excerpts for the exhibit, we reviewed dozens of interviews produced by project staff and workshop participants along with hundred of interviews housed in archives and historical societies. We found them filled with passages describing the range and significance of activities and events portrayed in the photographs. To our dismay and disappointment, however, most of them lacked detailed discussions of the web of feelings, attitudes and values that give meaning to activities and events.
>
> (Anderson and Jack, 1991: 12)

She argued that work from social scientists and historians working with other forms of evidence such as personal diaries were uncovering concerns and satisfactions not evident within the bulk of the oral history interviews. In other words, oral history – in this case of women's lives – had certain boundaries, ones which other forms of evidence and ways of researching had moved beyond. Anderson went back to her own oral history work to look at the process of the interview and through that uncovered how her methods may have inhibited the informant or given rise to lost opportunities. This has led her to the argument that 'we need to refine our methods for probing more deeply by listening to the levels on which the narrator responds to the original question' (Anderson and Jack, 1991: 17).

Listening skills are prioritized in a number of areas of work. Perhaps they are at their most developed and best understood within the fields of psychiatry and psychotherapy. Such methods can be applied within oral history interviews and

they can also lead us to understand a little more about interaction within the interview. Here I am taking six rules from the guidelines on listening offered by Michael Jacobs (1985) and use them to explore different aspects of the dynamics of interviewing.

Listening requires your undivided attention, without interrupting

This is remarkably difficult to do as our natural form of discourse is one of exchange. Oral historians learn to use body language to signal that they are attending to what is being said. Listening has to be established from the outset and losses in concentration and a reluctance to hear anything that does not accord with the researcher's agenda create ruptures and are likely to make clear to the informant that the interviewer is only interested in what *s/he* wants to know. Here is an example of this.

INTERVIEWER *When did you leave school?*
INFORMANT Thirteen. I started work at the week after – [Laughs]
INTERVIEWER *What did you work as? When you were 13. . . .*
INFORMANT Netting, mostly netting and traps, wire traps, catch rats and. . . .
INTERVIEWER *So did you go straight into the family business?*
INFORMANT Yeah, always been to the family business, yeah. Must have been, how many, must have been thirty few years weren't it from the time I leave school, you couldn't leave school without, before you had a job. – [Laughs]

After asking briefly about pay and about hours the interviewer moves on:

INTERVIEWER *Can you explain exactly what you did when you were making the nets?*
INFORMANT We, we used to make car garages and timber work and garages and poultry cages. Yeah, yeah. . . .
INTERVIEWER *Oh, did you! Did you make those?*
INFORMANT I didn't make 'em, we got carpenter to make em, three, three carpenters. Used to make greenhouses and but when we finished with, the timber got so dear, the wars broke out. The war broke out then we had to finish with timber, but wouldn't allow no timber-ware, not with, not with poultry houses or anything like. And we. . . .
INTERVIEWER *Where did the timber come from before the war?*
(Somerset Rural Life Museum Oral Archive)

The interview took place because a rural life museum had acquired some nets and traps and wanted to know more about their manufacture. All other information was extraneous to the interviewer and where it emerged the informant was interrupted. Information beginning to be offered about school, what work meant, the war, other forms of work undertaken, was deemed not relevant and was moved away from rapidly. The informant was not asked to describe or reflect on these major experiences. The transcriber notes how often

the informant laughs. One senses a man made nervous by the curious way in which the interviewer was asking about his experiences. Rather than take an interest in his whole life and the place of trap-making within it, the interviewer battled away with her single-minded task, resolutely moving the informant back every time he seemed to be slipping away from *her* subject. A lengthy, at times seemingly frustrating, interview is the result.

Commenting on similarly frustrating experiences, Cornwell and Gearing write that their feeling was that 'the interviewee had been made uncomfortable either by us or by questioning they perceived as intrusive or irrelevant' (1989: 38). What can be learned from this is that when interviewers are prepared to listen, they become much better judges of what is intrusive or irrelevant to the informant and more likely to respond to the cues given.

Do not change the subject unnecessarily

This also comes from not listening and is very much linked to the preceding and following rules. Sometimes it happens because concentration is lost or the thread has been dropped. At other times it happens because the interviewer is not interested in what has been said or judges it to be irrelevant. It is of course always necessary to steer the discussion so that culs-de-sac are avoided or at least evacuated in good time. But there is a balance to be achieved and effective listening can help determine whether a subject should be followed or moved away from rapidly.

The following is an extract from an interview with a farm worker, Edward Stone, in Somerset (born in 1904) and 85 years old at the time of the interview. Edward Stone left school at 10 years of age and worked on a farm for seven years before going into bakery work. In one part of the interview he is talking about taking part in the harvest as a boy, before the introduction of the reaper-binder. Sheaves were tied by hand using a strand of wheat. He describes how this was the work of women and boys and then goes on to talk about the introduction of mechanization and tractors, making comparisons between tractor and horse. The interviewer calls him back to women's labour:

INTERVIEWER *Did your mum, um, work on the field?*
EDWARD STONE No she never went out. She had enough to look after, we boys and father. He was a cripple.
INTERVIEWER *So, Ted, I'll ask you now if you can remember how old you were when you moved to Watchet.*
<div align="right">(Somerset Rural Life Museum Oral Archive)</div>

It is not clear what happened to switch the subject so abruptly. Perhaps the interviewer was only interested in farming methods and not farming families, so Edward Stone's family was not germane to the enquiry. But there must have been much to pursue at this point. The parents could have been born in the late 1870s and therefore deeper generational memories might have come through careful questioning. The opportunity was not taken to question how his father had been 'crippled' or indeed how they had managed to earn a living sufficient to bring up their three children. Interestingly too, when describing his mother's lot, of caring for 'we boys and father', he had omitted to mention his sister, although she is mentioned elsewhere within the interview. Without these

questions, an opportunity to understand something of domestic privation and survival was lost, among other things. It may be that the tape recorder was put on pause and that these things were talked about but not recorded. It could be that Edward Stone did not want to comment further. But one way or another, by changing the subject abruptly, something important was lost.

Listen to the bass line of what is being said

This is the area that particularly concerned Kathryn Anderson when she reviewed her own work. Her project was to document women and farming activities. Although genuinely interested in their work, she found herself taking their comments at face value. She was not, at this stage, alert to the 'bass note'.

In this interview, the informant, Elizabeth, had been talking about her relationships with her mother and half-sister. She then went on:

> ELIZABETH I practically had a nervous breakdown when I discovered my sister had cancer, you know: it was kind of like knocking the pins [out from under me] and I had, after a second boy was born, I just had ill health for quite a few years. I eventually had a low grade blood infection or something, because I was very thin, and, of course, I kept working hard. And every fall, why, I'd generally spend a month or so being sick – from overdoing, probably.
>
> KATHRYN *What kind of farming did you do right after you were married?*
>
> (Anderson and Jack, 1991: 14)

Anderson had responded to the imperative of her project and brought the interview back to that. Not until later did she realize the importance of relationships and the difficulties of farm life that led women to experience poor health and, from this, the significance of what Elizabeth was saying.

In the following extract from the same interview, the bass line has been picked up to some extent, only to be dropped again. Elizabeth is reflecting on how hard it was to be a full partner in the farm.

> ELIZABETH That is what was so hard, you know. You'd be out working together, and he'd come in and sit down, and I would have to hustle a meal together, you know and that's typical.
>
> KATHRYN *How did you manage?*
>
> ELIZABETH Well sometimes you didn't get to bed until midnight or after, and you were up at five. Sometimes when I think back to the early days, though, we'd take a day off, we'd get the chores done, and we'd go take off and go visiting.
>
> KATHRYN Was that typical? Neighbours going to visit each other after the chores were done.
>
> (Anderson and Jack, 1991: 15)

The same thing has happened; the agenda is back in full swing. Interest in the individual has been forfeited to interest in the general. Moreover, information about visiting neighbours could have been acquired in other ways, not

necessarily at the point where the informant was talking so lucidly about her own experiences.

Anderson discusses the ways in which women reflect on their experiences and how this can be muted or at least filtered through dominant cultural expectations. In other words, there is a sometimes silent channel of memory, where things unarticulated but strongly felt may lie. It involves a great deal of effort for this to come to the surface and be articulated, and when this happens powerful feelings are experienced, ones with which the oral historian may not be equipped to deal. The bass note is turned up loud. The following is an extract from an interview with Vera, in which Anderson in her questions finds herself ignoring the emotional content of her reflections on motherhood:

VERA Yes. There were times that I just wished I could get away from it all. And there were times when I would like to have taken the kids and left them some place for a week – the whole bunch at one time – so that I wouldn't have to worry about them. I don't know whether anybody else had the feeling or not, but there were times when I felt just like I needed to get away from everybody, even my husband, for a little while. Those were the times when I would maybe take a walk back in the woods and look at the flowers and maybe go down there and find an old cow that was real gentle and walk up to her and pat her a while – kind of get away from it. I just had to, it seems like sometimes. . . .

KATHRYN *Were you active in clubs?*

(Anderson and Jack, 1991: 16)

Through analysis of her own interviews and those of others, Anderson worked with Dana C. Jack to find interviewing methods that would allow narrators to speak much more freely and explore their lives.

Listen to what people are *not* saying and respect that choice

Listening to the bass note can allow more sensitive, rewarding and at best mutually beneficial interviews. However, there are times when it is quite clear that people are electing not to say things and that this is their choice. It is something that has to be respected, no matter how much the interviewer needs what is being held back. There are issues of privacy here, hinging on matters which the informant does not want to make public. There may also be life experiences that the informant has difficulties dealing with, and articulating them would not in their view be helpful or appropriate. As expressed by the Oral History Association in the United States (1990):

> the interviewer must expect the right of the interviewee to refuse to discuss certain subjects, to restrict access to the interview, or under extreme circumstance even to choose anonymity. Interviewer should clearly explain these options to their interviewees.

The following is an extract from a recording made of Harry Oates about a flag now in the Regimental Museum in Leicester which he had made on his release

from a Japanese prisoner-of-war camp in 1945. His experiences there had been terrible and he would only agree to be recorded on condition that he was not interviewed – he didn't want to answer any questions. He just wanted to say his piece and be in control of what he did say. The tape is full of lengthy silences which the transcript does not note:

> I came to Malaya with my Battalion, the First Leicesters in April 1941, and we were in defensive positions at a village called Jitra. The Japanese attacked on the 7 or 8 December 1942 and we were driven down Malaya, and eventually we were taken prisoners.
>
> Most of us were taken prisoners. Most of us were taken prisoner in Singapore and eventually we were all incarcerated at a place called Changi and kept there. We were held there until we were moved in a five-day awful journey into Thailand to begin building a railway, for the Japanese to move supplies from Thailand and East Asia, of course, right into Burma, as by then the Japanese had almost conquered Burma as well as almost all of East Asia.
>
> From Changi we were sent as I say, by train into Thailand. This journey took five days. To describe the journey would ... well, it would be almost impossible to give you a true picture of the awfulness of it. So I will leave it at that.
>
> (Living History Unit Archive, Leicester)

There are very few subjects that might be addressed in interviews that are totally without any other form of supporting information or alternative sources. We know that six million people, mostly Jews, were murdered in the Holocaust. We know that war brutalizes and robs people of their youth and innocence and changes everything it touches. Lives are scarred by memories of sexual or physical assault especially in childhood. The loss of parents, siblings and children through accidents or illness can carry with it deep desolation, sometimes lifelong. The loss of a business or property may have guilt and shame attached to it. These and other traumas are well documented; the historian is not bereft of sources. There cannot be any situation where it is justifiable to press an informant into disclosing a life episode they would rather leave to one side. That choice is theirs and theirs alone.

Listen to the body language and the silences

We speak with more than our voices. Our memories are in our bodies and in our facial expressions. They are also in our silences.

Oral history with its emphasis on words has lost much of this. This has been due in part to sound recording developing more quickly than audio-visual technology. In other words, it has been cheaper and easier to record voices than it has been to use cameras and sound together to record people speaking. Video recording is beginning to be more commonly used in the United States, but it is very infrequently used by museums in the UK unless for a dedicated exhibition project.

Where it *is* used there is a greater chance of picking up the clues which bodies and facial expressions give to memories. As part of a television series *All Our Working Lives*, transmitted by BBC2 in 1984, one programme was dedicated to work in the retail industry (see also Pagnamenta and Overy 1984). The informants were recorded on camera being interviewed by historians. Servetus

Hartley related his experience of working for the Co-op in Rochdale and his early days as an apprentice. He talked with increasing animation as things came to mind:

> Well what happened was that as you got older you gravitated from flour-boy ... you were brought up the counter and were allowed to stop there – perhaps ten minutes to half an hour ... a woman would come and you would get her things for her, but you weren't allowed to reckon them up and weren't allowed to touch them ... just had to put them on the counter and put them straight.
>
> We used to weigh everything out that there were ... currants, raisins, peppers, salt, tea, coffee, cocoa, all that. It had to be weighed by us. We used to have to make these cups, tuck it in, turn it up and present it. And now that was another thing... when we had made these packets up we had to put them on the counter and the boss would come round and look at them and he would shake them until he shook them loose and if he could shake them loose you got your ear hole cluttered.

As he talked his hands moved in smooth and faultless motion, as if twisting the packaging he was describing.

Similarly, Rita Greendale remembered her apprentice days at a department store in Hull:

> If you were a shop assistant you never wanted to be a factory girl. We used to look down our noses at them. Even though they earned more money, we looked down our noses at them. If you had a job in a Department store you were really one-up. But if you had a job in an ordinary shop and you got taken on at a Department store, you felt as though you had lifted yourself a little bit.
>
> I wasn't allowed to serve anybody for about a year. I had to observe the correct way to serve people. But in the meantime, you did all the dirty jobs, all the menial jobs.

As she speaks her eyes are cast down and she glances only fleetingly at the interviewer, the deference she was taught as a shop assistant and her consciousness of class position being translated into her present-day body language.

In responding – use questions to prompt, link and explore

Listening well gives the interviewer the opportunity to respond in ways that prompt the informant, helping them link and explore their memories. The following extract demonstrates this and also much that has been said in this section. The questions are short and to the point, placing the informant in the best possible position to draw from his memories. Because of the precision of his questions, the interviewer does not need to interrupt or change the subject. He is listening to the bass line as is evident in his questions, and he is aiding the narrator to move from description to reflection. The informant's name is Norman Stone and the interview took place in Leicester in March 1996.

INTERVIEWER *Now you said that on September 9th 1943 your battalion took part in the Salerno landings. Could you describe that to me?*

NORMAN Yes, the 2nd and 5th Leicestershire were part of 139 brigade 46th Infantry of the Oak Tree Division because that was our divisional star that we wore on our shoulders. Well actually the 128s and the 138s were the landing

brigades, we were the follow through brigade and we arrived off the coast of Salerno about 4 or 5 o'clock in the morning – and we were meant to land. But as we went to move in to land on the landing craft we were being shelled so the captain had to put it quickly astern and pull back again, so we had several attempts to do this and each time we were shelled. So eventually we awaited until late evening before they took us ashore, and made our way up through tracks to a little town which was about a mile inland, and it is no tribute to the British Army at all but the Sherwood Foresters and Leicesters were just all gathered together in the main street of this little town like a football crowd. It was dark, nobody knew what was happening, people were shouting out 'where's your company, where's this, where's the other?' and eventually we did get sorted out and took up an emergency position outside the town in a field in case of any attack, but it was no tribute to British Army organization what happened that night. It was lucky that nothing serious happened and we weren't attacked. As I said the nearest approach I can say is like a crowd of people when Filbert Street turns out, adding darkness to it as well.

INTERVIEWER *What were your feelings then as you headed in being shelled? I mean you were 23, was this your first time in action?*

NORMAN Yes – apprehension, but not actual fear. Apprehension – fear of not how you would react under fire, but all the platoon was in the same position so you supported each other mentally and physically – gave each other courage. You didn't feel brave. Basically you were there to do a job and you tried to do the job without letting yourself down and without letting your friends and battalion down and it was hard to define unless you are under fire. What I'm saying really – because there's so much on television and films about bravery and assaults on machine gun nests – but the actual drudgery of being an infantryman – you're constantly under fire from every sort of weapon. To a certain extent you get numbed and, strange to relate, you to a certain extent become accustomed to it. It's wholly alien to the human spirit to be assaulted like that, but as an infantryman every weapon can be aimed at you – from a pistol up to an aeroplane or an artillery man. You're there as a coconut shy for every weapon there is in the armed forces. And all the lads suffered like that, but you do get accustomed to it. You can even joke about it and joking is one way of keeping going. As I say it's so difficult unless somebody's been in that position to explain it – but I wouldn't call it bravery, but you keep your own end up and the end up of the platoon and the battalion and you didn't want to let yourself down,

partly pride I suppose, but certainly it was far removed from how it is depicted in films and television.

INTERVIEWER *You said that you had to come in under cover of darkness in the end. What scene met your eyes on the beach when you landed?*

NORMAN Well, as in every type of military operation, there's a holding period. The landings had taken place. Everybody has to re-group – and so just for a few hours everything was peaceful ... [Norman Stone continues in this vein in some detail, uninterrupted].

(Living History Unit Archive, Leicester)

It might be argued that the interviewer was just lucky that he was interviewing someone who took pride in narrating and transmitting his memories and was prepared to do so with considerable attention to what he was saying. This is in part true, of course. Norman Stone was engaging in what Wong and Watt might have classified as integrative reminiscence – balanced, reconciled accounts which accept both positive and negative life events. But this might well have been withdrawn or withheld if the interviewer had failed to listen, interrupted, changed the subject unnaturally or not allowed silences and reflection. It might also have been affected by how fully or directly the informant was engaged with his own *remembering* self and the rewards this experience held for him. Another factor was that the interviewer knew the subject well enough to ask particularly relevant questions and to demonstrate close attention. The interview witnessed the dynamic unfolding of Norman Stone's experiences through an interactive process, gently and thoughtfully structured by the interviewer who both listened and heard what Norman was saying. In the interview process they were mutually dependent, and the quality of the tape demonstrates how much they achieved together.

It is not difficult to establish the layers of responsibility. The museum professional conducting oral history work holds responsibilities to the museum as employer and to its commitments expressed in accepted policy statements. There are also responsibilities towards: the informant and the agreements established at interview; the public in whose name this work is carried out; and the professional group whose collective reputation hinges on individual standards. There are academic responsibilities to create as accurate a record as possible, through a high level of understanding and insight achieved in some part through the quality of investigation: the interpretations of the evidence depend on this. Further, there are responsibilities which are attached to the personal, especially in relation to conduct of oneself within the context of another's private life and how that contact impacts on the person interviewed.

Remarkably little attention is given to the responsibility of the interviewer to take care of themselves and not to put themselves in threatening or hazardous situations, although some oral history projects do issue a code of practice in this regard. An exception is the *Guidance on Safety When Working Alone* drawn up by Cynthia Brown for the Living History Unit in Leicester in 1996. This includes the following:

- If you feel uncomfortable when visiting someone in their home, make an excuse and leave.
- Carry a personal alarm, and make sure you know how to use it.
- Make sure other staff (or family or a neighbour in the evening) know where you are and what time to expect you back.

Guidance on the ethical relationship of the museum to the memory and the person who has made it available have some interesting configurations.

The American Association of State and Local History, based in Nashville, at the conclusion of its *Statement of Professional Ethics* (1997) on intellectual freedom, says, 'historical scholarship and interpretation demand intellectual freedom, with no qualification. Members shall refrain from any activity that wilfully restricts or discredits free and open exploration and interpretation of human experience.' Many of its members are museum and history curators who are working with memories through oral history. It is interesting therefore that no mention is made of memory in this regard and the section on collections is clearly written to refer solely to material collections.

The Oral History Society in the UK has a set of ethical guidelines which in a very businesslike way outline the principal areas of responsibility, before, during and after the interview has taken place (Oral History Society, 1995b). It strives to express how the arrangements made need to be clearly understood by all parties. The informant has to be treated with courtesy and respect and their wishes with regard to location and conduct of the interview have to be abided by, and in turn they are kept fully informed of the process and the likely uses of the tape. Issues of access and the informant's rights to stipulate restrictions are identified. The informant should receive a copy of the tape or a transcript, but only if such an undertaking has been given. There is no mention of the informant's well-being, any follow-up work or their later involvement in the use of their memories.

The Oral History Association in the States has a somewhat different tone in its statement on its 'Principles and Standards' (Oral History Association 1990). It states categorically in the preamble:

> regardless of the purpose of the interviews, oral history should be conducted in the spirit of critical enquiry and social responsibility, and with a recognition of the interactive and subjective nature of the enterprise.

As with the Oral History Society's ethical guidelines, this too sets a businesslike tone about agreements over the tape and the design of projects, but it balances this with a demand for interviewers to be sensitive to the diversity of social and cultural experiences. Interviewers and informants are charged with the responsibility of striving 'to record candid information of lasting value and to make that information accessible'. In this and other aspects of the guidelines the emphasis is on the exercise being created through joint and not singular endeavours. The guidelines are backed up with 'Evaluation Guidelines' that practitioners can use to test whether their ways of working and project design keep within the ethical guidelines set.

The ethical issues of collecting objects are outlined in the Museums Association's *Codes of Ethics* (1997). These were not written to extend to ideas about collecting memories, although obligations to the public are strongly

expressed and are given a priority of place within the *Codes*. Most museum activities are developed around objects. However, in the instance of the history museum, the idea of the collection as an integrated archive, with objects, sounds and memories being of equal importance and mutually dependent is developing and is likely to be of increasing importance over the years. It is the subject of collecting objects and memories that we turn to in Chapter 12.

12 *Collections of objects, or memories?*

History museums have a responsibility to both collect evidence of the past and to interpret that evidence within the public domain. The act of museum collecting has traditionally been seen as one primarily associated with objects and much of the early forms of acquisition rarely moved beyond this. Initially however, with the influence of regional ethnology from Scandinavia and more recently the need to create inclusive and relevant histories, methods have changed, although earlier antiquarian approaches still remain quite strong. This leads to a polarity. To express it at its most simplistic: on the one hand, the collection of objects is chosen for the objects' intrinsic value, however this may be defined, and often for their immediate availability. Thus a museum might be prepared to accept a fireback because it is offered as a gift and because it has other firebacks and can situate this one within a typology. On the other hand, there is the integrated archive developed to enable links between objects, memories, images and sounds so as to promote the effective exploration of the past. Thus in this situation a museum would collect the fireback, but in association with: photographs of it in use in its original location and perhaps the whole house for dating information; other material that it might be connected with (even if these connections are lateral, such as the apron worn by the maid who once had to clean the grate); and oral accounts of its use, disuse, rediscovery; and subsequent history. It might also be necessary to confirm and extend all of this with documentary sources, for example, census returns on who lived in the house or probate inventories where firebacks are mentioned.

The collection serves as a resource from which all other museum functions stem: exhibitions, educational work, identification and research, education and outreach. It is the raw material of the historian's craft within the museum setting; and in this the historian's role is very different from that of its counterparts elsewhere. The historian in the museum in the first instance has to decide what evidence is to be collected. From that point on all tasks are primarily theirs to perform, from the care of this material through to its ultimate interpretation and use. Few if any historians have responsibilities as wide as this. Curators literally make history by deciding what to collect and what to ignore, and by so doing dictating what should be remembered and what forgotten.

The selection of material for holding within a museum collection is a matter of judgement, sometimes a very difficult one. A number of factors need to be taken into consideration including the relevance of an object to the social history

of the area, its condition, the cost of maintaining the object in good order, the place of it within established collections, and its likely uses. A model of best practice is given by the Museum of Science and Industry in Manchester, whose thoughtful and constructive working documents *Collections Management Plan* and *Priorities for Collecting* have moved the thrust of collecting beyond the technical. They include a detailed procedure for acquisition, one which requires that any object acquired is justified not just as being relevant but as being affordable in terms of space, cost and the requirements of research. One of the main questions is: 'Does this proposed acquisition provide or come with stories about the people who used it? ... the human stories and purposes of people' (Museum of Science and Industry in Manchester, 1997).

The process of forming history collections has received some critical attention (Kavanagh 1990, 1993b; Moore 1997), but by no means as much as has exhibition, education or outreach work (for example, Falk and Dierking, 1992; Durbin, 1996; MacDonald and Fyfe, 1996). Internally, the emphasis has been more on procedures to promote the good management of collections (for example, Fleming *et al.*, 1993; Museums and Galleries Commission, 1997) and on describing and discussing current projects, usually in relation to exhibition work, through journals such as that published by the Social History Curators Group. An exception to this would appear to be the lengths that Swedish curators went in the early 1980s to develop the ideas which were later to form the basis of their co-operative programmes of contemporary documentation, by which they mean the comprehensive and integrated processes of collection, fieldwork and recording. In their deliberations they went back to first principles about how and why museums collected objects. This questioning of the fundamental tenets of museum activity led to new approaches to acquisitions, ones which stressed the importance of social and physical context, the symbolic values of objects and the broad 'fields' of people's lives (work, home, commercial, public) (Rosander, 1980; Nystrom and Cedrenius, 1982; Stavenow-Hidemark, 1985). Whether driven by instinct, scholarship, pragmatism or a formulated system, there is a great deal at stake.

In the selection of an object for a museum collection, history curators are choosing that which has evidence value on some level. It may be that the object holds this intrinsically, that is in its very fabric, such as a trade union banner or a lathe with a manufacturer's name plate. Perhaps it has evidence in association, such as a medal for school athletics won by someone who went on to be famous or a bible used by a Christian group which broke away from the established church to found its own order. Perhaps it is associated with particular memories (the bus conductor's hat worn by a woman in the Second World War and the stories which go with that experience) which imbue the object in certain ways. History curators have anxiously struggled with the use of objects as evidence. Traditional historiographic techniques are scarcely adequate in the analysis of the physicality of objects and borrowings from other disciplines such as archaeology or anthropology have been useful only to a point. A much more flexible and open approach is needed. From time to time however, this has led to questions, even confrontation, over whether objects are important any more (Davies, 1985; Tucker, 1993).

Moore has argued that with the museum remit so firmly set on the collection of objects, there can be no substitute for 'the study of material culture and its

meaning in people's lives at the heart of museum curatorship' (1997: 50). He makes a plea for new ways forward. Perhaps these lie in the study of objects *and* their meanings not as separate areas, the formalist and analyst perspectives in Ettema's parlance (1987), but in their total integration. The study of objects on their own can lead to cold forms of antiquarianism, revering the inanimate, remote from people and the lived past (the flat-iron and not the woman's life of which it was part). Yet to study just their meanings, and not the object, leads to that which is script-, narrative- or text-based (the woman's life and not the material she used within it). This risks the object becoming a mere touchstone or illustration. It is in the *integration* of these, of the meaning *and* the object, that history in museums becomes effective. This means a ready recognition of the value of tactile and visual evidence, as well as the meanings of objects in people's lives. Of course this also necessitates an acceptance that the meanings arrived at will not be straightforward or even rational. Nor will they be devoid of feelings, politics and a sense of self. To appreciate what this may mean to collecting, it is helpful to consider in general terms how we think of objects in relation to ourselves, our fantasies and memories.

It is not unusual to come across ways of discussing objects that appear to anthropomorphize them. For example, Lubar has written about how machines 'modulate, influence and intermediate the interactions of groups' (Lubar, 1993: 198). Pearce has written that objects 'do relate to each other in an objective sense, they fall into groups with shared characteristics' (Pearce, 1994: 128). She also argues that 'objects hang before the eyes of the imagination, continuously re-presenting ourselves to ourselves, and telling the stories of our lives in ways which would be otherwise impossible', and from this holds the view that 'our idea of identity resides more in objects than it does in ourselves' (Pearce, 1992: 47). Csikszentmihalyi has written that 'we like to think that because objects are human-made they must be under our control. However this is not necessarily the case' (Csikszentmihalyi, 1993: 21). This is a tendency by no means confined to academics and curators, and sometimes the language goes further, not just to anthropomorphize objects, to make them appear human, but to incorporate them within the human form – literally to embody them. Moore has pointed out how the return of the football used in the 1966 World Cup Final, largely engineered by the *Daily Mirror* newspaper, was greeted with the declaration 'That ball's part of Geoff' (*Daily Mirror*, 26 April 1996).

This can go to extremes. Lyall Watson has argued that 'things even those that are totally inorganic and undeniably inanimate, sometimes behave as though they were alive, on occasion even sentient'. He claims that we have succeeded in creating a new and rival form of life and that every aspect of our relationship with devices and machines is hedged about with a sort of suburban shamanism, deliberately designed at some time to give life to the inanimate (Watson, 1990: 11–12). We have, he claims, become midwives to matter. Drawing on newspaper reports, he supports his argument with evidence such as this:

> every time Ian Moncrieffe in Bristol boils his electric kettle, he receives mystic messages. In Norfolk Janet Barker's new cooker talks to her in Dutch. Office-cleaner Madge Gunn in London gets silly orders from her vacuum cleaner.... Doris Gibbons' electric meter is more polite [and so on].
>
> (Watson, 1990: 189–90)

Whether this obsession with objects living and speaking is a preoccupation of those with an object-centred perspective or a much wider Western phenomenon is open to question, however. In terms of the museums that have been created within Western tradition, they have been criticized for being sterile, concerned only with the past and not the present, non-emotional and non-threatening, focused on things rather than people, unaware of death, spiritually unattuned and academically distant. Such criticism is made from societies such as Maori in New Zealand, whose intense spirituality, kinship systems and reverence for the land brings totally different perspectives and ways of looking at things and believing in them. In Maori all things possess a *Mauri* (life force) and *wairua* (spirit). Treasures (*Taonga*) carry pain, sweat, tears and joy and these can be felt and communicated through access to them. *Taonga* holds power (*mana*) drawn from the past and the present which can help the future to be faced (National Museum of New Zealand/Te Whare Taonga o Aotearoa, 1989; Cassels, 1992). This is not so much 'objects speaking for themselves' as much as objects and their meanings being felt and experienced on a spiritual and kinship level which few traditions share and may not even come close to understanding.

Within Western traditions with a resistance to things spiritual, it is not clear why, when talking about objects, people feel the need to shed responsibility and project human shortcomings, risks and potential on to them. Objects are inanimate, and unless animated in some way by us or through us, cannot be the subject of an active verb. So an object cannot embrace, determine, decide, although we may embrace, determine or decide something in reference or with reference to it. We might imbue an object with magical properties or attach a belief to it, but this comes from within us and, unlike the Maori, it is not a central or stable part of our belief system. An object does not have free will or the right to make a point about something – it is the human agent who provides this through the manipulation of it. Nuclear waste, cars that pollute, shabby high-rise apartment blocks exist through human (not object) intent, just as shoes, drains, electricity and all the better things exist through human (not object) agency. We may well be drowning in the waste we have created, but it is in effect *our* waste, and the objects are not in a position to do anything about it.

Thus when a claim is made that an object 'acts' in some way, what is actually taking place is a form of transference. We can say that an RAF bomber dropped its bombs on the target below. But the plane did not do this (because it felt like it?) – it needed a war situation, political and strategic decisions, technical preparation and a skilled bombing crew to drop the bomb – the plane was just the conveyance at the behest of humans. We can use the object/plane as a transactional object, as a way of talking about the bombs dropping, that shields us from facing up to acknowledging what it takes to drop bombs, usually on civilians. If we talk only in object terms, we lose the human actions and responsibilities vital to a whole event, and as safe as this may feel, it is however a form of avoidance.

Overemphasis on the power, beauty or place of an object can lead to some bizarre ways of looking at them and, through this, thinking about relationships and past experiences. Lubar claims that 'household machinery is often where the expectations of genders clash'. Many would dispute this and look for more complex scenarios for 'gender clashes', if that is what these things are.

Expectations of gender become more powerfully evident in disputes about time, commitment, skill, and the generosity of spirit within a relationship (which could after all be between partners of the same sex as much as one with gender differences). Whether the Hoover is 1000 watts or 1200, blue or yellow, does not really come into it. Similarly, a piece of machinery cannot be 'the battleground where workers and managers struggle', as Lubar suggests. Without doubt there may well be occasions where the development or use of a lathe or a drill has been the *focus* of industrial disagreement, but it is more likely that the struggle is ideological, economic or social. The machine-breaking which began in 1811 and continued spasmodically in the years thereafter took place in industrial areas in England as the factory system was taking over from small workshops. However, this was not simply hostility towards the new machinery which threatened their work, although this of course played a part, but a desire to resist wage reductions and to demonstrate workers' solidarity (Briggs, 1959: 182).

Curators have an investment in stressing the power of objects as evidence. The language used can go so far as to become fantasizing rhetoric. At the very least, the argument may be given to over-extension. Yet without this case for objects, the case for museums would be even harder to develop. But there are difficulties here in how the past can be understood from material alone. Historians know that in research no single form of evidence is reliable or sufficient. There has to be a complex process of cross-referencing and cross-examination. Just as an economic history of a company could not be arrived at from the study of its account books alone, similarly it cannot be arrived at by the study of its products alone. The histories so created would have a very hollow sound and much of relevance and possible importance might be missed. Other forms of evidence have to be used to provide detail and context and to help reveal complexities, continuities and discontinuities.

Evidence of the past to be derived solely from objects, once divorced from their original context, as is the case with a substantial proportion of museum collections, is found in the fabric, form and signs of wear and use. A blacksmith's leather apron can be analysed to provide information about the hide used to make the apron and the kind of beast the hide came from, and something of the types of work the blacksmith was engaged in from the metal splashes and burns. But there the information stops; the apron is not articulate about whether the blacksmith's business was a good one, how he got into it, what he specialized in, what he liked/disliked about the work, what he made, the trends in the business, the impact of local or national events on his work, who he worked with, whether his work was at an end, who makes his products now, what kind of life he led, whether his wife handled the paperwork for the business and what his connections to the town or village in which his business was situated might have been. He could have been anything from the village drunk to the local magistrate. The apron would not 'tell us' this, but memories and other forms of evidence just might. As has been pointed out above 'the problem with things is that they are dumb. They are not eloquent, as some thinkers in art museums claim. They are dumb. And if by some ventriloquism they seem to speak, they lie' (Crew and Sims, 1990: 159).

So if we acquire an apron or a gas-guzzling car for the collection what are we doing? In that object we are holding traces of lives, decisions and designs, but

only that – traces. All the other elements of evidence have to be recorded in some other way, often at the point of collection. This information has to be written down, taped, photographed, and is then held separately from the object in store. The peeling away of an object from its meanings takes place when it is removed from context and, in turn, when whatever associated information is removed from it. This is a way of working that is directed towards the integrated archive. Yet it is more the case that curators fit the objects they collect into their own established patterns of knowledge and sequences of things, in which case the information additional to an object becomes extraneous to it. For example, a sign from a chemist's shop may have been collected to fit into a sequence of advertising material or because it is especially colourful or has certain graphic qualities. These features may be sufficient in the decision to collect. Views on the product it advertised, the commercial moment that gave rise to it, its place within the store, how the staff and customers felt about the sign and advertising in this way may not be deemed at all relevant – *at that particular moment* – and are therefore ignored.

One of the ways in which the evidence value of objects in individual and social lives can be rethought is to make reference to the emergent body of research on material culture in historical terms (e.g. Fraser, 1981; McKendrick *et al.*, 1982; Forty, 1986; Schama, 1987, 1995; Brewer, 1997) or to material culture theory and studies of collecting (Pearce, 1989, 1992, 1994, 1997, 1998). This would provide both background and apparatus for analysis. To take just one theoretical approach as a case in point: Csikszentmihalyi (1993) discusses how in his view artefacts allow us to objectify the self and give our minds the opportunity for self-regulation. They are the external props to our consciousness. He contends that they operate in our lives in three ways. First, to demonstrate the 'owner's power, vital erotic energy and place in the social hierarchy' – everything from the kind of car you drive to the cut of your suit would qualify here. Second, 'objects reveal the continuity of the self through time, by providing foci of involvement in the present, mementoes and souvenirs of the past, and signposts to the future' – here we could include everything from baby's first tooth lovingly kept to a CD which contains a deeply meaningful track. Third, objects give concrete evidence of one's place in a social network as symbols (literally the joining together) of valued relationships – perhaps everything from a boy scout badge to a set of golf clubs and a Rotarian pen would apply here. Csikszentmihalyi argues that 'in these three ways objects stabilise our sense of who we are' (1993: 23).

The sense of who we are may be full of contradictions and ambiguities however, so much so that placing material in the categories provided here would be confusing. A trombone owned and loved by a successful businessman and treasured above all possessions as an element of the continuity of self, in the hands of someone else could be a symbol of erotic power (most great jazz musicians have this) or as evidence of social relationships (the man's trombone now in his children's possession). In these perspectives, the trombone is little more than a symbol and, once moved, its meaning has altered (it is polysemantic). But if we had only the trombone and no other information, we would not know where to begin other than to name it. Museums are full of objects stripped of these associations and it is anyone's guess what they really meant in people's lives.

Perhaps Csikszentmihalyi is right in that the precariousness of our consciousness is such we have to externalize and do this through objects, which in turn become the props of our existence. We cannot be just in our bodies alone, we have to express our internal and conscious selves through things. This is both the beauty and peril of life. Yet we do not just externalize through things alone but perhaps more powerfully through actions, expressions and movement. A gospel song sung with a whole heart, a quietly spoken poem, a loving caress, a story told at the fireside are similarly important expressions of our selves and our state of consciousness; but they are not necessarily concrete.

Csikszentmihalyi believes that a richer, more satisfying life might be achieved where materiality has less of a hold and where richer cultural expressions and formal rites prevail; he uses the life of a Brahmin as an example. Unfortunately, enhanced spirituality provides no defence against the desire for things as, for example, the history of the Franciscans amply demonstrates. Perhaps it is not so much the shedding of things and dependence on them that should detain us. It is after all much too late to 'dematerialize' ourselves, although films, books and dramas about Armageddon and a potential nuclear holocaust provide stirring images of what life devoid of even bare necessities might mean. Although one can imagine a world more thoughtfully ordered, for example, without nuclear waste, decomposing power stations, weapons of mass destruction and the like, we are nevertheless dealing in what we have created and chosen. Perhaps a more articulate and thoughtful dialogue about ourselves and an awareness of how in a variety of different circumstances we project this on to objects would be more useful. This means starting with people and how memories and associations are built.

When we remember, we do a lot more than recognize things. Memory helps us to identify a bus as a bus, a telephone as a telephone, a policeman as a policeman. But as we live our lives we accumulate associations. As Greenfield has pointed out, 'everything we see, hear, taste, touch and smell is laced with associations from previous experiences' (1995: 10). Encodement specificity, identified by Tulvig, ensures that on some level these associations are present in both the laying down and bringing to mind of memories. To babies, the world is full of abstract forms and sounds; as the child grows, meaning and associations are made and, layer upon layer, these continue to gather for the length of the life itself. Such associations add to our individuality and in their way determine the quality of our conscious experience, in effect the quality of our lives.

To a significant degree the personal associations we have can determine, for example, whether the internal combustion engine is a source of fascination or total boredom, the sound of church bells a cause of comfort or rage, and the smell of the sea a moment of unalloyed joy or total indifference. As we grow older the associations are richer, deeper, greater in number and are associated with everything within our life experiences, not just objects, and some experiences will trigger more associations than others. Of course objects will play a strong part. Indeed, studies reveal that elderly people in care, with few objects to cherish around them, tend to have lower mood and life satisfaction (Sherman, 1991). In late life it is unfortunately not uncommon for people to be surrounded by very few things that are really their own, as they wait for death in hospital or in institutional care. They lose what Csikszentmihalyi identified as

the 'symbolic ecology that represents both continuity and change in the life course' (Csikszentmihalyi, 1993: 25). Perhaps for some, their life's course has been one of loss and denial and they have few really treasured mementoes and therefore few objects to remind them. Even so, the absence of objects must not be taken for the absence of memory and the ability to bring the past to mind if stimulated.

If within social history practice in museums we think about memories and the associations that laid them down, it is possible that layers of meaning, beyond the mere trace of things, can be accessed and recorded. Julia Clark, in her desperate disappointment about the museums she saw in the United Kingdom, wrote about how an anvil or an egg beater look pretty much the same whether they are in Queenstown, Little Rock or Birmingham. 'And when we get right down to it, what are the kinds of responses which things like this can elicit? – "Oh, that's an eggbeater"; "it looks just like/different from mine"; "they ate eggs in 1920"' (Clark, 1993: 58). To think about things we have to think about people, and to think about people we have to listen, ask and learn. Egg beaters are no means of introduction to a life lived and, even if they are, they would most likely confound our expectations; egg beaters can also be children's paint sprayers, fly swatters, puppy slappers, as well as largely useless kitchen implements that took volumes of determination and energy to use.

The ways that memories are associated with objects can be a very individual business. A 1960s mini for one person may sum up automobile design at its most innovative; for another it may have a different symbolic position, for example, one associated with sexual freedom and the exhilaration of building a new and exciting life. Jette Sandahl has pointed out how the position of the memory and its associations in relation to an object trace economic, social and emotional patterns within people's lives. Sandahl cites a women remembering 'I was standing right by this stove when I told him I'd got myself pregnant' and from this suggests that 'the stove is a condensed symbol of her apprehensive and difficult relationship to this man'. By the same token, 'the quiet gentle acts of sewing name tags into children's clothes before they go to school or camp become metaphors for mother love, the reluctance of separation, mixed with the pride of seeing them grow' (Sandahl, 1995: 100).

Some of the associations with objects are not obvious to the detached third party and may even be about forgotten or repressed feelings. From her work at the Women's Museum, Aarhus, Denmark, Sandahl tells of one woman who

> did not remember giving birth to her daughter who was born during World War II, but related in great detail how – heavily pregnant and after hours standing in a queue outside the department store – she managed to acquire the most lovely yellow wool for the baby's jersey, and how the daughter throughout many years as a junkie has kept and cherished this particular baby garment.
>
> (Sandahl, 1995: 102)

Alexandra Robertson of Glasgow Museums Service worked with a group of women who had experienced domestic abuse. The work they did together will in time become part of the new displays at the Kelvingrove Museum. The women were brought objects from the collection that expressed something about how women have been silenced and controlled in the past – a scold's bridle, a

nineteenth-century maternity corset and anti-suffragette postcards. These were handled and discussed by the women who were then encouraged to identify contemporary objects of their own which summed up their experiences. One woman chose a bunch of house keys because her husband had hit her across the face with these. A five-pound note was chosen by another because 'he starved me' and gave her only a fiver a week for food. Car keys summed up another woman's experience of a bullying husband as it was her role to drive him to and from work, even though this necessitated her leaving her own work early; his anger was brought down on her if she was late. One woman said her husband only hit her when he had been drinking whisky, so she chose a whisky bottle. A television remote control was chosen by another woman as her husband would take this from their children as soon as he got home to indicate that he was back in control of their lives.

The objects in museum collections may have meanings laden with emotional situations, shame and difficulty, yet not be recognized as such. The unworn child's dress in a costume collection may have survived because the child died before it was worn and the dress kept for as long as the child's life had direct meaning. Industrial collections may have developed because businesses failed and lives were ruined. Horse-drawn agricultural collections became available because farming was mechanized and industrialized, the working horse slaughtered for the tractor. Sandahl recounts a wedding dress in the collection which 'was never worn because the groom took off' and the bride saved 'the dress and the dream through a lifetime of loneliness' (Sandahl, 1995: 102).

By the same token objects may be associated with a very strong sense of identity. Ploughs on display in the agricultural galleries of Ulster Folk and Transport Museum have no meaning whatsoever to city children from Belfast. But elderly men who spent their working lives on the land have been known to step over the barriers in the urgent need to touch and handle these things once again. As they do so, stories emerge of their pride in their work, the difficulties associated with it and reflections on the changes. The act is spontaneous: to touch and recall the feel of an object meaningfully associated with work and the self-esteem it brought. These feelings, responses and memories carry so much more than the physical 'thinginess' of it – the shape of the coulter and the place of manufacture. As important as such features are economically, they are only part of a much larger picture of life (Bell, 1991).

In recent years the most discussed and written-about history object within a museum collection has been the *Enola Gay*, the American Airforce bomber from which nuclear bombs were dropped on Hiroshima and Nagasaki in 1945 (see e.g. Noble, 1995; Wallace 1995, 1996; Harwit, 1996; MacDonald, 1998). The fuselage of the *Enola Gay* is now in the ownership of the National Museum of Air and Space in Washington. Its re-display, planned for 1995, precipitated a dispute unparalleled in museum affairs, which centred not so much around the object – the fuselage – as its associations with the near-total destruction of two Japanese towns in the closing stages of the war. The dispute over the exhibition was bitter, each party – from Republican senators to American Airforce veterans, from history curators concerned at the threat to their freedom of interpretation to liberal journalists – claimed an association and priority of view on the meaning to be attached to the event, the object and the outcome of the

episode. The dispute in itself is now evidence of late-twentieth-century ideas of nationalism, war, curatorship and the dynamics of power. The object, the fuselage, remains inanimate and mute, yet its meanings are battled out between the lives, feelings of self, and identities of a range of people who may not ever actually have seen or touched it.

Museums provide the last resting place for objects such as these: the egg beaters, kitchen stoves, baby jackets (name-tagged or not), keys, ploughs and pieces of wartime aircraft that a curator at one time or another allowed through the gates. Bereft of the associations described above, the best we can do is to name them, add generalized associations or surrogate meanings. But with deeper forms of enquiry, archives can be built which allow a much closer understanding of life experiences, both now and in the past.

13 *Collecting memories and objects*

It is not possible to say how many objects are held within history collections in the UK. The facts and figures are near impossible to pin down, the museums profession being bereft of this sort of statistic at a regional or national level. Individual museums may at least be able to arrive at some form of estimation, although exaggerated claims have been known, at least when it comes to backlogs in documentation (Kenyon, 1992). In February 1997, the Ulster Folk and Transport Museum had 353,420 still or moving images, including 331,000 still photographs. It had 90,300 items within material collections, along with large library, document and sound recording holdings. In comparison, True's Yard Museum in King's Lynn, a small and independent museum dedicated to the fishing community of the North End, had somewhere in the order of 6500 objects and photographs.

This exercise, as interesting as it is and as vital as it proves to be within collection management, helps not at all in weighing the evidence value of museum collections and collecting. Where a fire engine, a suffragette sash, a dressmaker's thimble from 1710 and a monkey wrench are taken as single items and therefore numerically equivalent, the limitations of a count have to be recognized. Similarly in judging the museum worth of these four objects, something has to be known about the social and economic history of an area. As interesting as they may sound, if material more appropriate and especially resonant of the area's past has not been gathered, the museum has not been fulfilling its function and is burying itself under a tonnage of random material. It is also building false images. It is easy to argue all four items as being evidence of social history; anything associated with human experience such as fires, political rights, making clothes and fixing things can be fair game. But by concentrating on these, the museum may be creating configurations of the past not borne out by local memory or other forms of primary sources.

The most active period for collecting for many social history museums was through the 1960s and 1970s and to some extent the early years of the 1980s. These were hugely fruitful times and it is the bulk of this material which now fills museum stores. The last vestiges of agricultural systems based on horsepower and non-factory animal husbandry, the seemingly redundant country crafts (some now well revived), heavy industries in severe decline and endless urban renewal projects were yielding unparalleled collecting opportunities, and curators got to work fast, often either one foot behind and sometimes

one foot in front of the scrap merchants. There have been many occasions when there was limited time to assess whether something was right or wrong, central to the historic record or peripheral, as haste was of the essence. Curators had to react quickly or lose potentially important objects. This kind of situation still happens and underlines that there has to be pragmatic and reactive elements within history curatorship. This is not to excuse lack of planning or preparation, but there have been and always will be times when instant decisions have to be made and the consequences dealt with later.

Material collected during the 1960s and 1970s would now be extremely difficult to replace. Where once a horse-drawn harrow, a loom or a stationary steam-engine seemed a matter of picking and choosing, in the 1990s these things can be scarce, with a financial value placed on them where once there was next to none. With the changing dynamics of value, even a small thing like a mallet from a plumber's tool kit or a blade for chopping herbs can have a market value which in the 1960s would have seemed implausible. Not only did museums benefit from being able to gather material, often in extensive 'sets', such as whole chemists' shops and blacksmiths' forges, but the goodwill of these new museums and local identification with their mission led many people to donate objects to the museum collections.

Yorkshire and Humberside Museums Council undertook a study of the industrial and social history collections in their area in 1992. This was conducted by Janet Kenyon and is the only in-depth study of patterns of collecting and collections available at the time of writing. It is very useful however, and the comments made in it may well be true for the whole country. The effects of the ripe years of collecting material were evident enough: half the museum stores surveyed were full, a quarter were 90 per cent full and the rest 70 per cent full. How museums were to continue with the responsibility to maintain a record through objects with these limitations of space is by no means clear.

In the context of this chapter, it is interesting to note what the survey said about the documentation behind the objects collected, those which now fill the stores. What about information regarding the meaning ascribed to the object by those who knew it or perhaps used it? Kenyon concluded:

> large numbers of objects in industrial and social history collections lack any supporting information. Where information does exist it is often very limited, for example, to the name and date of donor and date of donation. As a result much of the historical significance of objects in collections has been lost. Some of the information may be there but requires linking to the objects.
>
> (Kenyon, 1992: 37)

This would seem to be a very bleak situation. It is one which might be rectified, for example, by the use of oral history. But here too the news was not good. The survey revealed there was little oral history work done in Yorkshire. The surveyors were unable to include it in their analysis, even as a segment of collections. Only three of the twenty-one museums surveyed in detail had oral history collections of any size. In each case this accounted for less than 0.5 per cent of their overall collections. On this evidence alone, the progress to an integrated archive of meshing forms of evidence is a long way away.

The survey to some extent considered what was included and excluded in the

collections. It was able to pinpoint significant gaps, for example, material from faiths other than Christian. The plurality of faiths to be found in Yorkshire, especially within the cities, was substantially ignored. These kinds of omissions raise important questions about how curators are thinking about people both in the past and the present and the extent to which they have a grasp on the social and economic histories of their areas. When analysis of collections is conducted with the subject very much in mind, the configurations of inclusions and exclusions and the forms of collecting process are very much exposed. This was certainly so with the study of mining collections in Wales undertaken by the Museums Council in Wales (Davies and Davies, 1996).

The South Wales coal industry has a long history. At its peak (1919 to 1921) it employed over a quarter of a million men – not counting industries linked to it such as the railways. There had been substantial growth in the industry between 1880 and 1913, with production increasing by 120 per cent to about fifty million tons a year. Very little of the built landscape of the South Wales valleys and the lives lived there makes any sense without knowledge of the industry. The social history of much of the eastern and middle part of South Wales is in one way or another the history of coal production, its rise and decline. The coalfields in the North had different characteristics and played a more integrated role in the economy, but were important nevertheless.

Six museums in Wales have major collections relating to the industry, with twenty-one museums also having coal-related material. At least twelve non-museum institutions held relevant collections. Taking the collections as a whole, as if they were in sum a national collection of mining, there are obvious strengths. The collection holdings were strong on mine buildings, equipment associated with production and development, transport of both coal and men, air monitoring equipment, mines rescue equipment (excluding fire-fighting), and protective clothing. The survey identified weaknesses in areas such as material covering management, the administration of the mines and the mine owners, industrial relations and welfare. Collections of film and oral history appear to be very limited. It might be inferred from this that collections which have been made available at their point of redundancy, such as buildings, rescue service equipment and cutting gear exist in good measure. Material which is about experience, and which would require proactive fieldwork to secure, is more likely to be absent.

Interestingly, none of the mining museums surveyed extended their collections or remit to the communities that existed alongside the mines, in symbiotic relationship to them. Big Pit looks out over Blaenafon, the small town typical of so many mining communities. Without it Big Pit could not have existed and Blaenafon is in severe decline now that Big Pit and other mines in the area are no longer working. The museum hardly mentions it. The people and the place are not part of the technology which the museum seeks to celebrate. This is not untypical. The coal collections in Wales focus on the technical process of coal extraction, with little emphasis on memories of it and what this might have meant culturally, politically or economically. Former miners employed as guides may well fill this gap for now, in that they can draw on their experiences to explain to visitors what they are seeing. But even these memories are not seen as part of the collection, but part of interpretation. When the miners retire from

these roles, with no people who have firsthand experience to replace them, this information could well be lost.

As museums find themselves with stores that are nearly full of collections often lacking in documentation, the prospect for museum work that lifts meanings, makes connections and facilitates new forms of understanding would appear to be somewhat depressing. This may not need to be the case, as there are many ways of working that can expand on what is being kept and can promote the addition of material that is not only hugely evidence-rich but economical to maintain.

One option is to re-research the material, to go back to its original contexts, talk with people, look at objects, think out the meanings. A well-documented example of this process centres on a Maryland tenant farmhouse rescued by the Smithsonian Institution in Washington at the point where the land upon which the house stood was being redeveloped. The Institution engaged in a rescue mission to acquire the abandoned house before the bulldozers got to it. It was dismantled and moved to the Institution where it was reconstructed in the Hall of Everyday Life in the American Past. Nearly ten years later the Institution hired George McDaniel to research the house and to undertake the fieldwork which it had not been able to do ten years before. The Institution had little if any documentation to go on and no names of the people who had lived there. Some of the more obvious research routes seemed at that stage to be closed. Through the use of documents, but particularly through talking to people, McDaniel painstakingly found the way back to the history of the house and the people who knew it and those who had lived there. He made contact with Edward Harley, who had lived in it for a time, and George Johnson, who had been born there. The kinship networks from these contacts led to yet more interviews and access to photographs. McDaniel was able to widen his research by looking at the style of construction and by asking people who knew it what they had heard about it being built. Taken together this evidence pointed to a date in approximately the 1880s. What did the residents recall about the house? McDaniel summarized it thus:

> Former residents recall that they cooked food, ate meals, washed dishes, bathed, sewed, took medicine, played music, churned butter, swept floors, rested and relaxed, washed clothes and slept. Babies were conceived and families heard the first cries of the new-born.
>
> (McDaniel, 1982: 15)

The research also revealed information about family size and parenting, length of tenancy, kinship relationships within the area, and how families managed within such a small living space. None of this information had been gathered when the Smithsonian Institution dismantled the house nor, when the house was secure in the galleries, had the Institution even noticed that it was displayed back to front. It took someone who really knew the house to point this out. From this experience McDaniel makes a strong argument that the study of objects should lead back to the people who used them and, through doing this, we are drawn to an appreciation of ourselves and of those whom we have forgotten. He wrote: 'the black families studied here did not live in "shacks". They are not stereotypes, mere cyphers' (McDaniel, 1982: 16).

But what can you do when the object you have is from a period outside of

firsthand experience? What if there is no one you can ask about it directly? The obvious range of evidence has an enhanced role to play here, especially documentary sources (such as maps and inventories, diaries and account books), images (paintings, prints and drawings), landscape features (including information about transport systems, raw materials, place names, etc.), dialect, stories, song lyrics – the list goes on, and is well covered in standard literature on social history research. This may well supply a useful context, but there will always be some form of limitations. Sometimes the replication of an object and, through this, learning about how it was made, the skill it took, using it in some way or talking to people who use an equivalent skill will begin to provide deeper insights.

Jonathan Bell of the Ulster Folk and Transport Museum has talked about the importance of experimentation in museum work and how this can reveal not just something about past technologies but also about social structures (Bell and Watson, 1986; Bell, 1994, 1996). This is a very appropriate part of the work of open air museums and farm museums. At the Ulster Folk and Transport Museum the agricultural curators have reconstructed an eighteenth-century plough from documentary sources. This was put to use at the museum's annual ploughing match, from which the curators were able to learn not just about the plough but about ploughing with it. This experience seemed to confirm contemporary accounts about the way the plough turned furrows and that the plough needed three people to operate it. It points to the degree of social cooperation needed on the land and the ingenuity and adaptability it took to overcome significant constraints present within farming systems. In the face of this, assumptions about the conservatism of the peasantry are hard to sustain and need to be re-evaluated (Bell, 1996: 37).

Edinburgh City Museum has developed ways of working cooperatively with people in the mutually beneficial process of remembering things about the past. This was especially effective in the development of the re-display of *The People's Story*, which hinged on individual memories of growing up or working in Edinburgh. The intent was to return history to those who had created it (Clark and Marwick, 1992: 54). Older adults working with the museum were able to correct the curators when any assumptions were made that were not borne out by their experience. For example, when the museum wanted to put a 1938 Electrolux vacuum cleaner into a reconstructed 1930s sitting room the members of the group were quick to ask, 'Why would you have a vacuum cleaner if you had no carpets?' (Clark 1988: 20). This work continues through a variety of reminiscence-based projects; in turn it has given useful insights into unexpected problems; for example, the temporary exhibition 'Headlines' on hair care in Edinburgh over the past 200 years employed considerable research and much oral history. A hair dryer from the 1920s was put on display as part of it. A mystery of why there was a lever on the side of the machine was solved by a former hairdresser in his nineties – it was for pulling it around the salon. From this point and others (for example, how toasters used to give electric shocks) comes discussion about work, relationships and social change (Marwick, 1995).

Sometimes established collections are not appropriate and new ones have to be formed. It can be a moment of innovation and real opportunity. Croydon Museum Services had to work from an established collection that was ill-fitted

for their purpose, which was to create a new museum reflecting the history of this very large borough south of London. To produce the kind of exhibitions that local people wanted, as expressed through a consultative process, new collections had to be built. These had to be based on real people's lives, not generalizations; which expressed the place through the people who had lived there and live there now; which challenged stereotypes and respected individuality; which were alert to life experiences and not just its detritus; and which recognized the passage of time and the cultural shifts resulting from local, national and international events (MacDonald, 1992, 1995).

Collecting for the new exhibition, called 'Lifetimes', evolved from a period of experimentation, in particular a series of road shows and a temporary exhibition through which people learned much about the power of memory and how life stories can reach across time and cultural differences. For example, in a temporary exhibition revolving around life stories, it was conspicuous that people visiting the exhibition took time to read the text, a phenomenon not often found in museums. People talked to each other, to strangers and to the exhibition team, and it was often more the similarities than the differences that they commented on. Angela Fussell describes one encounter:

> one woman told me how moved she was by the story of Gee Bernard bringing up her children in one room in the 1960s and that she had undergone a similar ordeal herself. She did not remark on the fact that she was white and Gee was black. Gee herself was particularly fond of the 1930s display because she could remember washing in a tin bath as a child in Jamaica and the sewing machine was just like her granny's.
>
> (Fussell, 1997: 46)

The museum was now set on a path of collecting and recording using life stories. The exhibition was planned with twenty-five themes, each represented by two or three objects in six displays covering a chronological period from 1830 to the present (see also Chapter 18). By recording life stories, the museum was able to work with people who would not otherwise have been donors to the museum and who might not have identified with the more traditional notion of a museum. Moreover, the museum intended only to have material on loan, not to acquire it permanently, thereby giving the owners the confidence that their treasured possessions would be returned.

The museum aimed to record life stories from a range of people who reflected the demography of Croydon. Minority group recording was essential, with black, Asian, Irish and gay researchers brought in to work with people from minority backgrounds. The material gleaned from these groups was fully integrated into the exhibitions, as it spoke of all the topics the museum aimed to cover. Later, separate leaflets were published which facilitated the lifting of minority group memories from the exhibition as a whole.

By working with life stories, the museum was able to pinpoint material resonant of the themes within which they were working. It demonstrated how material is embedded with meanings far beyond and often in contradiction with the technology of the object itself. It revealed this through a number of lateral shifts in meaning within the life-story process.

Enid Sturgeon was able to produce a photograph of her wedding to Arthur in Hackbridge in 1948. However,

Enid had nothing left of her wedding outfit, but remembering the day made her think of her wedding presents: 'that damask tablecloth was a wedding present. That was given to us by my husband's uncle. At that time everything was rationed and if you were given a tablecloth you thought – gosh, this is something special – because people couldn't afford the coupons. And we got a blanket, an electric iron, a clock, two or three toast racks, salt-cellars. What else did we get? Can't remember. Oh, Pyrex dishes, a canteen of cutlery. Can't remember anything else, I'm sorry. Yes, yes I can. We had a set of lovely glass dishes and a tea-set. . . .

At one point the museum sought a holiday souvenir to represent a carefree time indulging in the new-found pleasure of package holidays. Frances Stewart came forward with something suitable:

My daughter bought this [souvenir] when we were on holiday in Ibiza, must have been about 1969. It was a really dreadful holiday because my husband had had an affair and couldn't get over it and immediately took up with somebody else while we were there, to the embarrassment of myself and everyone else in the hotel, because he never hid things. Snogging with her in the disco and I was having to sit there and grin and bear it and everyone was saying 'Oh, you poor thing'. It was only a holiday romance, but I had to suffer it. It was a disaster.

Because of this memory, the souvenir became classified under relationships rather than holidays.

A parasol so redolent of Edwardian summers actually spoke more about parental relationships, an obsessed and over-strict mother and a much-loved father.

Plate 13 A souvenir brought back from a package holiday in 1969, a reminder not so much of the new-found luxury of a fortnight in the sun as of marital infidelity. Courtesy of Croydon Museum and Heritage Service.

Plate 14 The Farr sisters at the seaside in 1910. Dorothy Farr, the youngest sister, is in the pushchair. Courtesy of Croydon Museum and Heritage Service.

> Dorothy, the youngest of the sisters recalled 'Mother never sat out in the garden. Or on holiday. She liked us to be little bits of her really. You always had to do exactly as she said, you were never allowed to use your brains at all, not for anything. Another thing which used to annoy me, and it was really very unkind, when we went down to the seaside, and you got into the water as far as your knees, mother said "come along, child" and she would take our heads, and my elder sister was told to take the feet, and they dunked you, you see. It was a quick way, but really it was a horrible thing. Father would always put himself out on holiday. We'd go for long walks together and fly kites. I used to love flying kites. We used to play cricket and look for shells. He was very nice when we were on holiday.'

With this memory, the item could no longer be seen as an 'accessory'.

Interviews with gay men produced very different life stories, often uniting on one thing – the importance of the Wolfenden Report of 1957 which made the case for the legalization of consenting same-sex relationships. The museum went out and bought one. John had this to say:

> When the Wolfenden report came out I thought things are going to change now, but they didn't. It almost gave me a nervous breakdown, the disappointment and misery that caused. It was that which caused me to have psychiatric treatment at Maudsley Hospital. They were very sympathetic there. I believe they would have liked to recommend me to some gay group, but they couldn't because of the law. When they

finally did change the law in 1967, things were much easier because gay clubs and things began to open, but by then I was 57. I always remember going to this gay group for the first time. I was a bit nervous. I thought they might be a queer-looking lot of people, but they were ordinary people like myself. They had coffee evenings once a fortnight. It made a tremendous difference.

This movement from object-centred history museum practice to one working more flexibly with meanings and memories is coming more and more into museum thinking as expressed not just in curatorial practice, but in the name and central strategy of the museum as a whole. Significant too is the way in which the Museum of London expresses its mission in its five-year strategic plan 1998 to 2003:

> The Museum's mission is 'to inspire a passion for London', which it aims to do by communicating London's history, archaeology and contemporary culture to the wider world and by reaching all London's communities – through being London's memory: collecting, exhibiting, investigating and making accessible London's culture.
>
> (Museum of London, 1998)

This is clearly the direction in which museum work in general is beginning to move.

14 *Reminiscence and the older adult*

Article 23 of the UNESCO Declaration of Human rights states that 'everyone has the right freely to participate in the cultural life of the community'. The Museums Association in 'the museums charter' have supported the spirit of this through their statement that 'Museum collections are a fundamental national resource to which everyone has a right of access' (Kavanagh, 1994b: 17). At a local level, most history museums would accept the idea that they are there to serve the needs of all people within their area and many strive to do so. This has meant identifying who visits the museum, what they like and dislike about it, what they get from visiting and what they would like to see develop there in the future. It has also meant identifying those people who do not visit the museum, or who visit very rarely. In most museums, one of the biggest groups of non-users is older adults, the memory bearers.

A survey undertaken by the British Market Research Bureau in 1997 to 1998, using groupings by age, indicates that people over the age of 65 are the least likely to visit museums (Middleton, 1998). The trend is more than a general one: a survey of leisure activities of women over age 60 revealed that only 2 per cent of those surveyed had visited a museum in the previous month. The older adult has significant leisure time, calculated at ninety-one hours per week for men and seventy-two hours for women (Midwinter, n.d.), so having time to visit is not an issue. Instead there may be a host of other reasons. Some may be physical: museums are often difficult places to get to, can have too many steps and too few seats. Some do not even have public toilets, let alone catering and other facilities. There can be barriers based on experience; if little pleasure has been gained from visiting museums in the past, then they will not be associated with feeling good or personal enjoyment. In addition, museum visits can be expensive involving both travel costs and admission charges, daunting prospects for people on reduced incomes and a considerable disincentive for repeat visits. Furthermore, museums may simply not be interesting enough or offer sufficient rewards, intellectual and personal, to encourage older people to visit. Many history museums have recognized this and are finding ways to reach older adults who would not otherwise use their facilities and collections. Initiatives have included collaborative projects, guiding, voluntary assistance, and inter-generational education work.

A good part of museum commitment to serve the needs of older adults takes place within the field of reminiscence, which is being seen as part of the outreach

agenda. An increasing number of museums are providing support for agencies conducting reminiscence, often in situations of care such as residential homes, day centres or hospitals, through the provision and loan of reminiscence boxes. These are transportable boxes containing perhaps as many as twelve objects, selected around a theme such as health or holiday, which fall approximately within the same time period of use, for example, the 1930s. Age Exchange's range of reminiscence boxes now has in excess of twenty themes, giving carers choice and the opportunity to select those boxes likely to come closest to the experience of the older adults with whom they work. The 'Born in the Caribbean' box contains sugar cane, bay rum, country chocolate, dominoes, carbolic soap, herbs and spices, sarsaparilla, paraffin candles, traditional songs and a map of the Caribbean islands. The 'Proverbs, beliefs and superstitions' box contains a piece of coal, horseshoe, four-leaf clover, copper bracelet, wishbone, rabbit's foot and a corn dolly. The Irish box contains turf, curios belt, billycan, carrageen and dillisk seaweed, passport, Catechism and Irish music (Osborn, 1993). The boxes are regularly on loan to people in the London area.

Some museum professionals are conducting reminiscence work directly themselves, either in the museum or on an individual or group basis elsewhere. This gives them a better idea of how reminiscence boxes can be constructed. The balance of support and involvement is important, as it helps museum people appreciate what is entailed with reminiscence and therefore what is needed.

There is a sequence of potential benefits to be derived from reminiscence that have a correlation. Older adults benefit through access to collections, often familiar but rarely seen things remembered from the earlier stages in their lives. The museum benefits in that it demonstrates a commitment to an important yet easily neglected sector of society. The museum worker benefits from contact with older people and from the understanding of the past that they can gain from such encounters. Reminiscence work needs to be experienced; only then can people begin to understand how humbling, stimulating, hilarious and heart-breaking it can be. It is not easy work to do.

Distinctions have to be drawn and it is worth reminding ourselves what these are (see also Chapter 1). Working with reminiscence is not the same as working with oral history and the two should never be confused. Reminiscence is concerned with the stimulation of a person's memory and the use of this in positive and constructive ways that help build self-esteem and bolster a sense of identity. It is essentially about the process of remembering based on the premise that each individual is unique and has a special life story. Thus reminiscence is about enabling people to remember in ways that are supportive and personally satisfying and therefore is concerned with the personal, private and often confidential. In contrast, oral history is about recording memories to enable the processes of research and interpretation. Oral history is about sharing knowledge through scholarship. At its most simplistic, reminiscence is about giving and oral history about taking, and yet there is much giving and taking in both. From supporting reminiscence, the museum may gain much to aid other projects and could find people who might be formally interviewed for oral history; but this should not be the primary objective.

In developing reminiscence work it is vital that there is an awareness of ageing and the lives of older people. Generalizations about older adults and their needs

are not necessarily helpful. People in their seventies and eighties climb mountains, swim in the sea daily, run the London marathon, write best-selling novels, spearhead political campaigns, run successful businesses and even go into space. They have the wisdom of their years, the drive and the imagination to make what they can of life and do not give up easily. The statistics can let us down badly. The 'over-65s' so often quoted, for example, in the survey employed by Middleton (1998), can be in effect a group whose ages cover a thirty-year period or more (people in their sixties, seventies, eighties, or nineties plus). Indeed the great divide of 65 years, traditionally taken to be the retirement age, is of limited use to us. First, it is the retirement age of men not women. Second, patterns of redundancy and retirement have altered so much that 60 years (and falling) may be nearer the mark.

In 1995 Britain's population was in the order of 58.6 million, of whom 6.9 million were over the pensionable age, that is 18.2 per cent. In the 65 to 74 age group, 17 per cent of men and 36 per cent of women live alone. For those aged 75 and over, 33 per cent of men and 62 per cent of women live alone. It is anticipated that there will be a rapid rise in the number of people in retirement in the twenty-first century, with estimates that the number of people aged over 75 will have doubled by the middle of the century, while the number aged 90 and over will have tripled. This is accounted for not just by the postwar baby boom generation reaching retirement years and beyond, but by such factors as better healthcare and a decrease in the birth rate (information from Age Concern). This has been seen as a demographic time bomb, with huge implications for the economy as the active population declines in relation to those in retirement.

There are implications too for the level of spending needed on health and residential care (Rasmussen, 1997). Such anxieties rest on a fairly negative view of ageing and are bereft of an assessment of many of the positive contributions that a change in demography may bring, such as the opportunity to utilize talents and experience. New patterns of working, leisure and caring may well emerge or have to be designed to accommodate an ageing population and these could bring benefits across the age range. Even so, it is true to say that society will have continuous responsibilities towards the well-being of older adults, through their physical, emotional and intellectual needs. Museums will probably have the opportunity to develop levels of service for older adults on a par with current levels of service for schools. This will need to have a very wide remit, everything from opportunities for lifelong learning through to reminiscence.

The focus in this chapter is on the less active older adult who is likely to be in residential care, hospital or in the care of the family but with access to day centres. Before moving on to look at some of the work that museums are doing, it is important to remind ourselves of the role reminiscence plays and how this has developed. As outlined in Chapter 5, it is accepted that reminiscence in late life is natural and something that some, although not all people may choose to engage in. It can be pleasurable and meaningful in its own right, but it may also help in coming to terms with change and with making necessary adjustments, such as the loss of independence or the death of a lifelong friend. The terms 'life review' and 'reminiscence' are used in ways which sometimes overlap, but it is useful to keep some distinctions in mind.

Clinical practitioners can use the process of life review as a means of helping

older adults, especially where they are trying to deal with difficult memories or where they are experiencing the onset of dementia. Reviewing a life, all the phases, achievements and difficulties faced, can help the person to re-connect with themselves. It can help carers to see the whole person, someone with a complex and long history, and it can help the family come to terms with the close of a loved one's life. Life story-books, described in Chapter 4 as a means of helping children 'remember' who they are, are now being used with older adults. They bring together the images and details of the life, photographs, mementoes, family trees and anecdotes, and through these confirm a profound sense of self (Haight *et al.*, 1995; Haight and Webster, 1995b; Haight, 1997).

In contrast, reminiscence is a much more spontaneous activity, and can be stimulated within group settings or on a one-to-one basis, not necessarily with clinical intent. Research into the benefits and processes of formal reminiscence have been developing for some time (Bornat, 1994; Haight and Hendrix, 1995). Reminiscence is to be found in some approaches to nursing practice and in occupational therapy, and can take many forms. For example, it may be part of gentle conversations purposefully initiated by a carer when someone is being bathed or dressed. On the other hand, it can be stimulated through organized group sessions run by a skilled facilitator and it is this to which museums are contributing. But this work does not stand alone. Drama, music, art and writing are also being used to help people remember and talk about their past in ways that are creative and satisfying (see, e.g., Warren, 1984; Bornat, 1997). Specialist workers in each of these areas bring their skills to older adults, often those in institutionalized situations, providing a means of expression that is both creative and at times cathartic. Sometimes an experience or feeling can be more accurately expressed through music or movement than it can through words. This is especially so where verbal communication is impaired or the memory is too difficult to articulate.

In Britain, an impetus to the formal use of reminiscence in situations of care was given by the Reminiscence Aids Project. This ran between 1978 and 1979, was funded by the government and led by an architect, Mick Kemp. The project sought ways to design more stimulating environments for residential homes and it involved some experiments with sounds and images. The long-term objective of the project was to provide for people in residential homes a framework which would allow and promote caring interactions, the restoration of a sense of personal value and the regaining of a fuller perspective on their lives, the better to relate to the present (Bornat, 1997: 36). At its conclusion, the project was passed to the charity Help the Aged, which was able to take the images and sounds collected and turn them into six sequences of slides and tapes published in 1981 as *Recall*. The response from care workers was tremendous, as they now had the materials on which to base reminiscence work.

Other organizations followed, of which the most influential has been Age Exchange in London. It was founded in 1983 following a series of reminiscence projects, and developed into a unique organization, now recognized as a centre of excellence for reminiscence and the arts. Through its direct involvement of older adults in all that it did and through the use of interviews, theatre, publications, handling boxes and exhibitions, it demonstrated the potential of reminiscence in both valuing the lives of older adults and building bridges between generations

and cultures. Age Exchange has played a leading role in promoting training in reminiscence and has created a European-wide network of agencies involved with research into reminiscence or its provision.

Reminiscence work centres on what Tom Kitwood has described as 'personhood', seeing not just the elderly frail person, but something of the whole life that shaped them (Kitwood and Benson, 1992; Kitwood, 1997). He gives an example of this drawn from his own work. A woman in a nursing home is slumped in a chair having received her morning dose of sedative medication. The manager of the home refers to her as being 'very aggressive'. But if the bare facts of her life were known, would her aggression have been easier to understand and attempts made to meet her needs? She had a long career as a teacher and had become deputy head of a junior school. Her husband had been an engineer, but sadly their marriage had been a formality, a soulless affair, and he often went away. Their son after a promising beginning had become involved in drugs and his marriage had failed. Her daughter had distanced herself from the family, leaving her very much on her own. Her life had been marked by disappointments, played out now as she found herself lost and lonely in a residential home. An institution equipped to talk to her about her past and alert to the clues might well have worked this out and been in a position to help her.

There are many excellent examples of reminiscence work, life review, and art therapy in its many forms that are enabling, inspiring and a comfort to older adults. Museums are making their own contribution to this, as will be outlined, below. But it is important to be aware of how patchy the distribution and availability of reminiscence work actually is. Moreover, it exists in a very broad field of care provision, from rehabilitation wards in hospitals to residential homes, which has its own variabilities. Kitwood refers to the huge advances made in recent years, especially in relation to dementia care and how there is a leading edge, but that the greater mass still lags far behind. He writes: 'lip service is paid to the designing of care in a way that respects the uniqueness of persons; but if we look at the reality rather than the propaganda, far less has changed than we might have hoped' (1997: 96). As dismal as this sounds, there is at least no lack of models of good practice and the way ahead is well signposted.

Museums have become involved with reminiscence work to the extent that a formal network has been established by Lucy Shaw and Steph Mastoris in order to maintain contacts and support good practice. In 1995 a survey of member museums was undertaken to assess the amount of activity currently taking place. Those museums engaged in reminiscence work were substantially within the local authority sector and therefore by definition committed to meet the needs of all council taxpayers. Much of the work took place outside the museum (thirty out of forty-three replies) rather than inside (eighteen). In over one-third of those museums replying to the survey, the museum acts as a provider of resources and does not contribute directly to reminiscence sessions. A good number of the museums in the survey saw involvement in reminiscence as a route to building up oral history collections and were conscious that it might lead to acquisitions or further information about objects (Mastoris and Shaw, 1996).

Plate 15 Reminiscence session in Nottingham, led by Deepak Rewal, Museum Outreach Officer. Courtesy of Nottingham Castle Museum and Art Galleries. © Mandy Clark.

This is a small sample survey, but sufficient to show that there are museums engaged in a number of activities involving reminiscence, including inter-generational education work. It is important not to overestimate or exaggerate this. There are over two thousand museums in the UK and the survey was dealing with only forty-three replies. It was to be expected that national museums would not be represented in the replies as their interests tend to lie outside modern social history, although there are obvious exceptions. Other than independent community museums, like True's Yard in King's Lynn, independent museums in general are unlikely to engage in a time-consuming activity which may not meet its own costs. As a result, most of this work takes place in the local authority sector, in which a number of projects of extraordinary quality are to be found, such as the work done by Edinburgh City Museums (e.g. Clark, 1988; Clark and Marwick, 1992; Marwick, 1995) and the Open Museum in Glasgow (Edwards, 1996). These demonstrate that there is a valid role for museums in providing outreach services to older adults, especially those which involve reminiscence. The work in Glasgow and Edinburgh may well form the models for future projects, as more museums come to realize they have some responsibility to meet the needs of older adults in their area.

Group work centred on reminiscence can take many forms. For the more active it can be organized around visits, tea dances, talks, films and musical events. For less mobile people in residential homes or hospitals, reminiscence is undertaken either as a small group activity or on a one-to-one basis and there is now a good body of literature offering practical advice about the different ways

such sessions can be organized (e.g., Kaminsky, 1984; Osborn, 1993; Schweitzer, 1993; Gibson, 1994). Faith Gibson has identified one of the more appropriate models as being founded on the idea of 'mutual aid' or of being a 'reciprocal' group, where members join in shared discussion as equals on freely agreed topics. The emphasis is on achieving mutual communication (Gibson, 1994: 28).

As Bernard Arigho has outlined for Age Exchange, work of this nature needs to be organized around agreed objectives, with a skilful facilitator leading a structured session. The group needs to be reasonably small, especially if members have disabilities, for example, hearing impairment. There needs to be a definite programme which everyone understands, such as a regular sequence of hourly sessions for a set number of weeks. The group must have somewhere suitable to meet and within that meeting members should have a level of understanding about what they will experience. Arigho has also outlined the principles of good practice as being: respect for personal choice; respect for confidentiality; democracy within the group (a fair hearing for all); mutuality (people listening to each other); warmth; genuine interest; a systematic approach; enjoyment; a range of creative and social activities; and multi-disciplinary teamwork.

The skills needed to facilitate this sort of work include: the ability to listen actively to what is being said and to the bass note: to empathize and be attentive to people without losing a sense of perspective; to be sensitive and alert to both people and what they are saying and to group interaction; to respect people, even though you may not agree with them; to take control and relinquish it, as needed by the group; not to be frightened by people's emotions nor how these are expressed; and to be prepared and open to learning from your own experiences.

The activities undertaken can be based around keywords (such as pets or religion). They can be drawn from different forms of play, for example, using an empty plate to describe a remembered meal from the past and all the associated memories that go with this, or an empty bag into which is put a memory of a favourite treat from the past. Music may be used to stimulate memories of different periods within people's lives and what was taking place at that time. People might be asked to draw or map out, perhaps with the aid of a carer, somewhere special to them, such as the house they grew up in or a place where they were especially happy. Playground games, rhymes and sayings, stories and songs are also a good basis for reminiscence as well as creative opportunities. These and other ideas form the basis of reminiscence training at Age Exchange and are enlarged on in their publications (e.g. Schweitzer, 1993).

Material which triggers memories can be especially helpful in the reminiscence sessions (Gibson, 1994). Visual triggers such as photographs, videos of newsreel footage, newspapers and advertising are found to be very useful. These might include images of big events such as a royal wedding or local scenes of ordinary people doing ordinary things. Auditory triggers need not be just music, but voices from radio and television, or once everyday sounds such as a steam-engine leaving a station. Tastes and smells can be especially evocative, especially those that bring back memories of food. Finally, tactile triggers – objects – can provide much pleasure and instant recall. Gibson has commented that 'just holding something and then passing it on to the next person connects

people together and stimulates collective memories. Objects encourage demonstration of how they were used. They invite activity, shared opinion and animated conversation' (Gibson, 1994: 58).

Anecdotal evidence that handling objects can release memories is readily available. Alison McMoreland, director of Living Arts in Glasgow, brought this incident to the attention of a conference on reminiscence and dementia care in 1997. She had been working with one particular group for three weeks and, knowing that some of the women could have worked in a local jute mill, she obtained a mill bobbin. This was passed round in a 'feely' bag. One of the women, Annie, knew exactly what it was. Up to this point she had been content to be a passive member of the group and had not contributed to the talking, although she had joined in with the songs. Then,

> holding the bobbin, she told us what it was and that she used to work with these in the mill. I pulled the jute thread and broke it, asking Annie 'What happened when the thread broke?' (which in fact was a frequent occurrence). Annie proceeded wordlessly to tie the threads together in a complex knot. Her fingers worked surely and knowingly. All the attention was on Annie and I asked her if she would show us again, but slowly as it was a knot we didn't know. She said 'No you wouldn't, it's a weavers' knot' and then she leaned over and asked a group member what mill they had worked in. This atypical communication continued and in the process Annie's physical stature seemed to grow. She became a bigger person. Her fingers had remembered the weavers' knot, when all other times she had lost the words. In that session we later remembered and pieced together a song known to the weavers in Dundee.... The care staff later expressed their amazement and delight at this development. They stated that they were learning about and seeing a different Annie to the one they knew. This reawakening was sustained the next week with the same stimulus. Annie died the following week.
>
> (McMoreland, 1997: 112)

Mike Bender, Principal Clinical Psychologist at the Nuffield Clinic, elected to run one of his reminiscence groups at the William Cookworthy Museum in Kingsbridge, Devon. There were some difficulties in this, especially in relation to access, and the group had to comprise people who were sufficiently mobile to enjoy an outing. Bender comments on how responsive group members were to the objects. Two women who had been in service enjoyed handling domestic equipment on display in the old kitchen. One of the sessions was spent among agricultural equipment. Within minutes one of the group, formerly a farm worker, left the rest and started to wander among the machinery, stroking it. He had serious difficulties speaking and had not related well during the earlier sessions, but with encouragement and interest he 'became more fluent and assertive' (Bender, 1992: 12). Bender begins to raise some interesting questions about the use of objects in reminiscence. In his view, access to the material kept the members of the group on safe topics, avoiding self-exploration. But to some extent this is highly dependent on how the group was led and how the trigger material was introduced and used within the sessions. Handling objects for educational stimulus requires an approach with that end in view, whereas a totally different approach is needed if the intent is life review or reminiscence. Assuming a group member is willing to talk about their past, arguably it is not so much the presence of objects but the approach taken to talking about them that

triggers a constructive process of life review, as opposed to self-directed reminiscence which is what was happening here. The gentleman stroking the farm machinery was engaged in his own agenda of reminiscence.

Museums have a number of contributions to make to reminiscence work which uses tactile and visual stimulation. These include the provision of reminiscence boxes for loan and training in the histories behind the objects which the boxes contain. The former is becoming well established, the latter has yet to gather momentum. People who work with reminiscence are not necessarily social historians or indeed conversant with the meanings of the objects and images being used. Museums have this contextual understanding and can link things to social, economic and political trends. Briefing those using museum material can better position them to ask useful and relevant questions within the sessions.

It is this same contextual understanding that helps in the selection of objects and images for the boxes. The objects selected have to be robust enough to withstand transportation and possibly some rough handling. They tend not to be drawn from primary collections, but are duplicates or unprovenanced material. Popular themes include shopping, cooking, childhood games, going out and the home front. In a way the collections themselves dictate the themes and are a real test of how comprehensive and socially relevant museum collections are. Some topics would not be possible, for example, religion, as many museums have not collected sufficiently comprehensively. The periods represented by the collections may not be evenly spread, so there may be plenty of dolly pegs but nothing representing the early days of *Coronation Street,* or the 1948 Olympics in London, or the 1966 World Cup. Further, the collections may have been drawn from only certain sections of society, excluding a culturally plural perspective, thereby limiting substantially reminiscence material that might be of interest to people from different cultural backgrounds.

Beamish, The North of England Open Air Museum, provides a very useful example of how a museum can work co-operatively with health specialists to provide reminiscence materials suitable for work undertaken in hospitals and day centres. The museum recognized that whereas they did not have staff specialized in working with older adults in situations of care, especially those suffering from dementia, they were aware of how large their resources were, not just in terms of the collections but also the library resources, catalogues and research materials they had at their disposal. They were therefore particularly well positioned when approached by the health authority about two projects. The first was at the Grange Day Unit in Sunderland where the staff wanted to turn a store-room into a reminiscence room. Following discussions with the curatorial staff, the idea of a 1930s living room developed. Museum staff helped research the details of the room and provided many of the things required from the reserve collections, from a fire surround to magazines and crockery. The walls were papered and the window lead lighted. The net result was a comfortable and homely room into which groups of clients could be taken by nursing staff for reminiscence.

The second project began when the project manager from Prudhoe Hospital in Northumberland contacted the museum about borrowing material. He and a small team of psychologists and therapists were invited to the museum to discuss

possible ways forward. The Prudhoe staff spent a long time researching in the museum's archives, going through the photographic collections and the object stores. They interviewed their own clients to ascertain their needs and interests. The project gathered momentum, and in time the Prudhoe team was able to provide a reminiscence facility of a very high order. It took fully into account the memories, life stages and levels of ability of the people in the hospital's care, using the Beamish collections in association with all the care which staff had learned about the material (information from Lloyd Langley and Stephen Manion).

A similar example of working co-operatively with caring agencies can be found in Norfolk Museums Service, where the education staff help provide reminiscence materials to be used by Reminiscence Approaches with the Frail Elderly (RAFE), part of the local education authority, which specializes in providing training in reminiscence work for carers. One of the cottages at the Norfolk Rural Life Museum in Gressenhall is also used by RAFE for reminiscence purposes. Further ways in which the museum service might work with RAFE are being sought.

There is no doubt that there is a need for these forms of co-operation and that where this has occurred the rewards have been great, so much so that the demand for good reminiscence resources is significant. Glasgow's Open Museum makes in excess of 600 individual loans of reminiscence material each year (information from Nat Edwards). The work has many opportunities for further development.

15 *Working with reminiscence*

Working with reminiscence requires preparation and an appreciation not just of people's needs and well-being, but of their diversity.

People from ethnic minority groups represent just under 6 per cent of the population. Of these, 12 per cent of the Indian population and 17 per cent of the Black Caribbean population in 1995 were aged 55 and over. Many are first generation settlers and have memories of their country of origin as well as memories of Britain (figures from Age Concern). Living in Britain may have been hard, with experiences of racism, ill-health and homesickness. Accepting death in a country which is not that of your birth can be extremely difficult. Not all cultures approach old age and death in the same way and may have different views about the position of the elderly within everyday life. Language difficulties may arise within reminiscence. A poorly prepared facilitator, possibly not of the same culture, may lose the inferences and misread the clues. But for many there can be a strong urge to 'bear witness' to what they had experienced. For others, to make this witness known may be all too painful (Blakemore and Boneham, 1994; Gibson, 1994).

This is an area of work where Age Exchange in London has special experience, having worked with Jewish, Caribbean and Asian elders in the production of theatre, publications and exhibitions based on their memories. Pam Schweitzer has recently described the work undertaken with a group of elderly Sikh men and women from the Punjab living in the Belvedere area of south-east London. Many of the older people came over in the 1950s and 1960s in response to the British government's invitation to work here. The men came first and sent for their families as soon as they could afford to house them in Britain. Now elderly, they live with their extended families. The need for a place where they could meet, free from the kind of harassment that was experienced in places like public parks, led an Indian social worker to gain the consent of the temple that elders could use part of the building for a daily meeting place where they could come to cook, play cards, ask advice and talk to each other. Much of this talk was about life back home in the Punjab, and the social worker became interested in how this could be structured and how the older people's stories might be valued and recorded in some way. Age Exchange was invited to set up a reminiscence project.

It was essential to work within the elders' mother tongue and, through translators, Age Exchange discussed with the group the idea of reminiscence

boxes and the sorts of things one might contain to represent their experiences. They looked at some of the reminiscence boxes already in use, for example, the one on childhood games, and worked out what their equivalents would have been. Most of their toys had been home-made, so it was agreed that many of the objects that would go into the reminiscence boxes would be made by them. The men set to work constructing little wooden ploughs and kites, while the women made dolls and puppets from sticks and bits of cloth and wove pieces of string into skipping ropes: all the things they remembered from their own childhood. The men and women preferred to work separately, and conversation flowed more freely when they did. This was just the beginning. They went on to create two more boxes, putting in objects relating to marriage, health, food, clothing, religious observance and pleasure. They identified significant objects in their own lives, aware that these would have resonance for others. The older men were particularly keen to join inter-generational projects with local schools, and saw the boxes as a good starting point for classroom conversations. This project led on to other initiatives which will be described in Chapter 16, and in sum is a model of empowerment and enablement. (Schweitzer, 1998).

Many elderly people have some form of impairment. The effects of hearing, sight or speech impairment in late life can include a profound sense of isolation, even if living with others. The isolation is also experienced by people suffering from dementia, along with anxiety, agitation and depression. Reminiscence work can be designed to meet the needs of people with impairment. Some of this, especially with people who suffer dementia, may be highly specialized and demanding. It may require careful liaison with nursing staff, carers and family. The achievements to be gained through reminiscence for the especially frail may not always be dramatic and may appear small scale, but they are nevertheless important. Reminiscence work which has a strong sensory component has been found to be effective. Three examples will demonstrate different aspects of this.

The first is again from the work of Alison McMoreland. She was working with Angus on a one-to-one basis and had been told that he had been a piper and a composer of pipe tunes. Now in his eighties, Angus had become very isolated and withdrawn, was totally blind and partially deaf. On her third visit Alison McMoreland brought a set of Highland pipes, bag, chanter and drones and placed these in his hands. The chanter had no reed and was therefore incapable of producing sound. Angus placed the reedless chanter to his lips and when he discovered the inevitable absence of sound, he began to vocalize, 'diddle' the tune and at the same time shaped the silent notes with his fingers on the chanter. He was playing a famous pipe tune of his own composition. McMoreland goes on:

> This unexpected lifting of his voice in the tune, and his own composition gave back immediately to Angus dignity and authority. In that moment, we experienced a shared joy, as I the listener witnessed who he still was in his heart of hearts.
>
> Later I asked him 'how do you compose tunes, do you first hear then in your head?' 'No', he replied instantly, without stopping to think, 'I hear them in my heart.'
>
> (McMoreland, 1997: 112)

Eilean Taylor (1997) writes of how sweets at the Age Exchange Centre provide an opportunity for people to communicate, bringing back memories of childhood, siblings and corner shops. The use of sweets in reminiscence work

can unlock the five senses. Holding the bag and picking a sweet, looking at that sweet, smelling the aroma from the bag, hearing the rustle of paper and even the crunching sound of the sweet being eaten, eating the sweet, require the use of touch, sight, smell, sound and taste. These are senses which can be experienced and imagined. The thought of fish and chips, kippers and freshly baked bread can conjure up how they would taste, feel and smell, and, from this, further associated meaning and memories can be accessed.

In 1997, Edinburgh City Museums produced an exhibition entitled *Changing Perceptions: New Multi-Sensory Art*. A touring version of this called *See Sense* was developed. Works from eight artists were chosen which utilized not only the sense of sight but also touch, sound and smell. An educational programme was developed at the City Art Centre which complemented and built on the approaches taken by the artists. This offered opportunities for groups that were not regular users of art galleries. One of the workshops was devised for adults with dementia. Using one of the works, Clara Ursitti's *Self Portrait in Scent Sketch No 5 (Scalp)*, groups of people with dementia from day centres in Tranent, Kirkcaldy and Edinburgh participated in reminiscence sessions evoked by a variety of smells. One of the groups, from a project dealing with people suffering from the early onset of dementia, provided feedback. They had found the opportunity to be creative and particularly worthwhile, in particular relating smell to their sources, as well as colours and working with memories. The exercise was useful in expressing thoughts about the tasks they were given within a group setting. Indeed, the feeling of involvement was a great aid to the group.

All work with reminiscence has to accept that most people harbour at least some difficult memories. The most simple of topics may bring to mind some distress. There is simply not a 'safe' topic, which is why giving people the choice of what they would like to talk about or work on (or not) is so important. Failure to do this can have consequences which are at the very least unfortunate. One reminiscence worker, entrusted with a group of people who were new to him and for whom he had no briefing from the care staff, introduced the subject of children. He then asked each member of the group to talk about their children, how many they had had and what they were like. He turned to one woman who, up to this point had been very quiet and disengaged. In answer to his question, how many children did she have, her answer was 'one, and she was stillborn'. In another situation, perhaps on a one-to-one basis, talking about this subject with her permission might have been helpful. But in a group setting and without preparation it had put her in a very difficult position, and had stirred up feelings for which the facilitator was not prepared.

In a reminiscence session led by a member of the education staff from Cheltenham Museum, a photograph of a Morrison shelter evoked a

> matter of fact disclosure that it was like a cage he was locked in when he tried to commit suicide at 16. That was the way young suicides were dealt with in asylums then. Perhaps he felt fine about it, he certainly didn't show that he was upset – perhaps he felt so at ease he could share it – but for Liz, my colleague, and I, the occurrence was unnerving although we tried to be matter of fact about it and carried on. . . . I don't believe such occurrences are that unusual and I'm not sure how we can be prepared.
>
> (Information from Virginia Adsett)

This acts as a reminder that reminiscence work is not about eliciting golden memories of the good old days and mindless renditions of *Roll out the Barrel*. It involves life stories which have their share of tragedy and this is where the skill of the facilitator is paramount. Some of the difficulties and grief which people have experienced in life may be unresolved, and as a result can give rise to depression and stress. Access to reminiscence or the more detailed process which emphasizes an evaluation of achievements and successes as much as difficulties can act to settle and provide comfort. The triggers to difficult memories or to memories which have been repressed, or at least put to one side, are difficult to predict.

In Israel, many survivors of the Holocaust have remained silent about the traumas they experienced. There is growing concern for them and how they might be helped. In this, reminiscence and the sharing of memories with fellow survivors and, importantly, with their own families, is believed to be helpful. It has been found that retirement, sudden illness or the loss of a loved one can bring about the need to reminisce and give expression to a deep and difficult past. In addition, the children and grandchildren of the survivors want to know more. The sharing of information can have the capacity to relieve guilt and the recalling of memories of loved ones can give the survivors the strength to carry on (Schindler *et al.*, 1992).

Museums with collections drawn from regiments or service units and the campaigns with which they have been engaged can often provide anecdotal evidence of how memories of veterans are released on access to the material, often in the company of fellow veterans. Some of these memories may well have been unarticulated up to this point. Robin McDermott, formerly curator of the Kohima Museum, provides this example.

First, it is necessary to understand the context of the museum and its collection. The town of Kohima is just inside the border of north-east India on a road and rail junction giving geographical access to northern Burma. Positioned in hilly, closely forested country, the town had strategic military importance during the Second World War, being the gateway to the Indian subcontinent and therefore to the heart of the British Empire. During the months of April and May 1944, it was the scene of an intensely fought battle between the Japanese Imperial Army's Thirty-first Division and the town's garrison battalion, reinforced after the initial two weeks of fighting by the British Second Division. The impenetrability of the terrain precluded the use of tanks and large artillery pieces, and as a consequence much of the fighting was hand to hand. Many of the casualties could not be evacuated and those of both sides lay intermingled for days at a time.

The vast majority of the objects in the Kohima Museum collection have been donated by veterans. The collection is seen by the museum as being highly personalized and few of the objects have detailed labelling. The museum is only open to the general public by appointment, but is open to Kohima veterans all the time, but is seen as a particular focus for their annual reunions. The fiftieth anniversary of the battle was commemorated in 1994, and a larger number of veterans attended the reunion than usual. Among these were a veteran and his wife who were attending for the first time. They spent time in the museum and then left. While the husband was distracted by another veteran, his wife took the

opportunity to return and speak to the curator, thanking him profusely. She told him that in the fifty years since the battle he had not talked nearly as much about his experience as he had done on his visit to the museum. That day, she had learned more about what he had gone through than she had ever been privy to before. The visit, coupled with the opportunity to talk to others who had shared the experience, appeared to have lifted a burden from him. From then on he appeared to be quite relaxed while recalling his experiences, whereas in the past he had always appeared ill at ease if the war in the Far East had been raised in conversation. She saw the museum and its artefacts as a catalyst, acting jointly on her husband and the other veterans present in a way that no other environment or setting could have done.

Thus the trauma was faced because the triggers to memory were present in an environment which fully understood the experience and which could tacitly support him in bringing these things to mind. It was a safe place to do this and, out of this, meaning and sense were made of a very difficult life experience. It would be impossible to say for sure which was the most powerful component in this, whether it was being with fellow veterans again, the chance to talk with people who really understood what was being said, access to the things and images of the trauma itself or the presence of a life partner willing to know more. Each aspect probably played a vital part in examining layers of memories and the feelings associated with them.

One of the issues that arises here for both reminiscence and the museums involved with it, regardless of what type of reminiscence, is the importance of having knowledge of the past. The more a facilitator knows about the past, the better s/he should be able both to conduct and to facilitate reminiscence, providing the right clues and responses and, through these, enabling the older person to talk with a greater degree of depth and detail, knowing that they will be understood. This is an issue that rarely comes through in discussions about reminiscence. The premise that the older person is the expert and the facilitator the novice is a correct one for this form of work, as it puts value on what the older adult remembers rather than what the facilitator knows and therefore shifts the power relationship. However, this should not preclude facilitators having high levels of understanding about social and economic trends and cultural experience. Where this understanding revolves around topics which mesh with an older person's experience then, as with the Kohima example, new levels of understanding and exchange can take place. This is where social historians working in museums have a role to play in both briefing facilitators and the conduct of their own work in reminiscence.

Surprisingly, there seems to have been little written on the ethical standards of reminiscence work, although much of the literature makes implicit the responsibilities that go with it. Some of the difficulties to be faced are associated with meeting and acknowledging people's emotions – anger, guilt, disappointment, anxiety, tears. Some are concerned with group interaction, especially where the group has been inappropriately set up, perhaps with a dominant or bullying member or with people who have very little in common other than their age. Other difficulties may arise where the perversity of human nature has not been anticipated and one has to listen to memories strongly laced with attitudes that are racist, sexist, homophobic or with a variety of forms of hatred and

disrespect for other people. The memories disclosed may have elements that might be legally actionable, such as details of past violence or fraud, as people off-load within reminiscence as if within a confessional. Reminiscence may contain details which are hurtful to others, such as past marital infidelities, or about circumstances detrimental to them in the present, such as the poor standard of nursing care they might be receiving.

Entering into reminiscence work therefore requires facilitators to have a high level of social skill, awareness of the dynamics of memory in late life, a genuine concern for the older people involved, a clear sense of purpose and an agenda which is appropriate within the context of the work to be carried out. It needs at least some training and access to literature on reminiscence. If conducted by museum staff, it has also to be justified within the museum's mission and much thought given to the resources it involves. That being said, there is little doubt that reminiscence using museum collections and curatorial expertise has an important contribution to make, but there are questions to be raised first.

If the primary means of supporting reminiscence is through the supply of objects in travelling boxes, how are these chosen and what does this choice represent? There is a real risk that a museum may respond to established categories such as children's games with what is in the store, rather than what is relevant and what works together effectively as a set. The historian's skills in examining experience, trends and period are as relevant here as in all other areas of museum practice. In addition, the museum needs to engage in the pre-testing of materials to go into boxes through work with people who knew the objects at first hand. Only in these ways can the museum be sure that the material collected is appropriate in terms of class, ethnicity, age range and so on. The people who will work with this material need some means of support, either in the form of briefing notes or in training and handling sessions. Beyond this point museums need to have some idea about whether the material chosen works well in different settings and the kinds of memories it is releasing. This information should feed back into the development of further boxes. It can also aid the development of other activities based upon reminiscence.

16 *Working with the memory bearers*

Late life brings with it transmissive functions, in particular the sharing of wisdom, knowledge and cultural understanding with younger generations (Gutmann, 1987). Where the family unit and kinship systems are strong, and ties are based on sentiment as much as on obligation, the acceptance of a transmissive role may well be natural and emotionally very important. The parts which grandparents play, first, as stabilizers within family life and second as holders of valuable life experience which can be uniquely beneficial to their grandchildren, have been recognized in research and in at least one Government Green Paper (Jerome, 1993, 1994; Home Office, 1998). But with the many forms of both multi-generational families and blended families, created in the wake of death or divorce and further complicated by the distance which family members may live from one another, the roles and responsibilities of the older adult, especially in relation to transmission, are not so clear-cut. In addition, those who live outside of the ideological premise of the 'family' as the dominant structure of personal life would appear to be especially marginalized and their transmissive function largely negated.

What may have been slow to develop at least theoretically is the importance of transmission in a broader social sense, not just within the family but within peer groups and inter-generationally with others outside of the family unit. Whereas this may well be acknowledged in stable societies which have an established social place for older people, it may not be so well understood in terms of the older person in a society where personal bonds are a lot more fluid and liable to interruption. In such situations, transmission to others, not necessarily kin, may form just as important a function and may help supplement, or even be a substitute for, that which is possible within whatever form of family unit is enjoyed. As Wong and Watt (1991) and Coleman (1986) have pointed out, older people elect to remember in different ways and to engage in reminiscence in different forms. Not all older people would elect to adopt a transmissive function but, for those who do, the opportunity to exercise it fully and in ways which have meaning for them can be a profoundly satisfying and life-enhancing experience.

Museums can encourage, facilitate and allow for inter-generational transmission. This has tremendous possibilities for learning and therefore may be seen as part of the lifelong learning initiatives supported by museums. Such work enables the transfer of knowledge implicit in the transmissive function of remembrance. It is important, however, not to lose sight of the social as well as the educational

Plate 16 Mary Craig talking with pupils from Victoria School, Newhaven, in 1998. This was part of the cross-generational sessions at the school, where volunteers from the museum shared their memories with the children. Courtesy of Miles Tubb, Newhaven.

dimension, not least the influence of this work on the self-esteem and sense of well-being of those involved, especially older people. This should be some measure of the effectiveness of inter-generational work, even its *raison d'être*.

There is little research on the value of inter-generational transmission in a social or educational setting, although it is evident from feedback that, if appropriately prepared and run, there are significant benefits. There follows a selection of comments from volunteers who have been engaged in inter-generational educational activities, working with primary schoolchildren, on behalf of Age Exchange in London (quoted in Schweitzer, 1993: 7):

> 'You are giving them a little bit of your experience. You can tell them and explain it and they're really hanging on what you're saying, as long as you're telling the truth, that's the main thing. You must tell them the absolute truth.'
>
> (Lilian Burnett)

> 'We show them something we cannot get from books. Nobody can get it from a book what we know.'
>
> (Bill O'Sullivan)

> 'What more wonderful audience can you have than children when they're really listening to you? You get their attention and they're listening and they're intrigued. It's a wonderful feeling.'
>
> (Joyce Milan)

> 'They learn that all old people are not idiots. That once you get older you have a great deal of experience behind you and you are capable of passing that experience on and not just sitting in an armchair doing nothing.'
>
> (Dorothy Barton)

'I find it gives me a lot of confidence when I tell the children my experience. I feel really great. I couldn't do that with grown up people, but with children I come over well and I feel as though I've done something.'

(Eileen O'Sullivan)

These comments give us some of the keynotes: sharing; commitment to getting the information right; holding a special kind of information; the valuing of unique experiences and the authority that comes with it; self-image and the negation of false images; and confidence. This is reflected in comments made by older people working with a number of different projects at Edinburgh City Museums and Galleries. Here is Annie Scott, a one-time fifth housemaid at Carberry Tower, writing in her church magazine about her experience of being part of the projects behind the redisplay of *The People's Story*:

'at least I'm losing my inferiority complex I've had all of these years about my menial job ... they have an effigy of me dressed in the uniform I wore at Carberry, in a glass cabinet, on my knees, cleaning a steel grate. There is a video of me and three other people talking about our jobs. After I've gone, at least I'll be there for posterity, a museum piece.'

(Quoted in Marwick, 1995: 141–2)

Further keynotes of transmission, self-value as well as self-reflection, are evident here too.

Although such positive evidence may seem to indicate that in general terms reminiscence with others is beneficial, it has to be treated with a little caution. The people who become engaged in such projects are often self-selecting; that is, they volunteer or are persuaded. They have made a positive response in relation to projects which were ultimately successful. They are more likely to be people who enjoy and are ready to engage in narrative forms of memory, who are relatively easy in the company of others and not totally intimidated by the thought of communicating with strangers. Even so they may have had to overcome some anxiety to arrive at that point. Annie Scott remembered that she had been recovering from pneumonia when she first came across an advertisement in a newspaper looking for people who had been in private service. 'I wrote to them rather fearfully and they phoned me and arranged to come and see me' (Clark and Marwick, 1992: 56).

Older people can be helped to overcome their concerns by being supported through discussion, effective facilitation and training. However, not all older people would want this role and many would not seek it; indeed, many have not been in a position to make decisions or to create opportunities for themselves. Much depends upon how the situation is handled and developed. One adult education tutor found it difficult to gain the confidence of a particular group she was leading and had to prove herself by giving a straightforward, formal lecture. Marwick comments, 'thereafter the class breathed a collective sigh of relief and allowed her to adopt other approaches.' Similarly, during a project to create a banner for *The People's Story*, Marwick observed the reluctance of the older women to take decisions and their instinctive appeal to the project organizer, Helen Clark, 'who transferred the responsibility back to them, with positive results' (Marwick, 1995: 146). Working with older people needs considerable sensitivity to individual interests and dispositions, perhaps more so than with any other group.

Their memories, life experiences, aptitudes and interests will be endlessly varied and beyond generalization. The projects and approaches outlined in this chapter are therefore responses to the individuality found within inter-generational work.

Before looking at a number of projects which have transmissive purposes at their heart, I would like to consider one museum where transmission has been central to all that has been achieved from the outset and where older adults have played an essential part. True's Yard Museum in King's Lynn, Norfolk, is dedicated to the people of the North End, whose livelihoods were derived from the sea, that is, from fishing and shipbuilding and the many associated trades, and who lived in a relatively closed community at the north end of the town. In 1987, through the efforts of Pat Midgely, a retired special needs teacher, the museum began to save True's Yard in the North End, a small complex of buildings which survived the slum clearances from the 1930s onwards that had otherwise removed the greater part of the fishing community's homes. Pat Midgely recognized that it was necessary to preserve not just the yard but also the memories of the North Enders and to provide something of present-day value to them. The museum had to be about the past, the present and the future of the people of the North End: and so it proceeded. An independent museum trust was established, administered by Pat and run with the assistance of people, many in retirement, from the North End and elsewhere in Lynn who gave (and continue to give) their time to run the café, staff the shop, take people on tours, and help out in any way they could.

The museum depends substantially on volunteer effort and exists without the shelter of a formal and officially funded museum service. The North Enders donated their memories, photographs and precious possessions to the collections, knowing that they themselves were a part of and not an adjunct to what the museum was aiming to achieve. The older people were transmitting a complex body of information about a way of fishing and of the living derived from it that had almost disappeared They were placing their understanding of the past in an environment that not only valued it but connected it to the present day, as the museum also identifies itself with current fishery practices and the training of people who are dependent on the sea for their living. To this end the local Fisheries Co-op and some NVQ training schemes for the industry are based at the museum. Furthermore, the quality of the museum's archives and its research processes are now so good that it can support educational activity from that for the under-fives to research at doctoral and post-doctoral level. The collective endeavour built substantially on the efforts of those in post-retirement years is perhaps one of the most fulsome testimonies there is to the transmissive role of older people within the context of a museum.

True's Yard is exceptional in many respects. Most museums operate on rather different models, ones with a strong sense of professional control. In these the distance of the professional from the 'client', one of the defining characteristics of most professions, is apparent, as is the defended power and knowledge base of the professional (Kavanagh, 1991). This sense of control can at one extreme be so exclusive as to prohibit no other view but that of the curator. Yet at the other extreme the curatorial role can be very positive, promoting enablement through the judicious harnessing of resources and facilities in ways that respond constructively to both local needs and the

opportunities they present. I will outline a number of different examples of how museums and other agencies are working with older people as memory bearers.

Museums are well used to providing loans boxes for schools' use and, to a lesser extent, for reminiscence purposes (Mastoris, 1996; Anderson, 1997). One of the ways that inter-generational transmission can be promoted is to bring together older people and children so that they can discuss the things in the boxes and learn from one another. To date, this type of work has taken place in school classrooms, more often than not, frequently on the theme of school-days, but such work can and sometimes does take place in museums. These encounters can be very effective learning experiences for children and can make a useful contribution within the context of the national curriculum (Hazareesingh *et al.*, 1994; Redfern, 1996). Their success and effectiveness are dependent on a careful structure and a mutually agreed set of objectives. They can lead on to other projects for the children involving, for example, creative writing or artwork. When successfully run, they generate an intense engagement, as the following example shows.

In 1991, as an extension to a project on the National Health Service in Edinburgh, activity sessions for children were offered at the museum on the theme of 'home cures'. Members of the museum's reminiscence group (to be described further below) worked with pupils, teachers, parents and museum staff to demonstrate the remedies of the 1920s and 1930s, for example, bread poultices, a sweaty sock (for a sore throat), menthol crystals, lemon and glycerine. Beneath the fun of it all was a serious point: that before the set-up of the NHS, people relied on home cures simply because they could not afford to call out the doctor. What was meaningful to Betty Hepburn and other members of the reminiscence group was that it was *their* experience, *their* history that was being seen as meaningful and interesting to young people. In turn, one teacher said she had never seen her pupils so involved. The museum's staff recorded that a stimulating and invigorating time was had by all, summed up in the comments of one 10-year-old: 'see these two old ladies over there? – they're great!' (Clark and Marwick, 1992: 62; Marwick, 1995: 143).

Age Exchange, in London, has extensive experience of inter-generational projects for schools. On the basis of this, it has been able to list the perceived benefits for both older people and children (Schweitzer, 1993). Their work has the underpinning motive of creating good relationships between children and older people through careful listening and the use of fresh knowledge. In their view, the children gain through a change of routine and through meeting new people either in the museum or in the classroom. This brings with it an air of expectancy and excitement. Children are helped to associate the past with real people and can use their imaginations to consider how things have changed and what the older people's childhood must have been like. It tests their preconceptions about the past and about older people and gives them a way to find out about new objects. They can relate the information given to that current within their own families and make comparisons and contrasts. There are also opportunities to handle unfamiliar things and to talk about them with classmates and adults. This can lead to further interviews, the acting out of historical

Plate 17 Children from Victoria School, Newhaven, asking Mary Barker a set of questions they had specially prepared for her. Courtesy of Miles Tubb, Newhaven.

episodes in someone's life and other forms of creative work based on people's memories. Some of the responses are emotional as children enjoy the humour and the surprises the narratives contain, yet empathize with the difficulties endured. The work helps them increase their vocabulary, understand something of change over time and appreciate modern opportunities in new ways.

The rewards for older people include working alongside teachers, as well as museum curators and reminiscence specialists. Recalling their own school-days when talking to the children and noticing the evidence of continuity and change leads to perceptions of the common threads between different generations. Older people are rewarded by feeling appreciated for who they are and for their own life experiences. Gaining the attention of a younger age group can be a reward in itself, as is passing on skills and knowledge and realizing one's own depth of knowledge. Being thanked and appreciated by the children, teachers and museum staff is also a good part of the reward. Age Exchange has published very practical advice based on considerable experience of how both older people and children need to be prepared for these sessions and the different ways in which they can be run (Schweitzer, 1993).

There are educational rewards that need to be mentioned here too. Learning about the past through oral sources helps children appreciate the value of source materials and how each account of the past is unique and created within its own circumstances. Children can compare what different adults within the same age range say about the past and can relate this to other sources of information such as newspapers, documents, photographs and objects. By personalizing the past history becomes real and lived, and children can be taught to access it using historiographic techniques, alert to the strengths and limitations of the sources they are using. The combination of an authoritative older adult talking about the

past and the handling of objects from the episodes narrated can fire the imagination and leave long-term impressions. It can also create the momentum to learn more.

This is an area for museums where co-operation with other bodies can be especially fruitful. In Liverpool a group of women met on a Second Chance to Learn course called 'Women's histories; women's lives' run at the City of Liverpool Community College. They began their own project, visiting schools and showing children some of the games they used to play. They were then asked by the Education Officer at the Maritime Museum to put on some of their workshops there. The arrangement developed; the museum was able to provide facilities for rehearsal and to offer the eighteen women in the group access to museum collections. The History for School Children Group, as it is now called, has been able to increase the number of workshops it can offer. At the time of writing, these include the themes of children of the 1930s, the war years, home cures and the pawnshop.

Work such as this has embedded within it a huge variety of creative possibilities, one of which is dramatic exploration, with children taking the words used by the older person, who is either a member of a reminiscence group or a family member, and acting out something of what their experiences must have been like. Such work both reinforces and extends the learning experiences as the children explore the meanings behind the words used and look for contextual, visual and material clues to, or prompts within, the narratives.

The use of drama to explore the meaning in memories and to communicate these to different audiences in ways that prompt further discussion is an area of work where the experience of Age Exchange is beyond parallel in the UK (Schweitzer, 1993, 1994, 1998). They have made many productions based on people's memories, sometimes using professional actors, sometimes with the older people themselves or with children acting out memories. One of these was *Routes – The Journey of a Lifetime*. In Chapter 15, I described something of their work with Indian elders in the Belvedere area of London which led to the creation of reminiscence boxes and opportunities for inter-generational learning in schools. There was a parallel project, that of a play with Indian actors, using the stories the Punjabi people were telling. In the early experimental phase of the work, the actors acted out some of the words of the older people and used these to generate discussion about the memories and thoughts these presentations evoked. The men began to talk of the lives they had left behind, the work they had done in India and here in Britain, and spoke of their anger about their current situation. The women spoke of their arrival in Britain, the difficulties experienced in adapting, and the tensions with their children and grandchildren in the present.

With this as a foundation and with the actors also present in the reminiscence work, they were able to build a very close understanding, not just of what people said but also what things would have looked and felt like. Images, movement and sound became hugely important to the work, in contrast to other Age Exchange productions which are put together primarily from verbatim accounts. The play, containing both English and Punjabi dialogue, went through much experimentation, and in its final form was shown to the entire group of Asian Elders in their own space at the temple, where all the work began. Schweitzer comments:

they were very moved by the experience of having their own memories relayed to them by fine expressive actors with highly evocative music and movement. The audience laughed with recognition and frequently wept during the performance. Although all the stories were originally told by them, the fact of their being translated into theatre gave them a new immediacy and aroused further reminiscences from the group.

(Schweitzer, 1993: n.p.)

The production has proved particularly effective in helping children to understand something of how and why people moved from Indian villages to English cities and what the impact of that huge journey was, as well as the language and cultural barriers encountered.

Museums are both useful sites for performance based on reminiscence and useful partners, given their resources. For example, the Russell-Cotes Art Gallery and Museum in Bournemouth has hosted Theatre in Education productions (information from Victoria Pirie). This is another area where Edinburgh City Museums and Galleries has experience on which we can draw. In 1992 as part of the Edinburgh Festival, Age Concern had arranged a series of performances of a play entitled *Soapsud Island* by the Questors Theatre Company. After one of these performances, members of the audience of older people joined with the cast of the play and staff from *The People's Story* (the City's social history museum) for an informal reminiscence session. The museum subsequently ran a seminar attended by some of the actors and by the organizers of the older people's groups, who had seen the play, to explore the issues further (Marwick, 1995).

In general terms, some of the work involved with drama of this nature is very experimental and can need little beyond some space and an encouraging and supportive environment. Skilled and careful leadership is essential however. Drama using reminiscence is especially effective in prompting questions, promoting new levels of understanding, and encouraging people to listen and look much more carefully. But theatrical productions, however powerful, are transient, and although the impressions gained will linger long, for many people the opportunities to see them are limited. Museums have tended to concentrate their efforts on the permanent or at least the longer term, with the greatest proportion of activity with older adults going into collection management, exhibitions and other work.

17 *Bearing witness*

In many ways the production of a history exhibition, especially one which springs from testimony and works in partnership with people, has parallels with reminiscence-based drama, and perhaps this is best seen in the work of Edinburgh City Museums and Galleries. The work in the museum services and particularly in *The People's Story* is distinguished by the extent of its co-operation in the production of exhibits. Many museums would now build an exhibition around oral testimony and use memories as a means of giving textual support. At Edinburgh, however, the whole memory and the person behind it became central to the development of exhibitions.

Writing about the development of the displays in *The People's Story*, Helen Clark explained:

> as the museum is about life in Edinburgh, it seemed logical that local people should be involved in the discussions about the story that was to be told in the museum and the content of some of the displays. This involvement was essential to our aim that Edinburgh people should feel that the museum is for and about them, and for them to have a sense of pride in their own past and history.
>
> (Clark, 1988: 19)

The staff were prepared to recognize that this way of working would mean transferring some of the power from the curator to the public. Community involvement came in the form of three reminiscence groups set up by the Workers Education Association in 1986 as part of the project 'Memories and Things', with whom the museum worked closely. Out of their work came much taped reminiscence, two books, two calendars and two exhibitions. The group members also contributed to exhibition work and, having experienced how objects could be a trigger to memories, were very ready to take on the role of museum guides in *The People's Story*. It was a role to which they were well adapted as they had made contributions to many of the new displays. The museum learned much from them that was not recorded in historical sources. Objects gained new meanings when placed beside the words of those from the groups, and people elsewhere, who had owned or used them. For example, here is what Tam Morton, a former docker born in 1909, recalled about an apron now on display, his words accompanying it: 'some of us wore brats, what y'd cry an apron. This is a kind of coarse one ... see the rough bit round the neck. Mostly you got a soft bit there' (quoted in Marwick, 1995: 142).

So, the museum built its new displays around the memories the older people had shared with them. They introduced thirty-three figures to the displays, all based on real people, one of them Mary Mackay, who has become a museum guide. She is able to stand outside the 1940s kitchen and point out to visitors that the woman in the set is her mother and she is the 8-year-old girl standing on a chair fiddling with the wireless. Sandra Marwick and Helen Clark have commented: 'she has developed a great pride in herself and her story and it is *The People's Story* that has given her that' (Clark and Marwick, 1992: 56). Another member of the reminiscence group, Betty Hepburn, appears in the video. In the detailed processes that led to the final exhibitions in *The People's Story*, there was much of mutual benefit. The museum received exact details of clothes worn and equipment used as well as discussion about the nature of the surroundings with personal reflection on past experiences. The older people gained a great sense of involvement and pride not just in what they were helping to create at the museum, but also in themselves and their own narratives.

In discussing these kinds of inter-generational work with older people one word which recurs is 'creative'. It is not simply that the memories they work with were *created* out of their stock of experiences. It is also that they are given expression, that is, *re-creation*, through narratives, drama, writing, artwork or performance as a means of bearing witness to and exploring previously experienced events, episodes and feelings. It is well recognized that art has therapeutic benefits in that it can promote healing and help maintain good health. But further in the creation and re-creation of one's self in these ways there are genuine opportunities for empowerment. Many of the techniques of art therapy used in hospitals, rehabilitation and special education settings have an application elsewhere and can be of value to all people irrespective of life stage and aptitude. The body of work on arts therapy is increasing all the time (see e.g. Liebmann, 1986, 1990; Waller, 1993; Warren, 1984, 1993), the sum of which is based on the understanding that there is a need for 'each of us, no matter what our age or ability, to reaffirm ourselves and communicate with others' (Warren, 1993: 3). What it is specifically about creative work which is so involving is hard to pin down, but in Warren's view art motivates like nothing else can, and 'it is only through making a mark that no-one else can make that we express the individual spark of our own humanity' (Warren, 1993: 4). In this context, it is worth identifying projects which have encouraged older people to express their memories in creative ways.

Age Exchange worked on a simple but very effective project involving memory boxes. This developed from work seen in Hildesheim, Germany, where forty life portraits of local people had been prepared and exhibited by two community artists, Ulrike Brink and Alexandra Hupp. These used their mementoes and memories and spoke about aspects of their life experiences. Pam Schweitzer picked up on this idea and developed an English version. She acquired forty British army grenade boxes and had them renovated and lined with material. A young artist, Joscelin Platt, worked with the older people at the Age Exchange Centre to find ways in which they could express something of their lives, aspirations or experiences in a box of their own, using photographs, words, lights, maps, fabrics, cut-out figures and so on. Each of the older people involved was encouraged to engage in reminiscence and life review to establish

what mattered to them and what they wanted to say through their memory box. One woman arranged her box around the idea of the seasons of her life. Another planned her box using the image of the apricot tree in her garden. Planted by her husband it continues to flourish, even after his death; it is now a source of great comfort to her. One of the boxes is about a woman's memories of migrating from Ireland to live in London and the connections which still exist between the place of her birth and her later life in the city. One of the women involved had always had fantasies of being on the stage and a box was constructed to allow her to play out that fantasy complete with curtains and lights. The boxes, each very personal, have been exhibited and have toured a number of different locations, usually with its creator at hand to discuss the contents, what it was like to both create the memory box and share their memories through it.

The next example is again from Edinburgh. The University's Centre for Continuing Education established classes under the title *Hands up for New Jotters* which used writing, oral history and drama sessions to explore the theme of education. The classes involved people from across the age range and from all walks of life, but many were retired or near retirement. The starting point for the classes was material from a handling box on schools and school-days borrowed from the Museum of Childhood; visits to the museum were also made. An anthology of work from the classes entitled *Hands Up!*, containing prose, poetry and dialogue script, was published (Harthill, 1992). The following is an extract from this and was written by Lore Greenbaum as part of the project:

> I was such a bright eyed little girl that first day of school. First I had that traditional picture taken, dressed up in a trench coat and black beret, a cornet of chocolate and goodies. I still have that picture of a happy beaming little girl. I was so full of happy anticipation and totally unprepared for the sinister and oppressive days that were to follow. It was the very beginning of the Hitler years and already he had made his persecution of the Jewish people felt. The first thing I learnt was that all eight grades of Jewish children were to be herded into one classroom. Our teacher could not bear the strain and turned sadistic. At the slightest provocation he would call us up front and hit us with a bamboo stick. This was very painful. I was terrified of this bamboo stick and of having to share the toilet with a class of retarded children. Somehow I had gotten it into my head that being Jewish meant being retarded. I never felt at ease, there was always a tinge of fear.
>
> When my family finally decided that conditions were intolerable for all of us and made preparations to leave for the United States, I was ecstatic. Not ever again would I have to be constantly afraid.

The following was written by Sylvia Pearson:

> Ours was a singing street. As children we chanted rhythmic refrains during our ball and skipping games. We stotted grey tennis balls against pavements and walls, cawed ropes with shouts of 'you're in – you're out'. Higher and higher would the expert players of ball games aim the spinning sphere in order to execute three or four birls before catching. There was only one girl who could throw as high as the boys – up to the top flat window ledges – a miracle to an unskilled bookworm like me. Hand games with string – cat's cradle, magic knots, handslaps to shrill and cruel chants about well-known personalities – usually objects of scorn. Kick the can, hidey, the chaser singing out after a slow count of ten ' ready or n-ot, here I c-ome'. So many places to hide a honey comb of shadowy stairs and doorway, backgreen coal bunkers for the really brave, chunky privet hedges of the privileged main door gardens for the fearful.

At the conclusion of the project readings of members' work were made by professional actors from the Traverse Theatre. The following year the theme 'Life's Work' was taken, drawing on the experience of the previous year's project and the museum's own work with reminiscence (Marwick, 1995). The museum provides training in oral history to those in the project who might be interested and to members of the 50 + Network, an organization which brings together various voluntary and other agencies. The Department of Continuing Education has plans to expand the project so that voluntary tutors can work with housebound learners. The tutors would be people drawn from those who have taken part in the classes who could then share what they know with those who are unable to leave their homes.

Memories, sometimes as oral history, are a dynamic part of creative projects such as *Hands up for New Jotters*. In general terms, whether in creative projects or not, it would be difficult to quantify how much oral history work currently takes place outside museums, but it is fair to say that many different agencies are involved with it, not least schools. Some of this work leads to publications, a lot is for personal or family interest. Many schools undertake oral history as part of school work. Museums have become involved by helping to train people in the best methods to use. The Green Dragon Museum in Stockton-on-Tees, in partnership with staff at Beamish, has given training to three schools and helped them with projects which have included making their own exhibitions. For the older pupils the oral history work undertaken has contributed to their GCSE course work. Other work feeds into professionally directed and scripted drama with the Dovecot Youth Theatre. The work is very detailed, with pupils expected to transcribe the interviews they undertake (information from Mark Rowland-Jones). As was outlined in Chapter 11, work on oral history brings with it many responsibilities. It is very easy to conduct this type of work unthinkingly and insensitively. Edinburgh Museum Services, under the auspices of the Living Memory Association, published *Living Memory: Guidelines for the Collection of Oral History by Young People* (1993) as a way of instilling high standards into the work being undertaken. It was an initiative which took place in the wake of hearing worrying accounts of bad practice. The museum service also runs training sessions for people in the Living Memory Association and for museum volunteers likely to undertake interviews.

Museums can contribute to inter-generational learning through slide lectures, handling sessions, enquiries, and facilities for comments and feedback. All of these offer some reward. Further, the whole experience can be transforming if the museum is genuinely prepared to exchange understanding and to learn. The final example is from St Albans Museum, where in 1996 they received a donation of 1214 slides of aspects of St Albans from the late 1950s to the mid-1980s. The photographer was a gifted amateur, Alf Gentle, and the collection had been donated to the museum by his widow. It arrived in two cardboard shoe-boxes, loosely classified into groups such as wall, streets, factories and the like. Beyond this there was no further information. A dedicated volunteer set about cataloguing the collection and managed to identify about 90 per cent of it. The remaining 10 per cent was a mystery, and the museum decided to show these to local people in the hope that they might be able to remember aspects of the town that had either disappeared or been forgotten. The slide show was

Plate 18 Keyfield Terrace, St Albans. This was also known as Lavender Alley or Bog Row. Courtesy of St Albans Museums.

advertised in the local press and in the museum's bulletin, *Museums News*. Expecting about a dozen people, the curatorial staff were overwhelmed to find that they could have filled a room with a seating capacity of forty-two three or four times over. Repeat showings filled up amazingly quickly.

The audiences were encouraged to give whatever information they could about the slides, and seeing them evoked many memories. The sessions were lively and enthusiastically received, with people readily sharing what they knew. Here are two examples of the memories people were able to attach to what might appear to be fairly nondescript images:

Keyfield Terrace, *c*. 1959

These houses were demolished in 1961; the area was just wasteland for many years and is now a car-park. Although the curatorial staff were able to identify the terrace, new information was added to it through the slide shows. It was discovered that the image actually showed the front of the houses, not the backs as was first assumed. The doors seen in the photographs were the toilet doors and members of the audience informed the museum that this gave the footpath two alternative names – Lavender Alley or Bog Row/Alley. Residents who wanted to go into their back gardens had to go through a communal entrance at the top of the terrace. The key to this was held by a fearsome lady referred to as 'Aunt Edna', and apparently it was very difficult to persuade her to unlock the door. One of the occupants of 5 Keyfield Terrace (*c*.1930–1959) made her

living by laying out corpses, and in order to maximize her business she would leave two bottles of brown ale in the outside toilet for the police night patrols. Consequently, they made sure that she was the first to hear of any deaths.

Rear of St Peter's Street, 1970

This was one of our mystery slides and generated a huge debate. Some people were adamant that it shows the back of London Road, others that it was Catherine Street, others that it was St Peter's Street, and still others were just as sure that it wasn't in St Albans at all. It was interesting to witness how convinced all these groups were that they were correct. The curatorial staff were able to check out all the suggestions and found that it was in fact the back of St Peter's Street, but the roof line had been changed so dramatically that it was very difficult to recognize. It was possible to confirm it because the tall building to the centre of the picture still stands, although the buildings on either side of it have been replaced by equally tall ones. There are also new buildings covering the entire land in the foreground.

(information from Anne Wheeler)

So far the discussion has been about work with older people, but these ideas and approaches have an application across the age range and, with suitable adaptation, can be effective. For example, between 1992 and 1995, staff at Harborough Museum, led by Steph Mastoris, facilitated a number of activities with the inmates of HMP Gartree, a category B dispersal prison. The prison contains 250 men in the middle of long-term sentences, often for murder and violent crimes. The museum provided lectures, demonstrations, workshops and reminiscence sessions. In turn, these gave rise to two initiatives. The first was a collection of artefacts and writings about life in Gartree which led to an exhibition in the prison's education wing and ultimately the accession of the material to the museum's collections. The second was a photographic survey called 'A Cell of My Own', in which the interior decoration of the prisoners' cells was documented and later discussed. The museum staff worked closely with staff at the prison in the development of this work. The projects enabled the prisoners to come into contact with many new ideas, information and experiences. Hands-on experience with objects from the collections stimulated reminiscence, and the sharing of memories promoted an informal atmosphere and contributed to the socialization of some of the more withdrawn prisoners. Indeed, discussions based on the reminiscence continued back in the cell blocks after the sessions. For the prison this was further evidence that creative and cultural activities provide a useful social stimulus. Furthermore, there were moments when prison officers and inmates discussed objects and their memories as equals, something that rarely occurs during normal routines. The museum benefited through the increase of their collections, well-documented material representing an aspect of Leicestershire life hitherto overlooked (Mastoris, 1996).

There are other examples that can be cited, such as Nottingham City Museum Services projects designed to meet the needs of people with long-term mental health problems and the Pump House People's History Museum's creative writing project aimed at the unemployed (Dodd and Sandell, 1998).

A preparedness for museums to work with memory bearers may have resource implications, not least in terms of time. But commitment to it may be much more a matter of a change in philosophy than a change in primary

functions. Most museum staff can or should find the time to listen. Current commitments could be expanded to enable older people and others to express what they remember of the past. The museum represents an extraordinarily rich resource for learning and for the exchange of understanding. It will be losing a significant part of its potential if it does not enable those with memories to bear witness. The museum holds powerful triggers to memory and the means through which these memories can be shared. Hitherto, its support of the transmissive roles of older people has been significantly underdeveloped, although with notable exceptions. This is not to overlook the fact that inter-generational exchanges do take place within the serendipitous experience of visiting the museum in a family group, and it is to the place of memory within the visit that we now turn.

18 *Memories, dream spaces and the visit*

Within the visit, the history museum becomes a place where the products and processes of memory meet. They intermingle, tumble over one another, collide or simply pass by one another unnoticed.

The museum constructs histories from the products of its research and collecting. By drawing these together within exhibitions and public services, the museum publishes its commentaries on the past. These are a product in their own right, constituted in part from components of others' remembering. This may be as much associated with people recalling episodes from their lives, as choosing to make safe objects or images so that their connections to the past might not be totally forgotten. Although the processes of memory are ever present, what has been foregrounded has been the product. Even though it is attended to with care and the rigours expected of scholarship in the public domain, such products inevitably carry the imprint of when, where and who we are.

This is not a one-way process, however. When visiting museums and seeing the exhibitions constructed there, people bring their memories, interests and concerns. They have their own accounts of the past: some learned, others experienced. They also bring an instinctive understanding of what it is to be human and with that comes the potential for empathy and the capacity to learn about others. It also facilitates people sensing a little more about themselves and their relationships. People visit museums on their own, but more often than not visit in groups of kin or friends. They are equipped with the basic elements required for sympathetic remembering. These include a suite of triggers (visual and tactile stimuli and the conversations of others), narrators (one or several) and audiences (one or several).

This remarkable combination of museums making public the histories they construct and visitors bringing to them what they know in the company of those with whom they choose to share their leisure time makes for an extraordinarily promising encounter. It is certainly a very complex one to understand because it is difficult to tease into coherent elements. Much of what has been written about the visit has been about learning and communication, and how best the museum space and its facilities can be manipulated to improve this. This approach is premised on the notion that 'knowledge is now well understood as the commodity that museums offer' (Hooper-Greenhill, 1992: 2). The museum rests its case for continued public funding on the contribution it can make to

education and learning. This receives frequent emphasis in professional papers and formal reports. In 1991, the Museums Association made this the keynote of its museums charter:

> Ultimately we as citizens must determine the value we place upon one of the essential hall-marks of a civilised country: an educated and informed society. A strong and dynamic museum culture that is accessible and of benefit to all members of society is integral to this achievement. This principle should underpin national and local government policies for museums.
>
> (Museums Association, 1994: 17)

Similarly, it is strongly argued that museums have an unparalleled place in social opportunities for lifelong learning in a report for government, *A Common Wealth: Museums and Learning*:

> education is intrinsic to the nature of museums. Their educational missions drives every activity; it is an integral part of the work of all staff and an element in the experience of every museum user.
>
> (Anderson, 1997: xiii)

Because this is such a central tenet, research into learning and the communication of the museum's messages, both explicit and implicit, has received much attention. It has had the aim of creating better, more effective museum environments within which people can gain much more through access to collections (see Falk and Dierking, 1992; Hooper-Greenhill, 1994; Hein, 1998). This is not solely a matter of understanding more about learning, but also of knowledge of the museum environment. In other words, the configurations of knowledge and the facilitation of learning have powerful correlations and cannot be thought of separately. Theories of education in the museum have developed, and stand at the intersections of theories of knowledge, teaching and learning (Hein, 1998: 16). In sum, the museum knows something (through collections and research) and communicates this (through exhibitions and other activities) in ways that lead to intended information gains for visitors.

Yet much more is happening within the visit than a quest for learning. As was seen in Chapter 1, Annis called the learning element of the visit the 'cognitive space' and it is totally appropriate that museums should lay a great deal of emphasis on its improvement. But there is also a social or interpersonal agenda and the possibility, however serendipitous, of entering a personal world of the imagination and memory, the 'dream space'. Getting closer to understanding the visit requires an enlargement of interest to encompass these, looking initially at what visitors remember of their visit.

If museums are fundamentally educational institutions, it would follow that the learning which visitors achieve can be rehearsed and repeated, at the very least brought to mind. But it is not that simple. Education in the formal sense in schools and classes tends to have in-built assessment procedures whereby learning can be checked and to some degree proven one way or another. Education in informal settings is much more subtle and inevitably complex. It requires not just other means of measurement, but a very different set of questions.

Each year I ask those history students training to be curators to remember a museum visit that may have influenced their decisions to become historians and

work in museums. Perhaps it is a visit made in childhood or more recently as undergraduates. It might be anticipated that people so attuned to the study of the past and so committed to museum work would recount major learning events, centred around a fact or image that altered their knowledge in some way, but that is substantially not the case. Their memories of influential visits tend to be about being with people and experiencing things jointly, being able to move about in visually stimulating situations, being aware of physical space and size as well as the proportion of things, having the opportunity to touch or hear something. One student described what it felt like to slide over a polished floor and another what it was like to dress up in something unfamiliar. Although this hardly constitutes a scientific study, it does echo findings in other work, for example, Alan Radley's study of what people remember of museum visiting. In this, the size and scale of things, the company kept and the difficulties experienced dominated the responses made (Radley, 1991). Similarly, at a conference of museum professionals, participants were asked to recall highly memorable museum experiences. Hein collated these responses and observed that 'what was striking was the breadth and uniquely individual nature of the recollections' (Hein, 1994). The experiences recalled included memories of going behind the scenes, the positive and negative experiences of visiting with the family and the discussions generated (or not), the 'eureka' moment of discovering something new, the personal connections made and the feelings of tiredness associated with visiting.

In these three attempts to achieve some idea of what is remembered, there would appear to be common ground in the social and enabling aspects of visiting and the extent to which these were successful or otherwise. The students all reported experiences that confirmed for them that museums could be positive environments. The people in Radley's study recalled the immediately memorable aspects of the visit, for example, the difficulties of finding or accessing a building in a wheelchair. The people in the conference survey demonstrated similar patterns of recall, a little suffused with professional knowledge of what makes for good museums.

A small number of studies have examined the extent to which families remember visiting a museum. Memories of visiting *Launch Pad* at the Science Museum in London were researched in a careful study of family visits. Six months after being at the museum, families were visited and could generate without cue spontaneous memories. They were able to remember more when photographs of the museum were produced (Stevenson, 1991). Other studies have shown similar results. Paulette McManus's study of memories of visiting *Gallery 33* at Birmingham City Museum and Art Gallery revealed how very wide and personal these were. It also revealed the difficulty of researching memories of museum visits. Nevertheless, it was discovered that an uncued approach to eliciting visitors' memories produced a wider range of memories than structured face-to-face interviews. In her study, half of the uncued responses made by visitors were memories of objects, 23 per cent were of episodes and experiences, 15 per cent were to do with feelings formed, and 10 per cent were reflective accounts on the processes of remembering the experience of visiting the museum. Some visitors produced memories in all four areas (McManus, 1993).

It is difficult to cross-correlate this research as the central thrust of the enquiry and the methodologies adopted are so varied and the studies so few. However, it might be suggested that memories of visits have a number of layers. The first is drawn from the broad social and personal experience of visiting, born out of the fact that this is a decision taken about leisure time and about the exercise of personal preferences. It is well established that visiting happens through a decision to share time with others in ways that are likely to be mutually beneficial, especially in terms of enhancing bonds (e.g. Hood, 1993). People do not go to museums to have a hard time, feel miserable or become stressed (although some museum visits unfortunately induce these feelings). Given that the social (and within this the personal) imperative is so high, it must follow that the first-level memories are drawn from this. Theoretically this is the successful fulfilment of the lower levels of Maslow's pyramid of motivation towards learning, that is, to do with physiological, safety and belonging needs (Maslow, 1954). If feeling good was a motive for going, then memories of feeling good (or bad) will be strong, validating ones and are likely to be readily accessed. And, as McManus' research shows, if going to a museum was further motivated by an interest in seeing objects, some memories of those objects may also be near the surface. This takes us to the top layers of Maslow's pyramid, the needs associated with self-esteem and with the desire for self-fulfilment.

Recall of the social side of visiting is associated with affective or episodic memories. Recall of the messages and meanings which the museum contains is within the cognitive or semantic, and things learned manually as part of the visit, for example, how to strike a coin or thread a shuttle, are within psycho-motive or procedural memories. Therefore, exactly how we ask people to describe their experiences will have an effect on what they are able to remember. It seems that if we ask generally, we are more likely to get the recall of social details and the episode of visiting *per se*. If we provide clues and cues to content, we are more likely to get recall based on cognitive gain. If we ask someone to act out, say, striking a coin, we are more likely to get the procedural memory based on that act. Each memory can connect with and act as a prompt to the others, but it all depends upon the starting point and how it develops. It is likely that this is within the context of an individual experience and the needs and frameworks operating at that point in life.

Remembering precisely what was *learned* as opposed to *recalled* is difficult. In recalling a visit, the absence of a definite notion of learning something new does not necessarily mean that learning did not take place. In discussion with the history students, what emerges from them is the thought that what was learned in the positive environments they discovered in museums was something which contributed towards a constructive attitude to learning itself and to an awareness that the past has many visual and tactile forms of evidence. At that stage in their development, it did not necessarily matter as such if the fishing boat in the museum was from the 1770s, 1870s or 1970s (even though this in itself might be the source of inspiration): the point received was that things could be learned because the boat was there, and extrapolated from this, it follows that learning could also be derived from looking at things, not just in the museum but elsewhere and, moreover that this could be stimulating and rewarding.

Observing what people are doing on the visit may not provide much evidence

of what is really being experienced. In the early 1980s older elementary schoolchildren who had been to a science centre were asked to go to classes of younger children two weeks after their visit to tell them about their experiences. The children were able to teach others in detail about their visit, even though they had taken no notes and were not observed to be particularly attentive to, or reflective about, their experiences (Hein, 1998: 132). Perhaps here the change of identity from recipient (on the visit) to authority (in the classroom) was sufficient to rearrange and promote the initial layers of learning. Thus issues of identity may well be important in how we learn and how we embrace that learning. Christine Johnstone, an experienced social history curator, draws attention to how our ideas about and approach to history are very much linked to identity or, as she puts it, 'trajectory'. She writes that 'everyone has their own experiences, their own narrative trajectories through which they consume history, and everyone does it in a different way' (Johnstone, 1998: 74). The identity claims of a curator, academic historian, community leader, parent or interested individual will vary enormously as they look at the same exhibition. But these roles could be held by one and the same person who acts them out very differently, using different trajectories in each instance.

I visit many museums, most often as an academic working within the field of museum studies. On these visits my trajectory or identity claim is substantially influenced by that role. But it is not always so. My earliest memory of a museum visit is standing in the Galleries of the Museum of Welsh Life at St Fagans, looking at a display on the saddler and hearing the memories tumble from my mother about her grandfather who was a saddler. She talked about him in a way I had not heard before or since. I had a similar experience much later in life when I took my father to Big Pit Mining Museum and he talked of his life as a miner and particularly of his father, who had been the pit pony man at a neighbouring colliery. This for me was the cognitive gain, and to this day I would not be able to recall in any detail what was on display in the reconstructed saddler's shop or the contents of the empty blacksmith's shop in Big Pit, or what the museum intended to achieve by exposing these things to me. My learning in these instances was of a different order and, within the realms of inter-generational exchange, facilitated by the visual and tactile nature of the situation we were in. The trajectories were ones resting solely on my role as a daughter, and will be for ever linked in my mind to this.

Such identity claims or trajectories are possible because visitors stand in closer relationship to social history objects, in particular from the twentieth century, than any other material likely to be found in museums; further, they may bring with them knowledge of the use and manufacture of objects that the curators simply do not know. Social historians working in museums can attest to the fact that one of the most frequently overheard exclamations is 'your Granny had one of those!' (Johnstone, 1998: 68).

Museums are more than learning spaces under the curator's control. Falk and Dierking argue that to begin to understand what takes place in the museum, one needs an understanding of people rather than the exhibits. They have developed an 'interactive experience model' of museum visiting, based upon considerable fieldwork in American museums which included the observation of visitor behaviour and the analysis of conversations between visitors, along with focus

group work. The model at which they arrived describes the visitor's perspective of the visit as being composed of three overlapping contexts: personal, social and physical. The social context is the way the visit is experienced according to companionship and social encounter. The physical context includes the 'feel' of the building, objects, spaces, smell, texture and tone. The personal context they describe as incorporating

> a variety of experience and knowledge, including varying degrees of experience in and knowledge of the content and design of the museum. The personal context also includes the visitor's interests, motivations and concerns. Such characteristics help to mould what an individual enjoys and appreciates, how he wishes to spend his time, and what he seeks for self-fulfilment.
>
> (Falk and Dierking, 1992: 2)

Recognition of the differences in people's approaches, whether rational or irrational, is further given in the ideas which underpin the notion of constructivist learning in museums. This is enlarged upon by George Hein, and is based on the theory that learners construct knowledge for themselves, each making meaning in their own way as they learn. Moreover, in this view, learning can only occur when visitors can connect to what they already know, in essence when they can make a connection between the knowledge they bring with them and what is presented to them. Hein exemplifies this in the following terms:

> visitors respond favourably to art museum labels which personalise the artist, children engage in 'fantasy play' at science centers, and families reconstruct their own histories and personal connections with the events illustrated at historic sites.
>
> (Hein, 1998: 152)

New knowledge, associations and concepts can be built on established understanding. In this way, people move from what they know and are confident about to engagement with new areas of knowledge.

The ways in which we know or relate to the world can be approached from the idea of our intelligence. Howard Gardner's theories of multiple intelligences are used in support of constructivism. Gardner proposed that there is not just one form of intelligence, with lesser or greater aptitudes or IQs, but seven, with individuals being biased within one of the following: linguistic, musical, logical-mathematical, spatial, bodily-kinaesthetic, interpersonal, and intra-personal (Gardner, 1993). More recently he has been prepared to concede that there may well be an eighth, a spiritual intelligence, the natural aptitude for intuition and intuitive relating. Gardner's ideas are not without their critics, especially over such matters as whether intelligence exists in singular or multiple forms. For example, if intelligence is singular how would a trophy-winning sportswoman (bodily-kinaesthetic intelligence) who is also a gifted cellist (musical intelligence) and a diplomat for her sport (intra-personal intelligence) be classified? Indeed, how might the relationship between intelligence and talent be understood? In spite of the many questions raised, Gardner has struck a chord. His theory works within constructivism because it validates the different patterns and natural preferences within learning. Perhaps this needs to be taken further by saying it will also have an influence on how people remember and engage with the dream space.

Gardner has identified a number of natural learning proclivities, but surely these are not static. They must to some degree be enhanced or frustrated by

environment, however this is constructed, and also by experience. Thus links need to be made between intelligence, learning and a field hitherto much neglected within museum studies, namely, developmental psychology. The work of Jung, Adler and Freud has rarely entered into studies of visitors.

Life-span developmental psychology can have its applications here. The work of Erik Erikson has already been discussed in relation to the final stages of the life span and resolution (Chapter 5). His views from the study of the older person, have a relevance in the study of any individual or group within any life stage. Erikson (1965) argues that our development as individuals varies according to our histories and that the more life history we accrue, the more experiences we absorb, the less alike we become and therefore more unique in ourselves. He argues, in a similar vein to Jung, that developments occur on a number of different fronts, and each life stage has its own characteristics and potential. Finally he is insistent on the recognition of reciprocal influences between the person and the environment; the characteristics of circumstances, relationships and so on have considerable bearing on how we are as much as who we are. He points the way for museums to reconsider their visitors, to think of them as people with unique qualities and experiences, which build and contribute to the quality of life led within the different stages of the life span. Subjective variability, the ways in which we as individuals differ, is axiomatic from this viewpoint.

Developmental psychology adds an extra dimension to understanding multiple intelligences as described by Gardner. The bringing together of natural intellectual propensity with personality and accrued life experience casts an important light on what people actually make of things, what and how they remember. If, in addition to this, we can extrapolate from research on older adults remembering which demonstrates the different ways in which memories are used and the different forms of memories brought to the surface as perhaps also being preferences exercised earlier in life, we can suggest that how we learn and experience something within a museum is conditioned not just by our specific form of intelligence but also natural preferences in making associations and memories.

These may in turn be determined by what Neisser called the *remembering self*; that is, the ways in which we maintain, revise and present personal narratives so as to extend and develop personal relations. It is also influenced by the notion of the *private self*, the intensely and uniquely personal side of ourselves which gives us identify, and the *conceptual self*, which is the awareness of the workings of our own minds. Together, these support our degree of self-knowledge (see Groeger, 1997).

So if learning in the museum is substantially more than the absorption of the museum's intended messages, if it can embrace a whole range of experiences and the opportunities to learn about or use knowledge of ourselves, our own histories and those we are close to, then thinking about the visit in terms of the individual and their subjective variability, life stage, intelligence, use and styles of remembering, and awareness of the sense of self, has to be important. Drawing together so many hitherto disparate strands poses a number of very difficult research dilemmas, not least the endless variables that will occur when trying to establish connections and overarching patterns. Whether the research is conducted with naturalistic or experimental methodology, or designed for qualitative or quantitative results, there is no limit to the variables. However, it

is possible to take some elements, test these and hypothesize beyond them. A recent piece of research at Croydon, conducted by the Susie Fisher group on the semi-permanent exhibition *Lifetimes* demonstrates the importance of taking the life stage into account when designing exhibitions.

The development of a museum in Croydon, South London, has been well documented (MacDonald, 1992, 1995, 1998; Fussell, 1997) and references to the fieldwork and collecting undertaken there have been made in Chapter 13. The content of the exhibition *Lifetimes* hinged on episodes from people's life stories as a means of personalizing the past. The design divided the material into six time zones from 1830 to the present day, within each of which there are about fifty objects, two for each of the twenty-five themes set out in Table 1. The objects chosen were selected because they had interesting stories or very lucid memories behind them. For example, one of the objects on display is a gig or spinning-top. Made in the Caribbean in childhood in the 1940s, it was brought to Britain in 1961 by its maker Gee Bernard, and behind it are her thoughts about her expectations of Britain at that time and her experiences once here, of overcrowded conditions, racism and frustrated job opportunities. Her grass-roots politics grew out of such experiences, and the contrast between life as a child in Jamaica with life in Britain as an adult.

Table 1 Theme structure of each of the six time-span sets in the *Lifetimes* exhibition, Croydon

1	World events
2	National events
3	Demography
4	Home life and housing
5	Work
6	Personal hygiene and public health
7	Natural and built environment
8	Fashion and taste
9	Media and communications
10	Religion and morality
11	Crime and law
12	Sex and love
13	Education
14	Health
15	Transport and travel
16	Arts and crafts
17	Welfare
18	Politics and economy
19	Leisure
20	Food and farming
21	Retail, trade and shopping
22	Science and technology
23	Dying and bereavement
24	Parenthood
25	Other

Information about the objects and images, the memories and stories behind them and commentaries are offered on CDI technology, one station for each of six time units. The CDI also offers links and quizzes that allow for exploratory shifts within each set. The exhibitions have a number of deliberately planned interconnecting routes which can be followed through. The first level is through the six time zones, the second is through the twenty-five themes, and the third is the representation of minorities within each of the zones and within the section of material. Thus one could elect to look at the themes of Croydon and health, or Croydon and national events, and trace this through the different time zones; or one could take the experience of people settling in Croydon from Ireland and trace this through time. In essence there is an underlying structure which enables multiple use and forms of enquiry. But how has it worked in practice?

The consultants found that the ways in which people were using *Lifetimes* had an age- and life-stage relationship (see Figure 1). People were making the most of the time periods and material which they readily knew. When they encountered this, they settled down and spent more time looking and engaging with the exhibit.

The younger the visitor, the more likely they were to skip through the early time zones and give time to things which are current, modern and recognizable. Teenagers picked up interest in the displays from the 1960s onwards. Children picked up interest in the contemporary displays and the computer suite. Young adults became especially interested in the displays post-1945. The older generation became particularly interested when they reached the displays for the 1930s. It could be suggested from this that visitors were using their memories to orientate themselves to the exhibition and its chronological and narrative form. Moreover, they were employing received memories as well as their own. The older generation, younger adults and teenagers were all using memories which covered a span of time beyond their own, perhaps incorporating things they had been told by family members or had received through other educational media. Only the children were oriented solely within life span (Susie Fisher Research, conducted in 1995 for Croydon Museum Service).

This is not to suggest that people will only seriously attend to that which is within their immediate personal experience. In the survey, visitors were using most parts of the exhibition one way or another. But they were more comfortable working within the time frames to which they could relate. In other museums, the relationship can be one of role empathy, to which time span offers few barriers. Children can understand something of what life must have been like in Roman times by playing the games and learning the rhymes that children knew then and making comparisons. Touching a chord of what it has meant to be human – to be like you or not like you – is something which access to museum material can enable.

Market town 1830–1880	Turn of the century 1881–1918	Suburbia 1919–1938	Wartime and austerity 1939–1955	Mini Manhattan 1956–1969	Croydon now 1970 to the present	Computer mezzanine
Parents						
Young adults						
Teenagers						
Children						

Figure 1 Behaviour patterns in the *Lifetimes* Gallery, Croydon, showing a correlation between the age of the visitor and the elements of the chronological display to which they give their fullest attention. The younger the visitor, the more likely they are to skip the first three period displays and pick up interest after the 1939–1955 set. The bubble car in the 1956–1969 display grabs attention, with all that it suggests about youth and fun, and is a powerful point in the display. Most visitors find the computer suite on the mezzanine floor particularly engaging. They can sit down and at their own pace take a path that suits them through much of the information which has also been given within the displays downstairs.

Source: Susie Fisher Research for Croydon Museum Service

19 *Dreaming the rational*

The politics of class and culture have been the basis for much of the examination of how people engage with the idea of the museum (see e.g. Merriman, 1991; Davies, 1994). Because such work has taken a broad social perspective, there is a risk that generalizations have led to omissions, especially the individual perspective or the aberrant one. These need to be recognized. People bring with them to the museum not just characteristics drawn from their class status, cultural upbringing and political environment but also individuality of self, which has the capacity to rupture at least some of the features of cultural patterns and political assumptions. Visitors will accept, reject or totally ignore whatever it is the museum is trying to say or argue.

Hein observes: 'if we take the position that it is *possible* to construct personal knowledge then we have to accept the idea that it is *inevitable* that they do so regardless of our efforts to constrain them' (Hein, 1998: 35; emphasis in original). Although the museum may be an extraordinary site for imaginative leaps and for powerful yet unpredicted discovery, this does not mean that it can precipitate changes in attitude or indeed changes in heart. It would appear that people will see things as they want to see them, irrespective of the museum's efforts to the contrary. Hein supplies these two examples. First, a journalist writing a piece on the Holocaust Museum in Washington interviewed a number of visitors. He concluded from these conversations that the visitors' diverse reactions reflected the beliefs and attitudes they brought to the museum as much as anything they discovered within its walls. Some of the visitors he talked with were from a fundamentalist Christian school group; they had been around the museum and had concluded that it provided the evidence that the Jews had received punishment for their failure to accept Jesus Christ as their saviour. The second example is from the Museum of London, and relates to the temporary exhibition *The Peopling of London* held in 1996. This chronicled the continuous settlement of London by people from overseas, from pre-Roman times to the present day. For many visitors it was an insightful experience, one which prompted reconsideration of their perception of the city's population through time. For others it simply reinforced their attitudes, as was evident from the racist remarks in the comments book.

Histories which people bring with them are not just of their own families and life stories. Most of us have some fund of historical knowledge accrued from school, television programmes, novels, newspapers and magazines, among other

sources. Sometimes that interest has been kindled by family or personal connections, at others it has been fostered by necessity, for example, as an assessed part of the educational curriculum. Occasionally it might have been arrived at almost by accident through meeting someone with an enthralling story to tell or an aspect of a documentary that has unexpectedly fired enthusiasm for a subject.

The histories we encounter have shape and purpose. They are arrived at because certain evidence has survived, and accounts have been created using this and other material. The shape that history takes reflects something of the past, which is its content, but also something of the present in which it was made. Most of us encounter history arrived at through studies conducted by other people. Such secondary sources take the form of a book, radio or television programme or a presentation. The author may or may not have gone back to primary sources to gain fresh perspectives and a reconsideration of received opinion. They may simply be recycling histories written by others, with all their flaws. However, they may also be challenging firmly held assumptions and generalizations. This generates both histories and knowledge of the past based on dominant narratives which may well be flawed and are thus very ready for reassessment. Where reassessment does occur, it may take time to be accepted. Whatever their strengths or weaknesses, histories can be read as if they are unassailable truths.

More than this, the media used, whether film, scholarly text or novel, has to have the evidence and histories adapted into forms conducive to it. No matter how expert the advice given and even with extensive and authoritative research, a costume drama, for example, produced and filmed in the 1960s smacks of that period, just as the moral codes of the 1950s can be read in historical novels written at that time. What this does to the stock of historical understanding which we carry in one form or another is to meld together the authoritative and well considered with the well meaning yet spurious, and to do so in the shadow of present times. Working out the differences between received opinion and an accurate account of the past (as far as is possible) requires both better knowledge and a systematic and critical approach to enquiry.

Better knowledge of the past depends on how we are exposed to that past. A systematic and critical approach depends on the intellectual freedom and rigour we are encouraged or enabled to develop, as well as the span of histories to which we are exposed. Omissions from the syllabus can sideline important periods in the past as well as the experiences of minorities. If, for example, the social history of the eighteenth century does not figure in the history curriculum in schools, encouraging children to take an independent interest can be difficult. They could grow into adulthood having very little comprehension of a period of major changes and the implications of the building of the Empire, the development of industrialization, mass commercialization, urban growth and militarism. In contrast, 'the Victorians' does exist as a topic in the National Curriculum, but as a great chunk of a subject with little acknowledgement of the extraordinary social and political changes that took place over the three generations and sixty years that the reign covered. Finding a useful path through the histories presented needs some introductions to different ways of thinking about the past. It also needs an appreciation of primary sources so that the

dominant narratives can be checked, validated or refuted. Fortunately, in more recent years, the teaching of history in UK schools has been directed not just at building a foundation of understanding of key periods, but also at promoting a sense of enquiry and a means of questioning what is seen and heard about the past.

Even so, it is possible to go through all this and still be held in the grip of preferred histories and culturally dominant narratives, as Michael Frisch discovered when questioning history students at the State University of New York. In test conditions the students came up with names and configurations of American history drawn from dominant cultural perspectives on the past rather than historical scholarship. He wrote:

> the lesson is that indoctrination and education need to be more effectively de-coupled, not conflated. For students who already hold lists of heroes in their imaginations need a sense that history is populated by three-dimensional human beings, the famous as well as the forgotten, who live in and act on a real world that is always changing. . . . We must understand the depth of cultural symbolism our students and fellow citizens carry inside themselves long before they enter the classrooms.

> (Frisch, 1990: 54)

A similar set of findings was arrived at by Edward L. Hawes when he explored the stories that museum professionals and museum studies students constructed when asked to respond to a set of objects. These included a candlestick, a cooking pot, an axe and a photocopy of an 1850 newspaper. The stories were woven spontaneously and vividly, and the results were fairly uniform. They were concerned with the 'pioneer' or 'colonial' days and included references to the nuclear family building its cabin and images of a heroic yet simple life. Hawes argued that these stories are rooted in American myths about the past and issues of identity, and that it is the role of museums to question these stories and to promote a more critical awareness of the past.

The findings of Hawes and Frisch are placed in a more vivid light when related to the arguments made by Loewen in his book *Lies my Teachers Told Me* (1995). Here the contents of the principal textbooks used in teaching history in American schools are examined rigorously and are found to be at tremendous odds with current scholarship and constructed in a way that buttresses a highly political and exclusive view of the American past. These stress the heroic and the deeds of the great, and present a blemish-free and unassailable record. In light of this, it is little wonder that Frisch's students and the participants in Hawes's study when responding to a 'gut reaction' kind of test resorted to the essence of what they had been taught, with all its implicit myths.

In Britain, the history curriculum has a very different dimension, and educationalists have striven for inclusiveness and a critical approach, not without opposition and much debate about what should be at the core of history taught in schools (Sylvester, 1994). The debate goes on (e.g. Phillips, 1998). These arguments have relevance to museums in that history in the minds of curators as much as history in the minds of visitors has been laid down largely by how they were taught history in school and the critical tools (if any) with which this experience equipped them. The foregrounding of both personal and social memories takes place in this context. It is the formal knowledge we bring with

them and, with this, the ability to say, I don't think it was like that, or, Yes, I'm sure that's a valid point.

Accepting or rejecting an intellectual point is based on the premise of rational thought. In contrast, the idea of the dream space in the museum has been somewhat neglected. Lois Silverman has managed to put her finger on why this might be the case:

> In striving to educate visitors and to develop 'museum literate' people who know how to view and appreciate objects according to specific paradigms, we as museum professionals have long over focused on the task of providing visitors with information, facilitating the traditional or 'expert' discourses as aspects of visitors' meaning making process, such as their abilities to see formal elements in art work, or to provide historical context for artefacts from the past. In the process, the more personal and subjective ways in which visitors make meaning (such as through life experiences, opinions, imaginations, memories and fantasies) *are at best ignored and more often invalidated in museums, where they tend to be regarded as naive and inappropriate.*
>
> (Silverman, 1995: 161; my emphasis)

As was outlined in Chapter 1, the dream space within a museum visit can be filled with all sorts of things. It is the very personal element of experience, unbounded by agendas and resistant to structures. Into the dream space strays the unguarded recollection of conversations that needed better conclusions, the line of poetry or song lyric that keeps repeating itself, the gorgeous colour or shape of something at once familiar and unfamiliar. The space holds memories, imaginings and feelings. Because of this it is a place where anything could happen, from gentle wool gathering to astonishing insight. The mind is at play, free-wheeling and open to itself.

The Aerospace Gallery in the Science Museum in London has a whole section given over to the tiered display of engines. Beautifully cleaned and lit, they sit on a secure blue scaffolding, each one with a label. I have no real idea what they might mean technologically or in the history of civil air flight, but this never bothers me and I doubt I will ever stretch myself to find out. Nevertheless, this is one of my favourite areas of the museum, as I find the mass of them resembles a huge sculpture within which are parts like smaller sculptures. The shapes and the shine of them, the volume and variety somehow please me, and I am not concerned to rationalize beyond that point. Both to a technologist and to a person who hates technology on display, my personal response may well be *irrational*, but I like it and that's all that matters. In this instance I adapted the looking to my own ends.

This process can operate as much in relation to the rational as to the irrational. Within rational, established areas of knowledge and its pursuit, Eilean Hooper-Greenhill provides us with a useful example. She described how, when looking at pots in a display entitled 'Archaic Greece' at the British Museum, she found herself exploring them solely from the point of view of her personal interests in making sculpture (Hooper-Greenhill, 1991). She had appropriated the pots for her own rational ends and in her mind had disassociated them from the British Museum's intentions.

Getting closer to the personal, rational and irrational responses people make within a visit is difficult, but not impossible. In 1997, Birmingham City

Museum and Art gallery ran a contemporary exhibition called *Favourite Things!* Thirty-three people, including eight school children working in two groups, each selected ten objects or groups of objects from the collections – things that they liked or felt a response to – and wrote a label for each. The people involved were mostly volunteers, but some were invited. In their selection they were able to draw from all of the collections in a traditionally multi-disciplined museum service with a very strong art bias. What emerged was the choice of over 350 objects (and a few sounds), exhibited alongside very personal perspectives. The exhibition was very well received by visitors, with 640 people taking the trouble to log their reactions in a comments book, most of them favourable. One of these read, 'Lovely to see people's memories connected to the objects on display.'

The choices made and the labels reveal a variety of ways of looking at, responding to and talking about things. Although by no means the basis of a clinical study, what we have here does reveal something personal and very individual, much of which goes beyond easy categorization. However, it is useful to reflect on the scope and form of some of the responses and to think about these in terms of both the rational and irrational elements in how we visit museums. Whereas objects may not speak for themselves, perhaps these labels do, and for that reason I set out a number of them here. I am not convinced that categories can be successfully imposed on these responses and do so only because some method of grouping is needed. The sample was too small to configure patterns based on age, but they all made fascinating reading and I have chosen just a small proportion.

A good number of the labels had a direct memory component, some reflection on or link to something personal.

Paulette Burkill, who works as a secretary in a major engineering company and has an interest in local history, chose a sugar basin, and in the label linked her own knowledge of local manufacturing with a personal memory:

Silver and gilt and blue glass sugar basin, Matthew Boulton Plate Company Birmingham, 1812

One of the simple items from Matthew Boulton's Soho Manufactory – more appealing to modern tastes than some of their ornate work. The style evokes fond memories of Grannie's biscuit barrel!

Marjorie Attridge, a retired artist and designer, chose a tea service associated with the Suffrage movement, not just because it was visually pleasing, but because it had a link to the memory of her mother:

Part of a porcelain tea service used in the Women's Social and Political Union tea rooms, London, *c.* 1910

I thought that this would be a topical and interesting visual subject for the citizens of Birmingham. A striking symbol for 'National freedom' and the great importance of 'Votes for Women'. My mother was involved with these 'Freedom Fighters', marching with other women through our city tying herself, and her long auburn hair, to the railings of Putsford Street cemetery as an act of defiance against British justice.

Plate 19 *The Arrival of the Fourth Earl of Manchester in Venice in 1707*, Luca Carlevaris (1663–1730). 'The Earl, clothed in grey, can be seen at least four times, observed by a mongrel dog, in a similar fashion to a strip cartoon' (John Ellard). Courtesy of Birmingham Museums and Art Gallery.

Najam Mughal (born 1969) works in the National Health Service. She chose an image of the place where she has always lived, Small Heath:

Postcards of Small Heath, early 20th century
Amongst my earliest memories of childhood are visits to Victoria Park. My mother can remember boating on the pond and I can vaguely remember fishermen. But what I remember most are swings just behind the bandstand. The Coventry Road today is teeming with vendors as it was at the turn of the century, but with less trams and more traffic.

Farhana Begum from Golden Hillock Community School, and aged 16 at the time of writing this, chose a maquette for one of the many public sculptures in Birmingham. Here she too ties the object to a personal memory:

Maquette for the statue of Thomas Attwood, by Siobhan Coppinger and Fiona Peever
This maquette is for a sculpture in Chamberlain Square! We have

visited the Art gallery since we started at Golden Hillock School in 1992. As we walked there we would look up at the public works of art. We had our photograph taken, gathered around the statue of Thomas Attwood shortly after it was installed. When we saw the maquette we all felt that it would really interest everyone to see how the sculpture had developed.

People also associated something personal with the choice made.

John Ellard was aged 52 at the time. He works in the probation office which is located near the museum. He visits frequently and it is that association which he makes here.

The Arrival of the Fourth Earl of Manchester in Venice in 1707, by Luca Carlevaris (1663–1730)

Although I have always been attracted to Canaletto's and Guardi's Venetian landscapes, for years I passed this painting by with scarcely a second glance. Since a guided museum tour however, it has become one of my favourites. The Earl, clothed in grey, can be seen at least four times, observed by a mongrel dog, in a similar fashion to a strip cartoon. I also feel that Carlevaris is perhaps mocking the Earl in depicting the grimy British shop and flag on the left against the obvious opulence and grandeur of Venice.

Philip Davis first came to live in Birmingham in 1978 as a student at Aston University. Since then he has worked in many places and has suffered a nervous breakdown. He is now rebuilding his life in Birmingham.

Picture of Blakesley Hall

Every other month a Sunday newspaper supplement 'discovers' Birmingham's best kept secret, the Barber Institute. None have yet discovered Birmingham's best little museum, Blakesley Hall. I love this house, its very walls seem to emit the radiance of four hundred years of family life. I immediately feel at home whenever I'm there. I have spent the last twenty years of my life wandering, and I am now beginning to settle and appreciate the simple joys of family life. Blakesley Hall embodies the importance, and for me necessity, of family life.

Marjorie Attridge chose these:

A pair of candlesticks from the Great Parlour at Aston Hall, Flemish, 16th century

Since I attended evening service at our local church with my parents as a child, the beauty of candlelight in a dimly lit church attracted me enormously. Last year, I saw the sheer beauty of dozens of majestic candles in their brass candle holders in the Sacré-Coeur and Notre Dame Cathedral in Paris. With permission, I collected the loose wax from around the candles and created a wax model of the Crucifixion on Calvary.

Plate 20 *The Last of England,* Ford Madox Brown (1821–1893). 'All people who leave their native lands can identify with this picture: leaving behind friends and family and facing an uncertain future in another country.' Saleem Ayub. Courtesy of Birmingham Museums and Art Gallery.

Saleem Ayub came from Pakistan to live in Birmingham in 1970. He studied painting at Leicester School of Art.

The Last of England, by Ford Madox Brown (1821–93)

All people who leave their native lands can identify with this picture: leaving behind friends and family and facing an uncertain future in another country. I could put myself in the child's position (revealed only by its tiny hand), having come here from Pakistan with my parents. The hands providing comfort make it all the more poignant.

In the following set, the selectors bring in references to people who are important to them. In selecting an object and writing about it, they are also saying something about their personal relationships.

Saleem Ayub chose a totem figure and wrote about it with the help of his daughter:

Totem pole figure made by the Kwakiutl people of British Columbia, Canada, and a 'Totok' figure from Papua New Guinea: late 19th century

I particularly chose these because on my every visit to the museum my daughter Nadia (7 years) would ask to see them. She would never have forgiven me if they were not included. So, she in her own words is the best person to say why she likes them: '*I like the totem pole because of its colour and I feel that it is scared and there's a monster in front of him.*'

The relationships identified may not necessarily be family ones. Here, Philip Davis is reflecting on relationships with the women who have been important influences on his life:

Magda Mierwn, ul Nawojki, Krakow, August 1984
Craigie Horsfield (born 1949)

When I first saw this I was overwhelmed by the emotion of the picture. Gradually I realised how ambivalent it is. The sitter has both an open and closed posture, is advancing and retreating, dark and light, masculine and feminine. But above all she expresses both her power and vulnerability in a way which diminishes neither. At various times I have had important mentors, who have been women who have had this quality of showing both powerfulness and vulnerability. Indeed the only people I really trust are those who have the power to show their weaknesses.

John Ellard has two grown-up children, and memories of them visiting the museum with him are in this label:

Cased displays of dippers and guillemots and puffins

I have chosen this display to represent the Beale collection which I have known and admired since I first visited the museum in 1962. The naturalistic settings in which the taxidermists display the birds are works of art in their own right. My daughter and son have also been fascinated by these displays over the years, and I recall their giggles when they first noticed the naturalistic bird droppings.

In the next set, something of personal experience emerges. Megan Hughes was born in Barbados in 1948 and has had a visual impairment from birth. In her choice of objects, there is a heightened awareness of the tactile nature of things and the sounds they make. She chose a Zulu beaded girdle, a stuffed fox, a bull-roarer from New Guinea and a policeman's rattle. This is the label she wrote for a tunic and a riding suit she chose:

Tram driver's tunic, Birmingham City Council issue, *c.* 1925–30, and a riding suit made by R. E. Scudamore of Leominster, *c.* 1920

I often take the arms of people in uniforms and often wonder how they feel about wearing them. Examining one without a human being inside, it is clear these old uniforms were built to last. The riding habit is also intriguing. The places where you are in contact with the horse are incredibly reinforced. How fashion and function have parted company! Now jodhpurs are a fashion item, really tight-fitting and revealing the figure.

Carl Chinn was born in Birmingham and is now a lecturer at the University. He writes a column for the *Evening Mail* and chats about local history on local radio. He chose material that is fundamental to his work as a community historian and of which he has much experience, oral history and old photographs.

Extracts from the City Sound Archive

Stories are what made most of us interested in history. Stories of the day-to-day lives of our mums and dads and nans and granddads are vivid and real and pull us into the past. But for much of history the voice of our people has been ignored. No longer. The coming of tape recorders has opened up the past and made it more democratic. Most of all they have given us the chance to pass on our memories and those of our forebears – making sure that they'll never be forgotten.

Photographs of a charabanc trip from Nechells, 1923; the Abbiss family, *c.* 1919; the Scragg family, *c.* 1941

Photographs speak to us. The faces of the past look at us and tell us things. They talk to us of high days and holidays, of sadness and sorrow, of special events and everyday occurrences. Photographs not only bring the past into the present but also they take us back into the past. They urge us to make the great leap of imagination to wonder what it was like and how the faces grabbing us felt.

Najam Mughal chose another image of Birmingham, and on the label she records her own experience of the city and compares it with the detail it contains:

A view of Birmingham from Highgate, 1845

What I noticed first was not the rendering of a cow where the Grand Prix circuit should be, or even the lack of communications tower on the sky-line, but the bustle of industry in the distance which is still recognisable today.

Letting go of the mind to allow it to play with the material chosen can be a moment of liberation. In this set, selectors have been happy just to respond. Jo Wibberley, a 21-year-old student, could not help but choose:

Stuffed mole

This is one of those things you see and think 'yes, I want it'. I have no explanation why. I like its smooth skin and the tiny toes and hands sticking out at the sides.

Philip Davis chose a rather special armchair:

Pearwood armchair for the Servants' Hall, Aston Hall, English, 18th century
This is a lovely example of a simple plain piece of furniture. It looks just right. The colour is so rich and warm that the chair demands to be sat on. However, to a Terry Pratchett fan, the real joy of the chair is that it is made of sapient pearwood. On cold winter nights it grows little feet and walks across the room to be that little bit nearer the warmth of the fire.

Paulette Burkill allowed herself to think about the feelings within this piece:

***Paolo and Francesca*, marble, Alexander Munro (1825–71) 1852**
It's hard to believe that such tenderness and shyness can be conveyed by a lump of cold marble – you can almost sense her blushing – and being able to walk all round it is an added bonus. I like the details like the feather in his hat and his totally impractical shoes!

Many of the writers decided to choose things which they already knew something about and by doing so were both exploring what they know and connecting themselves to that knowledge.

Sayfur Rahman (11) from Canterbury Cross Primary School chose:

Egyptian mummified crocodile *c*. 1500–500 BC
I chose this because when I learnt about the Ancient Egyptians I found it very astonishing. I found out that they were very artistic, with their hieroglyphics and the beautiful mummy cases. Mummies are very interesting and tell us what the Egyptians did when people died. I was really amazed to see a mummified crocodile because I didn't know that animals were mummified. If I choose this a lot of people will be overwhelmed as well. Just before it died the crocodile had eaten a fish. If the crocodile is seen on an x-ray view you can see the skeleton of the fish.

Fred Dixon, a mature student at Birmingham University studying Bronze Age archaeology, chose a number of things to which he could link to his studies and his own interests, including this:

Pottery 'Cult Chalice' found in a tomb at Vounous, Cyprus, *c*. 2600–2300 BC
Evokes so many images. What was its place in religious ceremony? What was the purpose of the objects around the rim? How many dark secret rituals has it witnessed?

Two pottery 'stirrup jars': left Mycenaean Greek, *c*. 1300 BC; right Cyprus, *c*. 1100–1050 BC
The epitome of Aegean Late Bronze Age utilitarian vessels. They carried everything from wine to perfume to oil all over the Mediterranean, the equivalent of today's plastic bottles.

As the ideas on constructivism suggest, it is very likely that your reading of this text, especially the chosen labels cited above, will be an individual matter. Therefore how you have read them and what you have read into them, although perhaps influenced by the structure of this book, may not necessarily accord with its intent. When I read them, I am touched by the diversity of human responses to this material and how much of the individual behind each of the labels comes through in what they have written. I sense both the person writing the label and the objects they have in their sight when writing it. For some, this might be construed as an emotional reading, certainly one not devoid of feeling.

Emotion, like irrational thought, is as Silverman, quoted previously, confirms; it is something about which the museum has had little concern. Yet emotion is often at the heart of inter-generational or personal experience, in both the museum visit and all situations. Memories of the past and the imagination experienced in the present will both be couched in feelings – such as pride, anger, affection, dismay – determined by how something has been experienced or is being experienced. Having an audience for the narrating of a memory, association or random thought allows the acting out of these feelings. It has been argued that emotion is considerably more than an internal reaction to an external stimuli and that 'getting emotional' operates within the social and cultural worlds of the individual (Parkinson, 1995). Emotions are not just internal impulses, but the way we communicate who we are or want to be with others. It is the power behind the memory and how it is received. Perhaps this is what fuels the dream space and the flux of the rational and the irrational that museum visits can provoke.

I conclude by giving an example of this drawn from personal experience. On the visit to Big Pit Mining Museum in Blaenafon with my father which I described above, we saw an exhibition of photographs of men working underground. One of the photographs was of a group of men eating their crib (food) by the light of their lamps. One of the photographs had a caption of a miner's memory of a scene such as this. It told of how, during the course of one week, one of the men in a group like this had chosen to sit in the dark during the break. Only at the end of the week, when the man fainted, did they understand why. He had no food to bring to the mine for his break because that was the week when he had had to buy new shoes for his children. We read this silently together and I said, 'Doesn't that make you so angry?', and my father replied, 'No, it do make me want to bloody weep.' I turned and saw that there were tears in his eyes, and he started to walk away.

20 *Memory spaces, dreams and museums*

So at the end, where does all of this take us? I have been covering several large and hitherto disparate fields: memory, psychology and life spans, oral history, memories and objects, reminiscence work and museum visiting. Each of these warrants a volume in its own right, even more so when one considers that the contextual, theoretical and practical issues of each are extensive if considered within the frameworks of modern Western museums. So perhaps a book like this cannot do them justice, and I am just putting up signposts to larger territories and providing outline maps, however crudely drawn.

It seemed to me at the outset that it would be self-defeating and possibly disempowering to divide these territories of memory one from another. Surely we need to know more about reminiscence in order to improve approaches to oral history and achieve a greater awareness of cross-generational exchanges in order to get closer to understanding the nature of the history museum visit. Thoughts on recording the contexts of objects also relate to the ways in which such material is ultimately understood and handled. Memories do not stop being memories or in some way become vastly different because they are prompted by an expert historian asking an astute question, a reminiscence worker placing a weaver's shuttle in someone's hands, or a man telling his partner of what something in a display reminds him. The context and something of the relationships may be different and to a degree may shape the responses, but these are all memory-based episodes nevertheless. Moreover, they are encounters that are very typical of and often specific to a museum.

Understanding at least some of this could be imperative, especially if history museums are to fulfil all the expectations they raise. In general terms, museums seek useful social and educational roles. History museums aim to enable meaning and to prompt effective, critical exploration of the past. When they do this, they also have the potential to enable meaning not just in a broad sense but specifically within people's lives. This can be as much a private as a public act, and may have repercussions outside the perimeters of time and space that constitute the museum operation. If an exhibit makes someone cry or howl with laughter, or an interview or perhaps a handling session prompts unexpected elements of recall, this is not curtailed once the museum's doors are closed and the curator has gone home.

If this is understood, a greater alertness about both the power and problems of the dream space, that is, of the individual capacity for feelings, creative

thought and remembering, will follow. Moreover, if history museums succeed in getting closer to fuller records of the past, responsibility needs to be taken for their actions and interactions in people's lives. In this view, the dream space becomes central to both the purpose and experience of museums. Indeed this may well be where something of their magic and potential lies; but thereto also may lie their dullness and delusions. Just like dreams, they can provide comfort or disturbance, and be a source of refreshment or dismay.

In this final chapter, I must say something of what I feel this work may mean for history museums of the present and future. I frame this around four themes that the book has thrown up for me: individuality of memory; orientations of memory and history; the Western capacity to hold on to the past and its reluctance to let go; and finally something on the dream space.

Remembering our selves

By putting the emphasis on the individual, I do not wish to minimalize the ways in which the cultural frameworks and political systems, in which we all find ourselves, condition and influence us. That I have not dealt with this at length is in part due to the fact that a significant element of museum studies literature has taken this approach and I have chosen not to cover this ground once again (e.g. MacDonald and Fife, 1996; MacDonald, 1997). As a historian, I am conscious of the fact that I am a product of my class and upbringing and that this, along with my gender, sexuality and beliefs, informs the configurations of my approach to life. Could it be otherwise? How could any of us be exceptions to this? But underneath all of this is an individuality as distinctive as a signature.

Interest in people as people can be at the very heart of history museum work, as it is within the broader field of historical scholarship. Nevertheless, more traditional approaches to both historiography and history curatorship have reductionist tendencies; that is, they can be given over to generalization. Unfortunately this may achieve what Evans has identified as the 'virtual elimination of the individual human being in favour of anonymous groups and trends'. Thus a reconstructed workshop in an open-air museum or a display of carts and wagons or a group of china dolls in a glass case are offered as being 'typical of the area': a grand museum-style generalization. There they are, exhibited with the memories, dreams and associations of each stripped away and discarded. Evans hammers the point home: 'To reduce every human being to a statistic, a social type, or the mouthpiece of a collective discourse is to do violence to the complexity of human nature, social circumstances and cultural life' (Evans, 1997: 189). In order not to overlook the circumstances and conjunction of events that restrict or enable individuals, it is perhaps useful to be reminded by Evans of Marx's dictum that people make their own history, but they do not do it in circumstances of their own choosing.

None of us are islands unto ourselves, but we are nevertheless 'our selves' and no one else. For many historians, the addictive nature of historical enquiry and scholarship has been driven by a passion to gain some sort of purchase on how people have interacted within the circumstances in which they find themselves, and how these circumstances have altered them and the life paths they have followed. The past happened; it can be studied. With care, scrupulous attention

to evidence and a constant state of enquiry, something of how and why things happened can be retraced and thought about: this is the project with which historians and history museums of quality are largely engaged.

But it is also part of our personal project. Memories and individual perspectives can be subversive, challenging and disruptive. Nothing bursts the pretensions of formal histories more effectively than someone declaring with the kind of confidence that authority brings: 'I don't know where they have got that from. It wasn't like that for me. They've got it wrong.' For someone to arrive at the position where they can say such things, some process of remembering has had to have taken place. With this will come a development of identity. Although we try to avoid recall or deflect it, build it into something else or invent it, memories catch up on us all the time. They make us and we make them. When conscious, the process never stops completely. We are in a constant state of being reminded and are perpetually using our memories. You have now reached page 172 and have not forgotten the art of reading – it got you here to this moment. Who you are in yourself is enabling you to interact with this text in ways I cannot predetermine with any accuracy, although I can make some assumptions and generalizations.

Remembering well

In theory at least, historians work towards accounts which are as accurate and judiciously balanced as the sources and circumstances allow. In our own lives we attempt to remember as fairly and fully as we can. But the memories we have, like the histories we make or engage with, are neither pure nor innocent. Nor can they be a totally exact representation of the past. The reliability of the unreliability of evidence, however it comes, is defined in this moment and may be changed in the next. So too can the motivation behind the shape given to the narrative and from this the interpretation offered. This may be with malicious intent. It could be with careless abandon or determined attention to detail. But it will always be approached with some facet of being human, however disciplined or flawed.

Mixed up with both formal histories and personal memories are an intricate web of feelings and a sense of identity. We remember childhood well or badly according to the feelings we hold about childhood experience and recount it in a form suitable to the narrator's role. Talking about memories of childhood to parents, siblings, friends, counsellors or our own children will involve different patterns, each influenced by the role played. Similarly, historians make histories which are influenced by their own perspectives and experiences. The degree to which empathy and insight are achieved must to some degree be influenced by a personal capacity. Historians can be trained to be alert to the nuances of texts and the techniques of interrogating sources, but the capacity to come really close to understanding may be more of a personal matter. It is an old adage that history is written by the winners. It is also written by people saying something about themselves, whether or not they realize it.

We live with both good and bad memories and good and bad histories. We can use the past as a constructive influence. Knowing something can enrich our lives. It can provide us with intellectual stimulus and the stuff from which our

imaginations can soar. It can illuminate falsehoods and misconceptions. It can shine light on dark areas of the past and equip us with a better understanding of issues of cause and effect. It can empower us through recognition of both continuity and discontinuity. It can reclaim that which is hidden, obscured or forgotten. These are the outcomes of scholarly historical study as much as the candid and open exploration of life experiences held in memories. By the same token, sloppy scholarship or a covert personal mission will have the reverse effects, and in between there are many shades of grey.

Museums are placed within this complex web. They make histories and they provoke memories. Further, they make histories from memories and also enable the release of both. In this they can be destructive or constructive, depending on the sensitivity, depth of understanding and scholarship they apply. There is no real parallel with the museum and the ways it works with such a complete spectrum of evidence. By using objects, images and voices, museums permit multi-sensory engagement with ideas of the past. By opening up histories otherwise confined to the spoken word and printed page and by refusing to speak solely to peer groups, history in museums has the potential to be one of the most effective and thought-provoking means of generating debate about the past, whether this be personal or social.

Holding on and letting go

It is accepted that a key to our well-being is how we come to terms with our memories. People who hold on to grievances, who revisit past difficulties without achieving some form of resolution, have a problem moving on and being at peace with themselves. Some scars do not heal; we just become better able to deal with them, possibly to the point where they don't hurt any more and resolution is achieved.

There is a parallel here with history and with the work of museums. When should we hold on to the past? When should we let go? Where does remembering empower us by enhancing self-knowledge and value, and at what point does this degenerate into self-obsession and futility? Much has been made of the growth of the heritage industry and what is seen as a barely disguised mania to retain all things and resist the future. Through their collections, museums sanctify some forms of remembering, yet also endorse forgetting. The gaps and breaks in museum holdings signify those things which have been ignored or allowed to slip away. But that which *is* held is held with tremendous determination, and considerable resources are devoted to this end, irrespective of whether all that is retained is worthy. So concerned are curators not to make the wrong decisions about what is included and excluded from collections that acquisition policies are vital documents and the option for disposal is seen as the absolute last resort. The underlying reasons for collecting within the Western tradition are rarely examined from a psychological perspective.

David Lowenthal, however, provides a perspective on this. He reminds us that through the Native American Graves and Repatriation Act of 1991 a million and a half ritual and cultural objects will go back to the First Nations. There is an expectation that half of these will be buried, exposed to the elements or destroyed for purposes of purification, as happened in Australia following the

return of bones and grave goods to Aborigine groups. Lowenthal quotes the response of a white museum curator to this, when at a meeting:

> one Native American activist said 'why do white people need to know all of this stuff? Why can't they just let it go?' Listening I had a visceral reaction of horror. I knew he had hit on something very sacred to *my* culture. The thought of deliberately letting knowledge perish was as sacrilegious to me as the thought of keeping one's ancestors on a museum shelf was sacrilegious to the Indians in the audience.
>
> (Lowenthal, 1996: 30)

We have to acknowledge that there are profound and disturbing issues here about appropriation, the marginalization of one group by another and the struggle for recognition and self-determination that still goes on. Moreover, the material under question is substantially that of human remains and grave goods. The interference in the legitimacy of others is perhaps at its most distasteful and insulting when the dead are disturbed and their rites of passage violated.

Nevertheless, the point about when to hang on and when to let go can be carried across other materials and subjects, and comes back to how we remember and record. History museums can often be found to contain material that is strikingly alike, such as flat-irons, vintage cars, fiddle drills and packaging. It could be argued that this is the result of centuries of consumption and consumerism and that mass production has guaranteed a certain uniformity in our material culture. But the configurations of what is collected may owe more to what is deemed to be worth remembering and notions of what museums should contain. The sets of keys, TV remote control unit and bottle of whisky, symbolic in the eyes of three women subjected to domestic violence, or the little woollen baby jacket kept by a woman (discussed in Chapter 12) are not often the kinds of things which museums collect. Most museums do not seek to acknowledge such experiences, nor the individual histories behind them. The fact that they say something about the human condition and social history does not come into consideration. Generality is safer, even if it offers a tonnage of unprovenanced material. It suggests the veneer of holding on to objects while covering up the letting go of human experience. It eliminates the untidiness of human experience. Reminiscence work is one of the ways this can be exposed and reversed.

Dream spaces

Acceptance of dream spaces could lead museums to work in ways that are both more responsive and responsible. But the larger question still remains: How do we come to understand the operation of dream space within the context not just of museums, but in our lives as a whole? Why do we ever need to move beyond the rational and the cognitive, given that these are fundamental to our development? Why do we spend time 'dreaming' at all?

For the human species, just like any other, the primary need is to survive and reproduce. Yet people spend time and derive pleasure from activities which seem pointless. Indeed, telling stories, reciting poetry, decorating surfaces, remembering things that have no survival value are aspects of our humanity. Pinker (1999) asks what is it about the mind that lets people take pleasure in

shapes and colours and sounds and stories and myths? His answer is that the brain allows the senses in particular to engage in such delights as a means of lifting the capacity for instruction and cognitive adaptation. Thus sex is so much more potent when love is involved and love is an emotion stimulated greatly by the senses. Eating is so much more pleasurable where the taste-buds are stimulated, even surprised, and living is so much more comfortable and secure if the shelter is not just a shelter but a personalized home. In other words, we are even better at reproduction and survival if we are also capable of engagement with the dream spaces, and three trillion synapses in the brain are the guarantee of this.

Such thinking has little room for identifying the dream space as more than a cocktail of that which is electrical, chemical and physiological. For others, such explanations construe a landscape that is bare and desolate. It seems to deny any possibility of collective wisdom or mysterious abstraction. In these circumstances, trying to understand the intellectual, aesthetic and artistic power within us becomes something to which philosophy, even belief, might be applied (Vallely, 1999).

Eastern philosophy has some interesting contributions to make. The *Yoga Sutras of Patanjali* are thought to date from at least AD 300, and may possibly be older. In these, Patanjali wrote of the five aspects (*vritti*) of the mind: right knowledge, wrong knowledge, imagination (or imaginary knowledge), sleep (no knowledge) and memory (past knowledge). Memory is further divided into conscious memory, that is, the recollections of things already experienced, and subconscious memory that is dream, where one does not consciously remember but remembers unconsciously. The memory may be of two kinds: the one imaginary, the other real. In this philosophy every dream has a basis and no dream is baseless. Swami Satyananda Saraswati explains that memory, in particular subconscious memory, brings out 'the impressions of the preconscious and unfolds them on the conscious plane' and that this is one of the faculties of our consciousness (Saraswati, 1989: 59).

This philosophy contends that enlightenment lies within and not outside ourselves. Sri Swami Satchidananda has this to say:

> turning inside means turning the senses within: trying to hear something within, see something within, smell something within. All scents are within us. All beautiful music is within us. All art is inside us. Why should we search, running after museums and gardens, when every museum and garden is inside of us?
>
> (Satchidananda, 1978: 123)

Perhaps this may point the way to understanding the dream space which people find in museums. It is where our inner experiences find a mesh with the outer experiences which museums provide.

Bibliography

Age Concern England http://www.ace.org.uk/

Almqvist, B. (1979) *The Irish Folklore Commission: Achievement and Legacy*. Dublin: Irish Folklore Commission.

American Association of State and Local History (1997) *Statement of Professional Ethics*. Nashville: AASLH, http://www.aaslh.org

Anderson, D. (1997) *A Common Wealth: Museums and Learning in the United Kingdom*. London: Department of National Heritage.

Anderson, K. and Jack, D.C. (1991) 'Learning to listen: interview techniques and analyses', in S.B. Gluck and D. Patai (eds), *Women's Words: The Feminist Practice of Oral History*. London: Routledge, pp. 11–26.

Annis, S. (1987) 'The museum as a staging ground for symbolic action', *Museum*, **151**: 168–71.

Asch, S.E. (1952) *Social Psychology*. London: Bailey and Swinfen.

Balint, M. (1968) *The Basic Fault: Therapeutic Aspects of Regression*. London and New York: Tavistock.

Bell, J. (1991) 'The farming and food exhibition at Cultra', *Museum Ireland*, **1**: 31–3.

Bell, J. (1994) 'Social anthropology and the study of material culture in Irish museums', *Anales del Museo Nacional de Antropología*, **1**, 163–71.

Bell, J. (1996) 'Making rural histories', in G. Kavanagh (ed.), *Making History in Museums*. Leicester: Leicester University Press, pp. 30–41.

Bell, J. and Watson, M. (1986) *Irish Farming*. Edinburgh: Donald.

Bender, M.P. (1992) 'Reminiscence groupwork in a museum', *Reading Therapy Newsletter*. 4(1): 9–16.

Bender, M.P., Norris, A. and Bauckham, P. (1987) *Groupwork with the Elderly*. London: Winslow.

Birren, J.E. and Deutchman, D.E. (1991) *Guiding Autobiographical Groups for Older Adults*. London: Johns Hopkins University Press.

Blakemore, K. and Boneham, M. (1994) *Age, Race and Ethnicity: A Comparative Approach*. Milton Keynes: Open University Press.

Blatti, J. (1990) 'Public history and oral history', *Journal of American History*, **77**: 615–25.

Boden, D. and Bielby, D. (1983) 'The past as a resource: a conversational analysis of elderly talk', *Human Development*, **26**: 208–319.

Boden, D. and Bielby, D. (1986) 'The way it was: topical organization in elderly conversation', *Language and Communications*, **6**: 73–89.

Bodnar, J. (1990) 'Power and memory in oral history: workers and managers at Studebaker', in D. Thelen (ed.), *Memory and American History*. Bloomington and Indianapolis: Indiana University Press, pp. 72–92.

Bond, J., Coleman, P. and Peace, S. (1993) *Ageing in Society: An Introduction to Social Gerontology*. London: Sage.

Bonniface, P. and Fowler, P.J. (1993) *Heritage and Tourism in the Global Village*. London: Routledge.

Borland, K. (1991) ' "That's not what I said": interpretative conflict in oral narrative research', in S.B. Gluck and D. Patai (eds), *Women's Words: The Feminist Practice of Oral History*. London: Routledge, pp. 63–75.

Bornat, J.(ed.) (1993) *Community Care; A Reader*. London: Macmillan.

Bornat, J. (ed.) (1994) *Reminiscence Reviewed: Perspectives, Evaluations, Achievements,* Buckingham: Open University Press.

Bornat, J. (1997) 'Reminiscence reviewed', in *Widening Horizons in Dementia Care, A Conference of the European Reminiscence Network: Conference Papers.* London: Age Exchange, pp. 34–9.

Bower, G.H. (1981) 'Mood and memory', *American Psychologist,* **36**(2): 129–48.

Boyes, G. (1993) *The Imagined Village: Culture, Ideology and the English Folk Revival.* Manchester: Manchester University Press.

Brace, D., Clark, H. and Greig, E. (1998) *Newhaven: Personal Recollections and Photographs.* Edinburgh: City of Edinburgh Council.

Brewer, J. (1997) *The Pleasures of the Imagination: English Culture in the Eighteenth Century.* London: HarperCollins.

Brigden, R. (1993) 'Collecting methods: recording information with objects', in D. Fleming *et al.* (eds), *Social History in Museums: A Handbook for Professionals.* London: HMSO, pp. 197–201.

Briggs, A. (1959) *The Age of Improvement.* London: Longman.

Bringeus, N.A. (1974) 'Artur Hazelius and the Nordic museum', *Ethnologia Scandinavica,* **2**: 5–16.

Britton, D.F. and Britton, J.D. (1994) *History Outreach: Programs for Museums, Historical Organizations and Academic History Departments.* Malabor: Krieger Publishing Co.

Bromley, D.B. (1990) *Behavioural Gerontology: Central Issues in the Psychology of the Aged.* Chichester: John Wiley.

Bruley, S. (1996) 'Women's history, oral history and active learning', *Women's History Review,* **5**(1): 111–27.

Burne, J. (ed.) (1957) *The Handbook of Folklore.* London: The Folklore Society.

Burne, J. (1997a) 'Time to get off the couch?', *Independent on Sunday,* 27 April.

Burne, J. (1997b) 'Therapists who needs them?' *Independent,* 28 June.

Burnett, J. (ed.) (1984) *Useful Toil: Autobiographies of Working People from the 1820s to the 1920s.* London: Penguin.

Burnham, J.B. (1986) *Family Therapy.* London: Routledge.

Bushaway, B. (1982) *By Rite: Custom, Ceremony and Community in England 1700–1880.* London: Junction Books.

Butler, R.N. (1963) 'The life review: an interpretation of reminiscence in the aged', *Psychiatry,* **26**: 65–76.

Calder, A. and Sheridan, D. (eds) (1984) *Speak for Yourself: A Mass-Observation Anthology 1937–49.* London: Jonathan Cape.

Carnegie, E. (1996) 'Trying to be an honest woman; making women's histories', in G. Kavanagh (ed.), *Making History in Museums.* Leicester: Leicester University Press, pp. 54–65.

Cassels, R. (1992) 'Mind, heart and soul: toward better learning in heritage parks', *New Zealand Museums Journal,* **22**(2): 12–17.

Clark, H. (1988) 'Changing relationships between museums and the community', in L. Beevers, S. Moffat and H. Clark, *Memories and Things: Linking Museums and Libraries with Older People.* South East Scotland District, Edinburgh: WEA, pp. 17–21.

Clark, H. and Marwick, S. (1992) 'The People's Story – moving on', *Social History Curators Group Journal,* **19**: 21–7.

Clark, H., Dick, L. and Fraser, B. (1996) *Peoples of Edinburgh: Our Multicultural City. Personal Recollections, Experiences and Photographs.* Edinburgh: City of Edinburgh Council.

Clark, J. (1993) 'Any old iron?', *Museums Australia Journal,* **91–2**: 57–62.

Classen, C. (1993) *Worlds of Sense: Exploring the Senses in History and Across Cultures.* London: Routledge.

Coleman, P. (1986) *Ageing and Reminiscence Processes: Social and Clinical Implications.* Chichester: John Wiley.

Coleman, P. (1993) 'Psychological ageing', in J. Bond *et al.* (eds), *Ageing in Society.* London: Sage Publications, pp. 68–96.

Coleman, P. (1994) 'Reminiscence within the study of ageing; the social significance of story', in J. Bornat (ed.), *Reminiscence Reviewed: Perspectives, Evaluations, Achievements.* Buckingham: Open University Press, pp. 8–20.

Connerton, P. (1989) *How Societies Remember.* Cambridge: Cambridge University Press.

Conway, M. (1992a) 'A structural model of autobiographical memory', in M. Conway *et al.* (eds), *Theoretical Perspectives on Autobiographical Memory.* Dordrecht: Kluwer Academic Publishers, pp. 167–94.

Conway, M. (ed.) (1992b) *Theoretical Perspectives on Autobiographical Memory.* Dordrecht: Kluwer Academic Publishers. (Proceedings of the Nato Advanced Research Workshop on Theoretical Perspectives on Autobiographical Memory, Grange-over-Sands, UK, 4–12 July 1991)

Conway, M. (ed.) (1997) 'Introduction: What are memories?' in M. Conway (ed.) *Recovered Memories and False Memories.* Oxford: Oxford University Press, pp. 1–22.

Conybeare, C. (1998) 'Look who's talking', *Museums Journal*, May: 27–9.

Cooper, G. (1997) 'Recovered memory therapists backed by survey', *Independent on Sunday*, 6 April.

Copp, C. (1994) 'Researching popular culture: a case study – Boxing Harborough', *Journal of the Social History Curators Group*, **21**: 53–6.

Cornwell, J. and Gearing, B. (1989) 'Biographical interviews with older people', *Oral History*, Spring: 36–43.

Coupland, N. and Nussbaum, J. (eds) (1993) *Discourse and Life Span Development.* Newbury Park, CA: Sage Publications.

Crawford, K. (1992) *Emotion and Gender: Constructing Meaning from Memory.* London: Sage Publications.

Crew, S.R. and Sims, J. (1990) 'Locating authenticity; fragments of a dialogue', in I. Karp and S.D. Lavine (eds), *Exhibiting Cultures: The Poetics and Politics of Museum Display.* Washington, DC: Smithsonian Institution Press, pp. 159–75.

Csikszentmihalyi, M. (1993) 'Why we need things', in S. Lubar and W.D. Kingery (eds), *History from Things: Essays on Material Culture.* Washington, DC: Smithsonian Institution Press, pp. 20–9.

Csikszentmihalyi, M. and Robinson, R.E. (1990) *The Art of Seeing: An Interpretation of the Aesthetic Encounter.* Malibu: J. Paul Getty Museum and Getty Center for the Education in the Arts.

Cumming, E. and Henry, W. (1961) *Growing Old: The Process of Disengagement.* New York: Basic Books.

Cutler, W. (1996) 'Accuracy in oral history interviewing', in D.K. Dunaway and W.K. Baum (eds), *Oral History: An Interdisciplinary Anthology.* Walnut Creek: Altamira Press, pp. 99–106.

Davies, D.G. and Davies, K. (1996) *A Burning Issue: A Survey of Welsh Coal Mining Collections.* Cardiff: The Council of Museums in Wales.

Davies, S. (1985) 'Collecting and recalling the twentieth century', *Museums Journal*, **85**(1): 27–30.

Davies, S. (1994) *By Popular Demand: A Strategic Analysis of the Market Potential for Museums and Art Galleries in the UK.* London: Museums and Galleries Commission.

Dawson, G. (1996) 'Letter to the editors', *Journal of the Oral History Society*, Spring: 26–8.

Department of Irish Folklore (1985) *I gCuimhne Na nDaoine.* Dublin: University College.

Dex, S. (ed.) (1991) *Life and Work Analysis: Qualitative and Quantitative Developments.* London: Routledge.

Dobrof, R. (1984) 'Introduction: a time for reclaiming the past', in M. Kaminsky (ed.), *The Uses of Reminiscence: New Ways of Working with Older Adults*. New York: Haworth Press.

Dodd, J. and Sandell, R. (1998) *Building Bridges: Guidance for Museums and Galleries on Developing New Audiences*. London: Museums and Galleries Commission.

Duffin, P. (1989) 'Reminiscence: at the sharp end', *Oral History*, Spring: 15–21.

Dunaway, D.K (1996) 'The interdisciplinarity of oral history', in D.K. Dunaway and W.K. Baum (eds), *Oral History: An Interdisciplinary Anthology*. Walnut Creek: AltaMira, pp. 7–22.

Durbin, G. (ed.) (1996) *Developing Museum Exhibitions*. London: The Stationery Office.

Echevarria-Howe, L. (1995) 'Reflections from the participants: the process and product of life history work', *Oral History*, Autumn: 40–6.

Edwards, N. (1996) 'The Open Museum: Glasgow Museum', *Museum Practice*, 1(3): 60–3.

Elinor, G. (1992) 'Stolen or given: an issue in oral history', *Oral History*, Spring: 78–80.

Elliott, R., Eccles, S. and Hodgson, M. (1993) 'Re-coding gender representations: women, cleaning products and advertising's "new man"', *International Journal of Research in Marketing*, 10(3): 311–24.

Erikson, E.H. (1950) *Childhood and Society*. New York: Norton.

Erikson, E.H. (1965) *Childhood and Society*. Harmondsworth: Penguin.

Ettema, M. (1987) 'History museums and the culture of materialism', in J. Blatti (ed.), *Past Meets Present; Essays about Historic Interpretation and Public Audiences*. Washington, DC: Smithsonian Institution Press, pp. 62–85.

Evans, Ewart G. (1987) *Ask the Fellows Who Cut the Hay*. London: Faber. Originally published 1956.

Evans, Ewart G. (1960) *The Horse in the Furrow*. London: Faber.

Evans, Ewart G. (1966) *Pattern under the Plough*. London: Faber.

Evans, Ewart G. (1970a) *Spoken History*. London: Faber.

Evans, Ewart G. (1970b) *Where Beards Wag All: The Relevance of Oral Tradition*. London: Faber.

Evans, Ewart G. (1983) *The Strength of the Hills*. London: Faber.

Evans, R.J. (1997) *In Defence of History*. London: Granta Books.

Falk, J. (1993) *Leisure Decisions Influencing African American Use of Museums*. Washington, DC: American Association of Museums.

Falk, J. and Dierking, L. (1992) *The Museum Experience*, Washington, DC: Whalesback Books.

Fivush, R. (1994) 'Long term retention of infant memories', *Memory*, 4: 337–475.

Fivush, R. and Reese, E. (1992) 'The social construction of autobiographical memory', in M. Conway *et al*. (eds), *Theoretical Perspectives on Autobiographical Memory*. Dordrecht: Kluwer Academic Publications, pp. 115–34.

Fivush, R. *et al* (1997) 'Events spoken and unspoken: implications of language and memory development for the recovered memory debate', in M. Conway (ed.), *Recovered Memories and False Memories*. Oxford: Oxford University Press, pp. 34–62.

Fleming, D., Paine, C. and Rhodes, J.G. (eds) (1993) *Social History in Museums: A Handbook for Professionals*. London: HMSO.

Forty, A. (1986) *Objects of Desire: Design and Society 1750–1980*. London: Thames and Hudson.

Fraser, W. Hamish (1981) *The Coming of the Mass Market 1850–1914*. London: Macmillan.

Frisch, M. (1990) *A Shared Authority: Essays on the Craft and Meaning of Oral and Public History*. Albany: State University of New York Press.

Fussell, A. (1997) 'Collecting for Lifetimes: the interactive museum about Croydon people', *Nordisk Museologi*, 1: 39–56.

Gardner, H. (1993) *Frames of Mind: The Theory of Multiple Intelligences*. London: Fontana Press.

Gibson, F. (1989) *Reminiscence with Individuals and Groups: A Training Manual*. London: Help the Aged.

Gibson, F. (1994) *Reminiscence and Recall: A Guide to Good Practice*. London: Age Concern.

Gluck, S.B. and Patai, D. (1991) *Women's Words: The Feminist Practice of Oral History*. London: Routledge.

Greenfield, S. (1995) *Journeys to the Centers of the Mind: Towards a Science of Consciousness*. New York: Freeman.

Greenfield, S. (1997a) 'Enhanced memory? Forget about it', *Independent on Sunday*, 19 January, p. 42.

Greenfield, S. (1997b) *The Human Brain: A Guided Tour*. London: Weidenfeld & Nicolson.

Gregory, R.L. (ed.) (1987) *The Oxford Companion to the Mind*. Oxford: Oxford University Press.

Gregory, R.L. and Colman, A. (1995) *Sensation and Perception*. London: Longman.

Grele, R.J. (1991) *Envelopes of Sound: The Art of Oral History*. New York: Praeger.

Grele, R.J. (1996) 'Directions for oral history in the United States', in D.K. Dunaway and W.K. Baum (eds), *Oral History: An Interdisciplinary Anthology*. Walnut Creek: AltaMira, pp. 62–84.

Grele, R.J. (1998) 'Directions for oral history in the United States', in R. Perks and A. Thomson (eds), *The Oral History Reader*. London: Routledge, pp. 62–84.

Groeger, J.A. (1997) *Memory and Remembering: Everyday Memory in Context*. London: Longman.

Gutmann, D.L. (1987) *Reclaimed Powers: Towards a New Psychology of Men and Women in Later Life*. New York: Basic Books.

Haight, B.K. (1997) 'Use of life review/life story books in families with Alzheimer's disease', in *Widening Horizons in Dementia Care, A Conference of the European Reminiscence Network: Conference Papers*. London: Age Exchange, pp. 71–81.

Haight, B.K. and Hendrix, S. (1995a) 'An integrated review of reminiscence', in B.K. Haight and J.D. Webster (eds), *The Art and Science of Reminiscing: Theory, Research, Methods and Applications*. Washington, DC: Taylor & Francis, pp. 3–22.

Haight, B.K. and Webster, J.D. (eds) (1995b) *The Art and Science of Reminiscing: Theory, Research, Methods and Applications*. Washington, DC: Taylor & Francis.

Haight, B.K. and Webster, J.D. (1995c) 'Memory lane milestones: progress in reminiscence definitions and classification', in B.K. Haight and J.D. Webster (eds), *The Art and Science of Reminiscing: Theory, Research, Methods and Applications*, Washington, DC: Taylor & Francis.

Haight, B.K., Coleman, P. and Lord, K. (1995) 'The linchpins of successful life review: structure, evaluation and individuality', in B.K. Haight and J.D. Webster (eds), *The Art and Science of Reminiscing: Theory, Research, Methods and Applications*. Washington, DC: Taylor & Francis, pp. 179–92.

Harrison, S. (ed.) (1986) *100 Years of Heritage: The Work of the Manx Museum and National Trust*. Douglas, Isle of Man: Manx Museum and National Trust.

Harthill, G. (ed.) (1992) *Hands Up! An Anthology of Writing from the Reminiscence Project on Education by the Centre for Continuing Education 1991–92*. Edinburgh: University of Edinburgh.

Harwit, M. (1996) *An Exhibit Denied: Lobbying the History of the Enola Gay*. New York: Copernicus.

Havighurst, R.J. and Glasser, R. (1972) 'An exploratory study of reminiscence', *Journal of Gerontology*, 27(2): 245–53.

Hazareesingh, S., Kenway, P. and Simms, K. (1994) *Speaking about the Past: Oral*

History for 5–7 Year Olds. Stoke-on-Trent: Trentham Books in association with Save the Children.

Healy, C. (1991) 'Working for the Living Museum of the West', *Australia Historical Studies*, **23**(91): 153–67.

Hein, G.E. (1994) 'Evaluating teaching and learning in museums', in E. Hooper-Greenhill (ed.), *Museum, Media, Message*. London: Routledge, pp. 189–203.

Hein, G.E. (1998) *Learning in the Museum*. London: Routledge.

Hellspong, M. and Klein, B. (1994) 'Folk art and folk life studies in Sweden', in B. Klein and M. Widbom (eds), *Swedish Folk Art: All Tradition Is Change*. Stockholm: Abrams/Kulturhuset, pp. 17–41.

Henige, D. (1982) *Oral Historiography*. Harlow: Longman.

Hepworth, D.H. and Larsen, J.A. (1986) *Direct Social Work Practice: Theory and Skills*. Chicago: Dorsey.

Hewison, R. (1987) *The Heritage Industry: Britain in a Climate of Decline*. London: Methuen.

Hobsbawm, E. and Ranger, T. (1983) *The Invention of Tradition*. Cambridge: Cambridge University Press.

Home Office (1998) *Supporting Families: A Consultation Document*. London: The Stationery Office.

Hood, M.G. (1993) 'After 70 years of audience research, what have we learned? Who comes to museums, who does not, and why?', *Visitor Studies: Theory, Research and Practice*, **7**(1): 77–87.

Hooper-Greenhill, E. (1991) 'A new communication model for museums', in G. Kavanagh (ed.), *Museum Languages*. Leicester: Leicester University Press, pp. 47–62.

Hooper-Greenhill, E. (1992) *Museums and the Shaping of Knowledge*. London: Routledge.

Hooper-Greenhill, E. (1994) *Museums and Their Visitors*. London: Routledge.

Horne, D. (1984) *The Great Museum: The Representation of History*. London: Pluto.

Hoskins, W.G. (1955) *The Making of the English Landscape*. London: Hodder and Stoughton.

Howkins, A. (1988) 'George Ewart Evans 1909–1988', *Oral History Journal*, **16**(2): 6–17.

Howkins, A. (1994) 'Inventing Everyman: George Ewart Evans, Oral history and national identity', *Oral History*, **22**(2): 26–32.

Humez, J.M. and Crumpacker, L. (1979) 'Oral history in teaching women's studies', *Oral History Association Review*, **7**: 53–69.

Huyssen, A. (1995) *Twilight Memories. Marking Time in a Culture of Amnesia*. London: Routledge.

Imperial War Museum (1994) *Department of Sound Records, Oral History Recordings: Gallipoli*. London: Imperial War Museum.

Imperial War Museum (1996) *The Spanish Civil War Collection, Sound Archive, Oral History Recordings*. London: Imperial War Museum.

Jacobs, M. (1982) *Still Small Voice: An Introduction to Pastoral Counselling*. London: SPCK.

Jacobs, M. (1985) *Swift to Hear: Facilitating Skills in Listening and Responding*. London: SPCK.

Jacobs, M. (1988) *The Presenting Past: An Introduction to Psychodynamic Counselling*. London: Harper and Row.

Jenkins, J.G. (1974) 'The collection of ethnological material', *Museums Journal*, **74**(1): 7–11.

Jenkins, K. (1991) *Re-thinking History*. London: Routledge.

Jenkins, K. (1995) *On 'What Is History?' From Carr and Elton to Rorty and White*. London: Routledge.

Jerome, D. (1993) 'Intimate relationships', in J. Bond, P. Coleman and S. Peace (eds), *Ageing in Society: An Introduction to Social Gerontology*. London: Sage, pp. 226–54.

Jerome, D. (1996) 'Ties that bind', in A. Walker (ed.), *The New Generational Contract: Intergenerational Relations, Old Age, and Welfare*. London: UCL Press.

Johnstone, C. (1998) 'Your grannie had one of those! How visitors use museum collections', in J. Arnold *et al.* (eds), *History and Heritage: Consuming the Past in Contemporary Culture*. Shaftesbury: Donhead, pp. 67–78.

Jones, L.A. and Osterud, N.G. (1990) 'Breaking new ground: oral history and agricultural history', *Journal of American History*, **76**: 551–64.

Kaminsky, M. (ed.) (1984) *The Uses of Reminiscence: New Ways of Working with Older Adults*. New York: Howarth Press.

Kavanagh, G. (1990) *History Curatorship*. Leicester: Leicester University Press.

Kavanagh, G. (1991) 'The museums profession and the articulation of professional self-consciousness', in G. Kavanagh (ed.), *Museums Profession: Internal and External Relations*. London: Leicester University Press, pp. 39–55.

Kavanagh, G. (1993a) 'History in museums in Britain: a brief survey of trends and ideas', in D. Fleming *et al.* (eds), *Social History in Museums: A Handbook for Professionals*. London: HMSO, pp. 13–24.

Kavanagh, G. (1993b) 'The future of social history collecting', *Social History Curators Group*, **20**: 61–5.

Kavanagh, G. (1994a) *Museums and the First World War*. Leicester: Leicester University Press.

Kavanagh, G. (ed) (1994b) *Museum Provision and Professionalism*. London: Routledge.

Kavanagh, G. (ed.) (1996) *Making Histories in Museums*. Leicester: Leicester University Press.

Kavanagh, G. (1998) 'Buttons, belisha beacons and bullets: city histories in museums', in G. Kavanagh and E. Frostick (eds), *Making City Histories in Museums*. Leicester: Leicester University Press, pp. 1–18.

Kenyon, J. (1992) *Collecting for the 21st Century: A Survey of Industrial and Social History Collections in the Museums of Yorkshire and Humberside*. Leeds: Yorkshire and Humberside Museums Council.

Kitwood, T. (1990) *Concern for Others: A Psychology of Conscience and Morality*. London: Routledge.

Kitwood, T. (1995) 'The uniqueness of persons in dementia in Europe', in *Widening Horizons in Dementia Care, A Conference of the European Reminiscence Network: Conference Papers*. London: Age Exchange, pp. 96–8.

Kitwood, T. (1997) *Dementia Reconsidered: The Person Comes First*. Buckingham: Open University Press.

Kitwood, T. and Benson, S. (1992) *Person to Person: A Guide to the Care of Those with Failing Mental Powers*. Loughton, Essex: Gale Publishers.

Lambert, M.J., Shapiro, D.A. and Bergin, A.E. (1986) 'The effectiveness of psychotherapy', in S.L. Garfield and A.E. Bergin (eds), *Handbook of Psychotherapy and Behaviour Change*. New York: Wiley.

Lance, D. (1978) *An Archive Approach to Oral History*. London: Imperial War Museum and International Association of Sound Archives.

Lawrence, J. and Mace, J. (1992) *Remembering in Groups: Ideas from Reminiscence and Literacy Work*. London: Oral History Society.

Liebmann, M. (1986) *Art Therapy for Groups: A Handbook of Themes, Games and Exercises*. London: Croom Helm.

Liebmann, M. (ed.) (1990) *Art Therapy in Practice*. London: Jessica Kingsley.

Loewen, J.W. (1995) *Lies My Teacher Told Me: Everything Your American History Textbook Got Wrong*. New York: New Press.

Lord, B. *et al.* (1989) *The Cost of Collecting: Collection Management in UK Museums*. London: HMSO.

Lowenthal, D. (1993) 'Remembering to forget', *Museums Journal*, June: 20–2.

Lowenthal, D. (1996) *The Heritage Crusade and the Spoils of History*. London: Viking.

Lubar, S. (1993) 'Machine politics; the political construction of technological artifacts', in S. Lubar and W.D. Kingery (eds), *History from Things: Essays on Material Culture*. Washington, DC: Smithsonian Institution Press, pp. 197–214.

Lubar, S. and Kingery, W.D. (eds) (1993) *History from Things: Essays on Material Culture*. Washington, DC: Smithsonian Institution Press.

Lummis, T. (1998) 'Structure and validity in oral evidence', in R. Perks and A. Thomson, *The Oral History Reader*. London: Routledge, pp. 269–72.

McAdams, D.P. and Ochberg, R.L. (eds) (1988) *Psychobiography and Life Narratives*. Durham, NC: Duke University Press.

McDaniel, G. (1982) 'Something of value preserving a people's culture', *History News*, 37(2): 12–16.

MacDonald, S. (1992) 'Your place or mine? Or are museums just for people like us?', *Social History Curators Group Journal*, 19: 21–7.

MacDonald, S. (1995) 'Changing our minds: planning a responsive museum service', in E. Hooper-Greenhill (ed.), *Museum Media, Message*. London: Routledge, pp. 165–74.

MacDonald, S. (ed.) (1997) *The Politics of Display: Museums, Science and Culture*. London: Routledge.

MacDonald, S. (1998) 'Croydon: what history', in G. Kavanagh and E. Frostick (eds), *Making City Histories in Museums*. London: Leicester University Press, pp. 58–79.

MacDonald, S. and Fyfe, G. (eds) (1996) *Theorizing Museums*. Oxford: Blackwell.

McGlone, R.E. (1990) 'John Brown's family and Harpers Ferry', in D. Thelen (ed.), *Memory and American History*. Bloomington and Indianapolis: Indiana University Press, pp. 50–71.

McKendrick, N., Brewer, J. and Plumb, J.H. (eds) (1982) *The Birth of a Consumer Society: The Commercialization of Eighteenth Century England*. London: Hutchinson.

McMahon, A.W. and Rhudick, P.J. (1964) 'Reminiscing: adaptational significance in the aged', *Archives of General Psychiatry*, 10: 292–98.

McManus, P. (1993) 'Memories as indicators of the impact of the visits', *Museum Management and Curatorship*, 12: 367–80.

McMoreland, A. (1997) 'I hear it in my heart: music and reminiscence', in *Widening Horizons in Dementia Care, A Conference of the European Reminiscence Network: Conference Papers*. London: Age Exchange, pp. 110–13.

Martin, R.R. (1995) *Oral History in Social Work: Research Assessment and Intervention*. Thousand Oaks, CA: Sage Publications.

Marwick, S. (1995) 'Learning from each other: museums and older members of the community – the People's Story', in E. Hooper-Greenhill (ed.), *Museum Media, Message*. London: Routledge, pp. 140–50.

Maslow, A.H. (1954) *Motivation and Personality*. London: Harper and Row.

Mastoris, S. (1996) 'Outreach with prisoners: Harborough Museum', *Museum Practice*, 1(3): 56–7.

Mastoris, S. and Shaw, L. (1996) 'Museums and reminiscence work', *Museum Practice*, 1(3): 58–9.

Merriman, N. (1991) *Beyond the Glass Case: The Past, the Heritage, and the Public in Britain*. Leicester: Leicester University Press.

Middleton, V.T.C. (1998) *New Visions for Museums in the 21st Century*. London: AIM.

Midwinter, E. (n.d.) 'Europe in retirement; ageing and leisure in the 1990s', in J. Titley (ed.), *Sharing the Wisdom of Age*. London: MAGDA/Age Concern.

Miers, Sir H.A. (1928) *A Report on the Museums and Galleries of the British Isles*. Edinburgh: Carnegie.

Miller, R. (1999) *Four Victorians and a Museum*. London: Farr Out Publications.

Minister, K. (1991) 'A feminist frame for the oral history interview', in S.B. Gluck and D.

Patai (eds), *Women's Words: The Feminist Practice of Oral History*. London: Routledge, pp. 27–41.

Moore, K. (1997) *Museums and Popular Culture*. Leicester: Leicester University Press.

Morrisey, C.T. (1998) 'On oral history interviewing', in R. Perks and A. Thomson, *The Oral History Reader*. London: Routledge, pp. 107–13.

Moss, W. (1996) 'Oral history: an appreciation', in D.K. Dunaway and W.K. Baum (eds) *Oral History: An Interdisciplinary Anthology*. Walnut Creek: Altamira, pp. 107–20.

Museum of London (1998) *Museum of London, Five Year Strategic Plan 1998–2003*. London: Museum of London.

Museum of Science and Industry in Manchester (1997) *Collections Management Plan*. Manchester: Museum of Science and Industry in Manchester.

Museum Training Institute (1993) *Museum Sector Workforce Survey: An Analysis of the Workforce in the Museum, Gallery and Heritage Sector*. Bradford: MTI.

Museums Association (1994) 'The Museums Charter', in G. Kavanagh (ed.), *Museum Provision and Professionalism*. London: Routledge, pp. 17–18.

Museums Association (1997) *Codes of Ethics*. London: Museums Association.

Museums and Galleries Commission (1997) *Larger and Working Objects: A Guide to their Preservation and Care*. London: Museums and Galleries Commission.

National Museum of New Zealand/Te Whare Taonga o Aotearoa (1989) *Taonga Maori*. Wellington: National Museum of New Zealand/ Te Whare Taonga o Aotearoa.

Neisser, U. (1988) 'Time present and time past', in M. Gruneberg *et al.* (eds), *Practical Aspects of Memory: Current Research and Issues*, vol. 2. Chichester: John Wiley, pp. 245–60.

Neisser, U. (ed.) (1993) *The Perceived Self: Ecological and Interpersonal Sources of Self-Knowledge*. Cambridge: Cambridge University Press.

Neisser, U. (1994) 'Self-narratives: true and false', in U. Neisser and R. Fivush (eds), *The Remembering Self: Construction and Accuracy in the Self-Narrative*. Cambridge: Cambridge University Press.

Neisser, U. and Harsch, N. (1992) 'Phantom flashbulbs: false recollections of hearing the news about Challenger', in E. Winograd and U. Neisser (eds), *Affect and Accuracy in Recall: Studies of Flashbulb Memories*. Cambridge: Cambridge University Press, pp. 9–31.

Nevins, A. (1996) 'Oral history: how and why it was born', in D.K. Dunaway and W.K. Baum (eds), *Oral History: An Interdisciplinary Anthology*. Walnut Creek: Altamira Press, pp. 29–38.

Noble, P. (ed.) (1995) *Judgement at the Smithsonian*. New York: Marlowe and Company.

Norris, A. (1989) 'Clinic or client? A psychologist's case for reminiscence', *Oral History*, Autumn: 26–30.

Nystrom, B. and Cedrenius, G. (1982) *Spread the Responsibility for Museum Documentation – A Programme for Contemporary Documentation at Swedish Museums of Cultural History*. Stockholm: Nordiska Museet/SAMDO/National Council for Cultural Affairs.

O'Neill, M. (1994) 'Curating feelings: issues of identity in museums', unpublished paper given to the Canadian Art Gallery Education group conference, November.

Ofshe, R. and Watters, E. (1995) *Making Monster: False Memories, Psychotherapy and Sexual Hysteria*. London: André Deutsch.

Oral History Association (1990) Oral History Evaluation Guidelines (including principles and standards), Pamphlet no. 3. http://www.baylor.edu/~OHA/welcome.html

Oral History Association (1996) *Oral History at Arrowhead: Proceedings of the First National Colloquium on Oral History*. Los Angeles: Oral History Association.

Oral History Society (1995a) 'Oral History Society ethical guidelines', *Oral History*, Autumn: 87.

Oral History Society (1995b) *Copyright, Ethics and Oral History*. London: Oral History Society.

Oring, E. (ed.) *Folk Groups and Folklore Genres: A Reader*. Logan, UT: Utah State University Press.

Osborn, C. (1993) *The Reminiscence Handbook: Ideas for Creative Activities with Older People*. London: Age Exchange.

Pagnamenta, P. and Overy, R. (1984) *All Our Working Lives*. London: British Broadcasting Corporation.

Parkinson, B. (1995) *Ideas and Reality of Emotion*. London: Routledge.

Pearce, S.M. (ed.) (1989) *Museum Studies in Material Culture*. Leicester: Leicester University Press.

Pearce, S.M. (1992) *Museums, Objects and Collections*. Leicester: Leicester University Press.

Pearce, S.M. (ed.) (1994) *Interpreting Objects and Collections*. London: Routledge.

Pearce, S.M. (ed.) (1997) *Experiencing Material Culture in the Western World*. Leicester: Leicester University Press.

Pearce, S.M. (1998) *Collecting in Contemporary Practice*. London: Sage Publications.

Peate, I. (1972) *Tradition and Folk Life: A Welsh View*. London: Faber and Faber.

Perks, R. (1995) *Oral History: Talking about the Past*, 2nd edn. London: Historical Association, in association with the Oral History Society.

Perks, R. and Thomson, A. (eds) (1998) *The Oral History Reader*. London: Routledge.

Peterson, R.A. (1996) *Age and Arts Participation with a Focus on the Baby Boom Cohort*. Washington, DC: Seven Locks Press/National Endowment for the Arts.

Phillips, R. (1998) 'Contesting the past, constructing the future: history, identity and politics in schools', in J. Arnold, K. Davies and S. Ditchfield (eds), *History and Heritage: Consuming the Past in Contemporary Culture*. Shaftesbury: Donhead. (Papers presented at the conference, Consuming the Past, University of York, 29 November to 1 December 1996.)

Pinker, S. (1999) *How the Mind Works*. Harmondsworth: Penguin.

Popular Memory Group (1982) 'Popular memory: theory, politics, method', in R. Johnson *et al.* (eds), *Making Histories: Studies in History-Writing and Politics*. London: Hutchinson, pp. 205–53.

Portelli, A. (1981) 'The peculiarities of oral history', *History Workshop Journal*, 12: 96–107.

Portelli, A. (1996) 'Oral history in Italy', in D.K. Dunaway and W.K. Baum (eds), *Oral History: An Interdisciplinary Anthology*. Walnut Creek: Altamira, pp. 391–416.

Price, S.J. and Molyneux, N.A.D. (1993) 'Collecting methods: recording interiors', in D. Fleming *et al.* (eds), *Social History in Museums: A Handbook for Professionals*. London: HMSO, pp. 187–96.

Prince, D.R. and Higgins-McLoughlin, B. (1987) *Museums UK: The Findings of the Museums Data-Base Project*. London: Museums Association.

Radley, A. (1990) 'Artefacts, memory and a sense of the past', in D. Middleton and D. Edwards (eds), *Collective Remembering*. London: Sage Publications, pp. 46–59.

Radley, A. (1991) 'Boredom, fascination and mortality: reflections upon the experience of museum visiting', in G. Kavanagh (ed.), *Museum Languages: Objects and Texts*. Leicester: Leicester University Press, pp. 63–82.

Ramer, B. (1989) *A Conservation Survey of Museum Collections in Scotland*. London: HMSO.

Rasmussen, L. (1997) 'An overview of ageing and health in Europe', in *Widening Horizons in Dementia Care, A Conference of the European Reminiscence Network: Conference Papers*. London: Age Exchange, pp. 6–10.

Redfern, A. (1996) *Talking in Class: Oral History and the National Curriculum*. University of Essex: Oral History Society.

Reese, E. and Fivush, R. (1993) 'Parental styles of talking about the past', *Developmental Psychology*, 29: 596–606.

Rosander, G. (ed.) (1980) *Today for Tomorrow. Museum Documentation of Contemporary Society in Sweden by the Acquisiton of Objects*. Stockholm: SAMDOK Council.

Rose, S. (1992) *The Making of Memory: From Molecules to Mind*. London: Bantam.

Rosh White, N. (1998) 'Marking absences: Holocaust testimony and history', in R. Perks and A. Thomson, *The Oral History Reader*. London: Routledge, 172–82.

Ross, C. (1993) 'Great ideas, even better execution?', *Journal of the Social History Curators Group*, **20**: 42–6.

Ross, C. (1998) 'Collections and collecting', in G. Kavanagh and E. Frostick (eds), *Making City Histories in Museums*. London: Leicester University Press, pp. 114–33.

Rovee-Collier, C.K. and Shyi, G.C.W. (1992) 'A functional and cognitive analysis of infant long-term retention', in C.J. Brainerd, M.L. Howe and V.F. Reyna (eds), *The Development of Long-term Retention*, New York: Springer, pp. 3–55.

Ryan, T. and Walker, R. (1985) *Making Life Story Books*. London: British Agencies for Adoption and Fostering.

Rzetelmy, H. (1988) *How to Conduct a Life Stories Project*. Brookdale Centre on Aging, Hunter College, New York.

Samuel, R. (1981) 'Editorial prefaces', in R. Samuel (ed.), *People's History and Socialist Theory*. London: Routledge & Kegan Paul.

Samuel, R. (1994) *Theatres of Memory*. London: Verso.

Sandahl, J. (1995) 'Proper objects among other things', *Nordisk Museologi*, **2**: 97–106.

Saraswati, Swami Satyananada (1989) *Four Chapters on Freedom*. Munger: Bihar School of Yoga.

Satchidananda, Sri Swami (1978) *The Yoga Sutras of Patanjali*. Buckingham, VA: Integral Yoga Publications.

Schacter, D.L., Norman, K.A. and Koutstaal, W. (1997) 'The recovered memories debate: a cognitive neuroscience perspective', in M. Conway (ed.), *Recovered and False Memories*. Oxford: Oxford University Press, pp. 63–99.

Schama, S. (1987) *The Embarrassment of Riches: An Interpretation of Dutch Culture in the Golden Age*. London: Fontana.

Schama, S. (1995) *Landscape and Memory*. London: HarperCollins.

Schaverien, J. (1987) 'The scapegoat and the talisman: transference in art therapy', in T. Dalley *et al.* (eds), *Images in Art Therapy*. London: Tavistock Publications, pp. 74–108.

Schaverien, J. (1997) 'Transference and transactional objects in the treatment of psychosis', in K. Killick and J. Schaverien (eds), *Art, Psychotherapy and Psychosis*. London: Routledge, pp. 13–37.

Schindler, R., Spiegel, C. and Malachi, E. (1992) 'Silences: helping elderly Holocaust victims deal with the past', *International Journal of Aging and Human Development*, **35**(4): 243–52.

Schweitzer, P. (1993) *Age Exchange's Reminiscence Projects for Children and Older People*. London: Age Exchange.

Schweitzer, P. (1994) 'Dramatising reminiscences', in J. Bornat (ed.), *Reminiscence Reviewed*. Milton Keynes: Open University Press, pp. 105–15.

Schweitzer, P. (1998) 'Age exchange cross-generational theatre work with ethnic elders' memories', in *The European Reminiscence Network: The Journey of a Lifetime: Festival Papers*. London: Age Exchange, n.p.

Schweitzer, P. with Bornat, J. (1992) 'Age Exchange; a retrospective', *Oral History*, Autumn: 32–9.

Seldon, A. and Pappworth, J. (1983) *By Word of Mouth: Elite Oral History*. London: Methuen.

Sherman, E. (1991) 'Reminiscentia: cherished objects as memorabilia in late life reminiscence', *International Journal of Aging and Human Development*, **33**(2): 89–100.

Shulman, L. (1979) *Skills on Helping Individuals and Groups*. Ithaca, NY: Peacock.

Silverman, L.H. (1993) 'Making meaning together: lessons from the field of American history', *Journal of Museum Education*, 18(3): 7–18.

Silverman, L.H. (1995) 'Visitor meaning-making in museums for a new age', *Curator*, 38(3): 161–70.

Slim, H. and Thompson, P. (1993) *Listening for a Change: Oral Testimony and Development*. London: Panos.

Snell, K.D.M. (1985) *Annals of the Labouring Poor: Social Change and Agrarian England 1660–1900*. Cambridge: Cambridge University Press.

Stacey, J. (1991) 'Can there be a feminist ethnography?', in S.B. Gluck and D. Patai (eds), *Women's Words: The Feminist Practice of Oral History*. London: Routledge, pp. 111–19.

Stanley, J. (1996) 'Letter to editor', *Oral History*, Autumn: 25.

Stavenow-Hidemark, E. (1985) *Home Thoughts from Abroad. An Evaluation of the SAMDOK Homes Pool*. Stockholm: Nordiska Museet/Samdo.

Steiner, C.K. (1993) *The Accessible Museum: Model Programs of Accessibility for Disabled and Older People*. Washington, DC: American Association of Museums.

Stevens, C. (1986) *Iorworth C. Peate*, Writers in Wales Series. Cardiff: University of Wales Press.

Stevenson, J. (1991) 'The long-term impact of interactive exhibits', *International Journal of Science Education*, 13(5): 521–31.

Storer, J.D. (1989) *The Conservation of Industrial Collections: A Survey*, London: Conservation Unit of the Museums and Galleries Commission/Science Museum.

Storr, A. (1995) *Jung*. London: Fontana, HarperCollins.

Sugarman, L. (1986) *Life-span Development: Concepts, Theories and Interventions*. London: Methuen.

Swain, H. (1997) 'Things ain't what they used to be', *Times Higher Educational Supplement*, 16 May.

Sylvester, D. (1994) 'Change and continuity in history teaching 1900–93', in H. Bourdillon (ed.), *Teaching History*. London: Routledge, pp. 9–26.

Taylor, E. (1978) 'Asian interpretations: transcending the stream of consciousness', in K.S. Pope and J.C. Singer (eds), *The Stream of Consciousness: Scientific Investigations into the Flow of Human Experiences*. New York: John Wiley, pp. 31–54.

Taylor, E. (1997) 'Working with groups at the Age Exchange Reminiscence Centre', in *Widening Horizons in Dementia Care, A Conference of the European Reminiscence Network: Conference Papers*. London: Age Exchange, pp. 140–1.

Thelen, D. (1990a) 'Introduction: memory and American history', in D. Thelen (ed.), *Memory and American History*. Bloomington and Indianapolis: Indiana University Press, pp. vii–xix.

Thelen, D. (1990b) 'Remembering the discovery of the Watergate tapes', in D. Thelen (ed.), *Memory and American History*. Bloomington and Indianapolis: Indiana University Press, pp. 93–133.

Thomas, H. (ed.) (1976) *Patterns of Ageing: Findings from the Bonn Longitudinal Study of Ageing*. Basle: Karger.

Thomas, K. (1983) *Man and the Natural World: Changing Attitudes in England 1500–1800*. London: Penguin.

Thompson, E.P. (1993) *Customs in Common*. London: Penguin.

Thompson, P. (1978) *The Voice of the Past*. Oxford: Oxford University Press.

Thompson, P. (1996) 'The development of oral history in Britain', in D.K. Dunaway and W.K. Baum (eds), *Oral History: An Interdisciplinary Anthology*. Walnut Creek: Altamira Press, pp. 351–62.

Thompson, P., Itzin, C. and Abendstern, M. (1991) *I Don't Feel Old: The Experience of Later Life*. Oxford: Oxford University Press.

Thomson, A. (1996) 'Letter to fellow editors', *Journal of the Oral History Society*, **28**, Spring.

Thomson, A. (1998) *Undergraduate Life History Research Projects: Approaches, Issues and Outcomes Working Report*. University of Sussex/History 2000.

Thornton, S. and Brotchie, J. (1987) 'Reminiscence: a critical review of the empirical literature', *British Journal of Clinical Psychology*, **26**: 93–111.

Titley, J. (ed.) *Sharing the Wisdom: Museums and Older People*. London: Age Concern.

Tonkin, E. (1992) *Narrating Our Pasts: The Social Construction of Oral History*. London: Cambridge University Press.

Tucker, D. (1993) 'A traditional view *or* a radical re-think', *Social History Curators Group News*, Summer: 6–8.

Tulving, E. (1975) 'Ecphoric processing in recall and recognition', in J. Brown (ed.), *Recall and Recognition*. London: Wiley.

Tulving, E. (1983) *Elements of Episodic Memory*. Oxford: Oxford University Press.

Vallely, P. (1999) 'At the altar of the atheists', *Independent*, 13 February.

Vansina, J. (1965) *Oral Tradition: A Study in Historical Methodology*. London: Routledge & Kegan Paul.

Virgoe, R. (ed.) (1989) *Illustrated Letter of the Paston Family*. London: Guild Publishing.

Wallace, B.J. (1992) 'Reconsidering life review: the social construction of talk about the past', *Gerontologist*, **32**(1): 37–53.

Wallace, M. (1995) 'The battle of the Enola Gay', *Museum News*, July/August: 40–62.

Wallace, M. (1996) 'The Battle of the Enola Gay', in M. Wallace (ed.), *Mickey Mouse History and Other Essays on American Memory*. Philadelphia: Temple University Press, pp. 269–318.

Waller, D. (1993) *Group Interactive Art Therapy: Its Use in Training and Treatment*. London: Routledge.

Walsh, K. (1992) *The Representation of the Past: Museums and Heritage in a Post-Modern World*. London: Routledge.

Ward, A. (1990) *Manual of Sound Archive Administration*. London: Gower.

Warren, B. (1984) *Using the Arts in Therapy*. London: Routledge.

Warren, B. (1993a) 'Introduction', in B. Warren (ed.), *Using the Creative Arts in Therapy: A Practical Introduction*. London: Routledge, pp. 3–9.

Warren, B. (ed.) (1993b) *Using the Creative Arts in Therapy: A Practical Introduction*. London: Routledge.

Watson, L. (1990) *The Nature of Things: The Secret Life of Inanimate Objects*. London: Sceptre.

Watt, L.M. and Wong, P.T.P (1991) 'A taxonomy of reminiscence and therapeutic implication', *Journal of Gerontological Social Work*, **16**(1/2): 35–57.

Webster, J.D. (1994) 'Predictors of reminiscence: a lifespan perspective', *Canadian Journal on Aging*, **13**: 66–78.

Webster, J.D. (1995) 'Adult age differences in reminiscence functions', in B.K. Haight and J.D. Webster (eds), *The Art and Science of Reminiscing*. Washington, DC: Taylor & Francis, pp. 89–102.

Welsh Folk Museum (1983) *Tape Recording and Welsh Folk Life: Discussion Paper*. St Fagans: Welsh Folk Museum.

Whittington, A. (1997) 'It's good to talk: turning young people on to culture', *Museums Journal*, September: 37–9.

Williams, G. (1991) *George Ewart Evans*. Writers in Wales Series. Cardiff: University of Wales Press.

Williamson, B. (1982) *Class, Culture and Community: A Biographical Study of Social Change in Mining*. London: Routledge & Kegan Paul.

Wilson, M. (1992) 'Oral evidence work with undergraduates', *Oral History*, Spring: 63–6.

Wolfe, T. (1997) 'Sorry but your soul has died', *Independent on Sunday*, 2 February, pp. 6–10.

Wong, P.T.P. and Watt, L.M. (1991) 'What types of reminiscence are associated with successful aging?' *Psychology and Aging*, 6: 272–9.

Wong, P.T.P. (1995) 'The process of adaptive reminiscence', in B.K. Haight and J.D. Webster (eds), *Art and Science of Reminiscing: Theory, Research, Methods and Applications*. Washington, DC: Taylor & Francis, pp. 23–36.

Wright, P. (1985) *On Living in an Old Country*. London: Verso.

Yapko, M. (1994) *Suggestions of Abuse: True and False Memories of Childhood Sexual Trauma*. New York: Simon & Schuster.

Yapko, M. (1997) 'The troublesome unknown about trauma and recovered memories', in M. Conway (ed.) *Recovered Memories and False Memories*. Oxford: Oxford University Press.

Name index

Page numbers in **bold type** refer to captions.

Subject index

Page numbers in **bold type** refer to illustrations.